STREET ART

The public has a right to art.
The public needs art, and it is the
responsibility of a 'self-proclaimed'
artist to realise the public needs
art, and not to make bourgeois art
for the few and ignore the masses.
I am interested in making art to be
experienced and explored by as
many individuals as possible
with as many different individual
ideas about the given piece
with no final meaning attached.
The viewer creates the reality, the
meaning, the conception of the
piece. I am merely a middleman
trying to bring ideas together.
Keith Haring
Journal entry, 14 October 1978

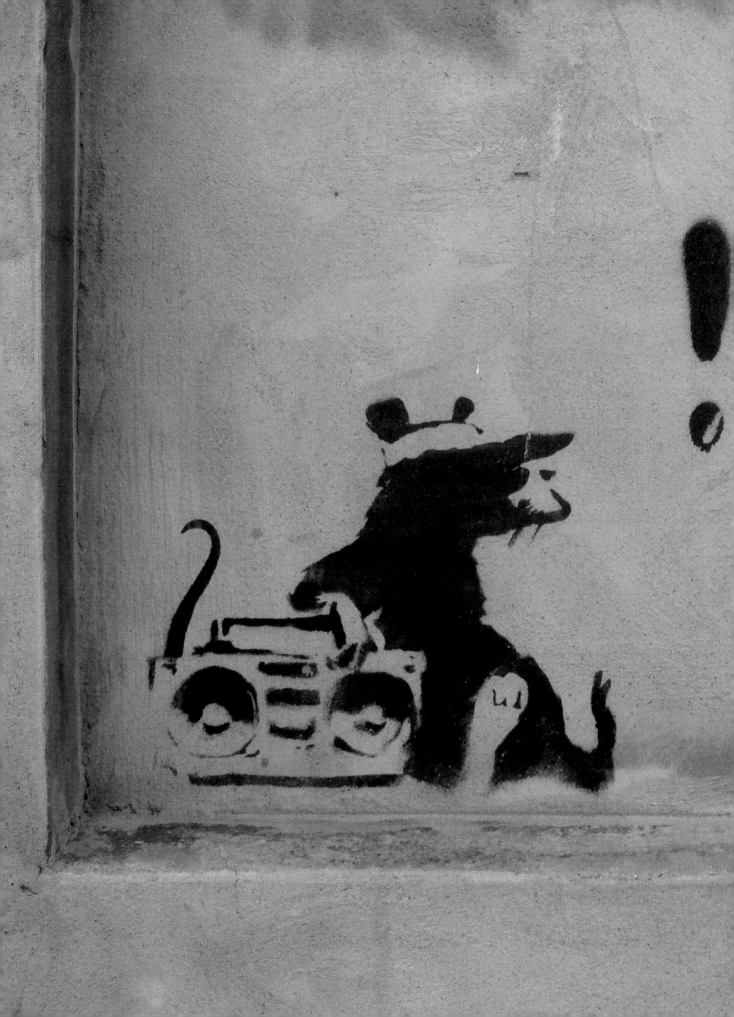

Cedar Lewisohn

STREET ART

THE GRAFFITI REVOLUTION

Tate Publishing

First published 2008 by order of the
Tate Trustees by Tate Publishing,
a division of Tate Enterprises Ltd,
Millbank, London SW1P 4RG
www.tate.org.uk/publishing
A catalogue record for this book is
available from the British Library

ISBN 978 1 85437 767 8

Designed by Adam Brown at 01.02
Printed by Grafos, Spain

Unless otherwise indicated, all photographs were
taken between 2006 and 2008.

Front cover: Miss Van, Barcelona
Back cover: Graffiti Research Lab, New York
Frontispiece: Banksy, Liverpool

Author's acknowledgements

My thanks to all the artists, photographers and
others who have helped make this book possible
and appear in the following pages. Thanks also
to Henry Chalfant for his fantastic Foreword.
I'm very grateful to all at Tate Publishing for
their support, in particular Mary Richards, who
has overseen the whole process with calm
insight and always excellent advice. Thanks to
Barry McGee and Eine who helped me formulate
the initial idea for this project, and thanks also to
Ghost Patrol in Melbourne and Jonathan
Le Vine in New York for the hook ups.

I would also like to thank and acknowledge
The Arts Council of England and the Esmée
Fairbairn Foundation, whose support enabled
my research while on the Inspire Fellowship
programme. For their support in this process,
special thanks go to Emma Dexter and Sheena
Wagstaff, as well as all the other Tate staff who
were such gracious hosts during my fellowship.
For his legal advice, I would like to thank my
uncle David Lewisohn.

Last, but by no means least, I would like
to extend my sincere gratitude and never-ending
thanks to Patricia Ellis, without whom
I probably could not have written a Post-It
note, let alone a book!

Contents

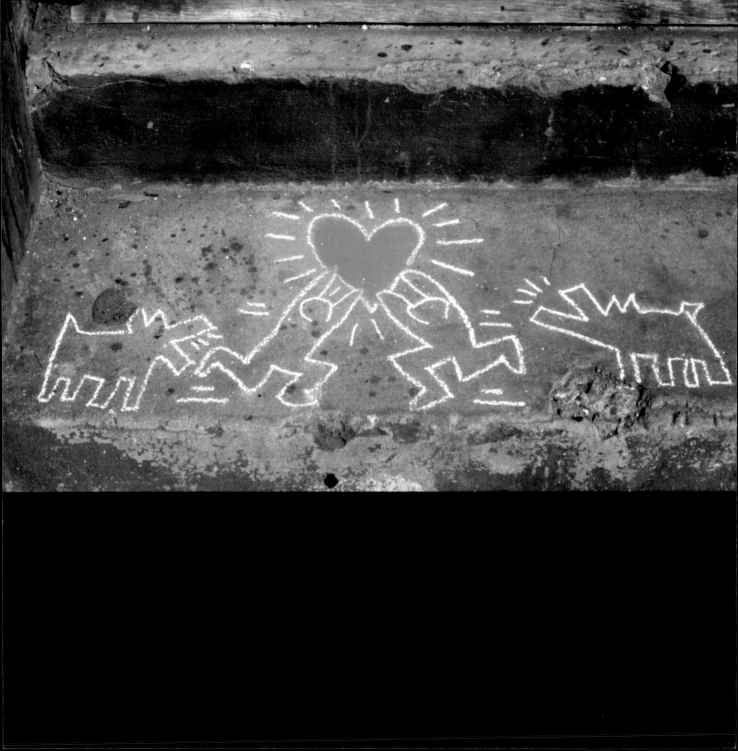

Foreword

In New York in the 1970s and 1980s, graffiti writers challenged the industrial power of 600 miles of steel and machinery that run like arteries beneath the city, blasting through the tunnels and thundering along the 'el' over miles of rubble where apartment buildings once stood. They proclaimed, 'We are here. We will not be ignored!', ushering in a period of innocent creation and achievement that brightened the decaying city, turning deferred-maintenance wrecks into brilliant canvases that put a new face on the concept of public ownership. The story is one of owning nothing yet owning it all, infusing the faceless grid with your own identity, your own spirit, and offering form and colour as medicine for a community in pain.

Graffiti and hip hop were born in beleaguered urban communities like the South Bronx that were victims of the urban renewal schemes and highway building that took place in the middle of the last century. Urban renewal is often justified as the desire to improve the lives of others, but it is mostly just a pretext for the real motive: making money. In New York City, Robert Moses was the driver of this restructuring, with a vision resembling Flash Gordon's world of glimmering highways and tall towers. There was money to be made in the building and expansion of real estate, new highways and the development of the suburbs, a process that has driven the US economy ever since. But this combination of modernisation and speculation laid waste to once viable communities.

Hostility to the urban poor has a long history. Planners think it's a great idea to bulldoze and rebuild, to displace the teeming neighbourhoods with real-estate opportunities for entrepreneurs, while destroying these 'dangerous' communities that might upset the social order. This notion is best articulated by Le Corbusier with his famous saying, 'Kill the street'. He envisioned a city made up of towers in a park. The underlying political idea was to isolate and break up potentially rebellious communities, to prevent the formation of a critical mass for unrest. This vision, combined with Frank Lloyd Wright's 'Usonian' suburban ideal intended to be affordable for the 'common people', drove a change in focus onto economic development in the United States after the Second World War. This generated new money and spawned visions of great opportunity in suburban development to the detriment of the cities, which were allowed to crumble and die. These formerly vital communities, displaced and relocated, suffered as if from root shock. The shining towers became notoriously unliveable housing projects. In the ensuing era of neglect and economic decline, graffiti was born.

Ironically, out of the destruction of once viable urban neighbourhoods, a new community sprang up – one that couldn't be bulldozed. This new community was autonomous and impossible to control. Based on a creative response to the given conditions, the urban youth invented hip hop and graffiti art. Graffiti, this new form of expression on the walls and trains, was profoundly disturbing to the people in charge, who wanted to destroy it at all costs, but couldn't catch the perpetrators. In his early article on graffiti, Nathan Glazer stated that graffiti had to be destroyed because it was a symbol that society had lost control, 'The sense that all are a part of one world of uncontrollable predators seems inescapable'.

A bleak environment of metal, brick and mortar is a good starting point for a work of

Keith Haring, New York City, 1986. The artist left this chalk drawing on the steps of Henry Chalfant's studio

7

art. But the days of painting trains in New York finally came to an end, succumbing to the MTA's campaign of prevention and renewal, which saw to it that even if you did paint a train, you would probably never see it run. But, as graffiti writers Mare 139 and Duro have said, 'We may have lost the trains, but we've gained the whole world.' Graffiti died in New York, but not before planting a seed that is flourishing and spreading around the globe. A worldwide renaissance of culture that had its start on the mean streets of New York has taken place. Artists who began as 'bombers' have infiltrated every branch of the media and entertainment business, graphic design, web design, film, music and dance in an explosion of cultural expression. In the 1970s, graffiti writers transcended the rigid territorial boundaries observed by the warring gangs who preceded them. They created a multicultural, multi-racial community that reflected the diverse population of New York. Now, in the face of a world that is becoming increasingly balkanised, street artists, using rail passes and the internet, emulate the original graffiti writers by crossing national and cultural borders to create an international movement.

Street art, the natural heir to graffiti, is rooted in the creativity of the dislocated and alienated urban communities of America in the second half of the twentieth century. The movement is inspiring people in similar circumstances in a world increasingly urbanised, divided by a growing gulf between the rich and the poor, and by migration and dislocation. The *favela* is now the model for most of the world's cities, as vast numbers of people continue to migrate to them in order to survive. These communities have amazing creative potential and a deep need to express themselves, to own the walls that surround them. Street art is evolving and flourishing. The style is 'in your face', anti-authoritarian, irreverent, irrepressible, wise, ironic, a voice for the powerless and the have-nots. Thus it has the potential to spread like wild-fire through a world exploding with *favelas*. Street art inherits its spirit from hip hop: an autonomous subculture, not for sale, free of direction from any force of society or government, and free of the dictates of the market place. It's about artists taking control of their lives. Own the walls that surround you!

Henry Chalfant
New York City, 7 August 2007

Author's Foreword

Below: Chin Chin, Berlin
Following page:
New York,
various artists

The worlds of graffiti writing and street art are constantly evolving and reinventing themselves. These are genres that stubbornly refuse rules of categorisation, but which do at the same time adhere to certain codes and fashions. We can consider their relationship a living dialogue.

The public understanding of these subjects is also in constant flux. Ten years ago, 'graffiti' was a dirty word, denoting an activity that was seen by the majority as containing little artistic merit or social consequence. Today, it is still a dirty word in some contexts, but our understanding of it has developed. There is now a general appreciation of the fact that there are practitioners out there on the street whose art might be illegal, but is far from pure vandalism. Stories of 'art pranks' – not quite graffiti, not quite gallery art – are often reported in the media, and this fuels the public interest. These interventions are often referred to in the media as 'guerrilla art' or 'urban art' and sometimes 'street art'.

All over the world, the same thing is happening and has been happening for many years. There are magazines, galleries and websites dedicated to the various separate aspects of the intertwining scenes. The attitude to graffiti and street art changes greatly according to where you are in the world, although wherever you are, you're more likely to see graffiti writing than street art. In the end, it's up to you as the viewer to decide what is art and what is not, what is interesting and what is not. But before you make up your mind, you have to learn to look.

Introduction

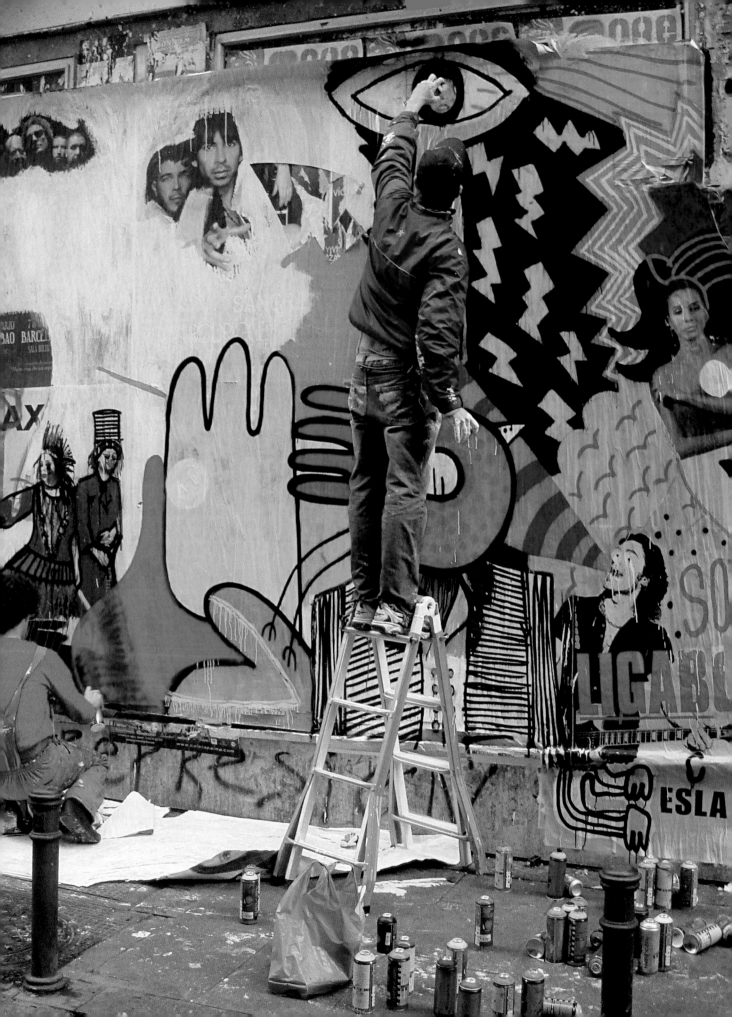

Street Art or Graffiti?

Street art is more about interacting with the audience on the street and the people, the masses. Graffiti isn't so much about connecting with the masses: it's about connecting with different crews, it's an internal language, it's a secret language. Most graffiti you can't even read, so it's really contained within the culture that understands it and does it. Street art is much more open. It's an open society. Faile

By 'graffiti', it is generally understood that we mean any form of unofficial, unsanctioned application of a medium onto a surface. Although it has come to be used as a singular noun, it is in fact the plural form of 'graffito', which means an image or text scratched onto a wall. 'Graffiti writing', which is separate from graffiti, is the movement most closely associated with hip hop culture (though it pre-dates it), whose central concern is the 'tag' or signature of the author.

'Street art' is a sub-genre of graffiti writing and owes much to its predecessor. Though there is a good deal of crossover between the genres, they are distinct and separate in their own right. The difference between graffiti writing and street art is as great as that between, for example, jazz and techno music. Just as techno could arguably never have come into existence without predecessors such as jazz and blues, street art derives from graffiti writing. There are, of course jazz musicians today who work with techno and there's jazzy techno if you want it. No genre is ever pure. Similarly, many street artists will have come to their work through an interest in graffiti writing and may even do a bit of graffiti on the side. Many hardcore graffiti writers don't like street art, just as some purist jazz musicians don't have much time for techno.

If all this compartmentalising weren't complicated enough, we also need to take into account the fact that many of the artists *we* might consider street artists wouldn't necessarily accept this term themselves. Some prefer just to be known as 'artists'. The problems with the term 'street art' lie in its broadness. It seeks to cover a vast group of artists working all over the world in many different ways. Artists, as a rule, don't welcome external categorisation; they prefer to be looked at as individuals. Street artists are by definition rule-breakers, so if you attempt to categorise them, they'll simply go and break the rules that have been set to define them. It's their nature and it's the nature of the genre. Once these rules have been broken, the parameters of the art form will also have been stretched, but the work may well still qualify under the original definition. Despite all of this, it's useful to have some workable term for this art form, and 'street art' is the best we've got. The benefit of the term is that it's wide enough not to strangle any one individual, but precise enough to eliminate other works that don't fall into the category.

The etymological origins of the term are difficult to pin-point. The phrase was certainly in common usage throughout the late 1970s. In 1978, the artist John Fekner curated *Detective Show* in an outdoor park in Jackson Heights, Queens, New York, which included the words 'street museum' on the invitation card. He recalls, 'We laughed at the term "street

3TT Man and Sixeart installing work on the Madrid streets

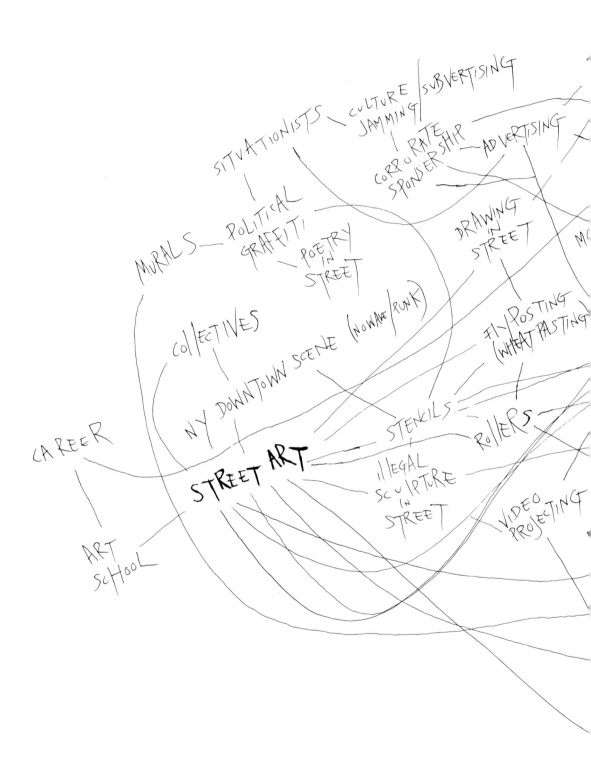

SITUATIONISTS — CULTURE/SUBVERTISING JAMMING

CORPORATE SPONSERSHIP — ADVERTISING

MURALS — POLITICAL GRAFFITI

POETRY IN STREET

DRAWING IN STREET

COLLECTIVES

FLY-POSTING (WHEAT PASTING)

NY DOWNTOWN SCENE (NOWAVE/PUNK)

CAREER

STENCILS

ROLLERS

STREET ART

ILLEGAL SCULPTURE IN STREET

ART SCHOOL

VIDEO PROJECTING

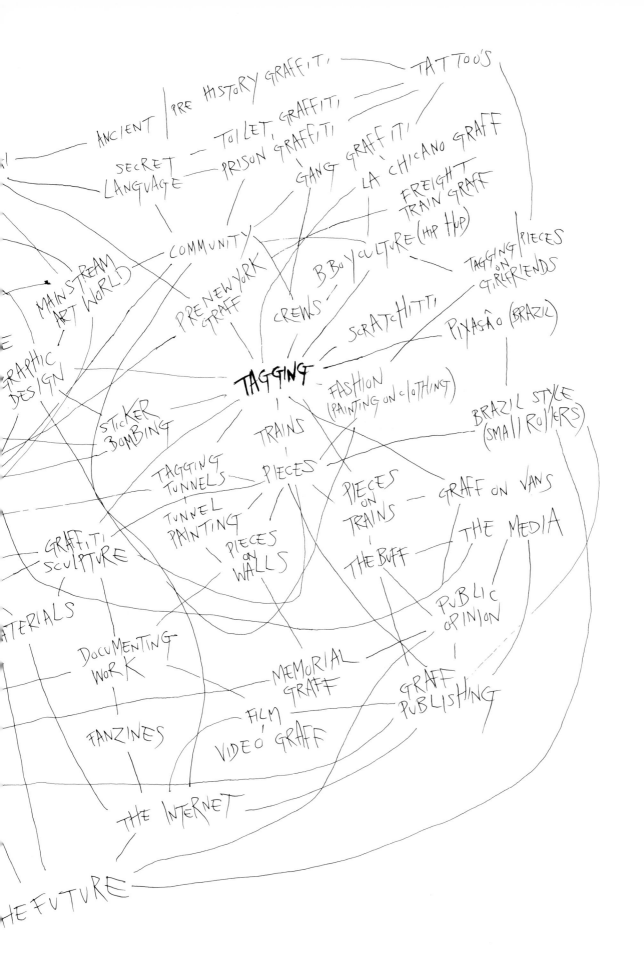

ANCIENT | PRE HISTORY GRAFFITI — TATTOO'S

TOILET GRAFFITI

SECRET LANGUAGE — PRISON GRAFFITI

GANG GRAFFITI

LA CHICANO GRAFF

FREIGHT TRAIN GRAFF

COMMUNITY

MAINSTREAM ART WORLD

PRE NEW YORK GRAFF

B BOY CULTURE (HIP HOP)

TAGGING / PIECES ON GIRLFRIENDS

CREWS

SCRATCHITTI

PIXAÇÃO (BRAZIL)

GRAPHIC DESIGN

TAGGING

FASHION (PAINTING ON CLOTHING)

STICKER BOMBING

TRAINS

BRAZIL STYLE (SMALL ROLLERS)

TAGGING TUNNELS

PIECES

PIECES ON TRAINS

GRAFF ON VANS

TUNNEL PAINTING

THE MEDIA

GRAFFITI SCULPTURE

PIECES ON WALLS

THE BUFF

MATERIALS

PUBLIC OPINION

DOCUMENTING WORK

MEMORIAL GRAFF

GRAFF PUBLISHING

FANZINES

FILM VIDEO GRAFF

THE INTERNET

THE FUTURE

art" when it started to get around a few years later. If you had a degree, you did "street art" as opposed to graffiti.' An early use of the term in print came with Allan Schwartzman's excellent book of that name in 1985. Since then, many artists have been happy to be known as 'street artists' and actively encourage the use of this term over, for example, 'graffiti artist', 'graffiti writer', 'urban artist' or the numerous other names that are associated with the art form. This is an indication that both genre and title have some validity.

One of the principle reasons for making a distinction between street art and graffiti writing is that graffiti has such a bad public reputation. Graffiti writers as a general rule couldn't care less about this; street artists are often more concerned with external perceptions. Here we see the start of a separation process. This separation has evolved to include several defining factors, including differences in technique, differences in motivation and audience, and major differences in the way the separate genres actually look.

Street art and graffiti writing may be very similar pastimes, both stemming from a similar place with some congruous ideas and cross pollination, but they are different in terms of form, function and most importantly, intention. In strict academic terms, it is necessary to differentiate between them in order to correct some of the mistakes of art history, which has mislabelled as 'graffiti art' a very important and influential group of works made in recent years. When art-historians talk about 'graffiti artists', they are usually referring to a small number of artists associated with street art and graffiti from the 1980s including Keith Haring, Jean-Michel Basquiat and Kenny Scharf, who would never have considered themselves 'graffiti artists', and would certainly not be considered as 'graffiti writers' by genuine graffiti writers of that period. The term 'graffiti artist' is considered misleading by many graffiti writers, the implication being that they are concerned with producing work that relates to external rules of aestheticisation. By clearly defining street art as separate from graffiti writing, it may be possible to correct some of these mistakes.

Art history is understood in a linear way, with one movement following the next. Experts in this area rarely look outside of the lineage, so when art forms arise that are foreign to 'the story', they may not fully comprehend them. The graffiti-writing movement from the mid-1960s onwards had a fractured relationship to art history, but was still very appealing to the art world of the time, and has been to varying degrees ever since. Despite its popularity, the work was never fully comprehended by the majority of academic thinkers, and their misconceptions have now become accepted. The casual label 'graffiti art' has led to an inaccurate representation of a genre that should correctly be known as 'graffiti writing' or more colloquially, 'graff'.

The conceptual universe in which graffiti writing exists, however, is so huge that it can accommodate many different ideas, styles and movements within its boundaries. It is for this reason that graffiti writing has the ability to be both art and not art at the same time. It is art in that it is a practised skill to which the artists or 'writers' devote their lives, perfecting a certain style of letter formation. The fact that graffiti has no real purpose, other than its own existence, would also strengthen the case that it is a solipsistic art form. Many

Rowdy, London.
This work mixes the
original wall colour
with the application
of spray paint

theorists believe that art should be infinitely impractical, and graffiti is certainly that.
The other side of this argument, however, is the fact that many graffiti writers, 'taggers' in
particular, do not want to be considered as artists. They're out to destroy; they're out to
make a mess; they find the term 'art' offensive. They look down on art and are happy to be
known primarily as vandals.

Graffiti writing, particularly tagging – or 'bombing' – fits very well into the idea of
destruction as a form of creativity, an 'anti-art'. Despite all of its destructive tendencies,
tagging is a highly aestheticised form of vandalism. This crafted aesthetic is almost
dandyish in quality: like calligraphic peacocks, graffiti writers spend years practising
and cultivating their personalised alphabets, primarily to write the same word over and
over again.

The problem for the external viewer is that this aesthetic code exists in such an
internalised language that the main group of people who can fully appreciate it are other
graffiti writers. This language that no-one else understands is then used for destroying or
defacing cities. It's about making ugly places even uglier; a beautiful concept to some, but
not an easy notion for outsiders to comprehend. The idea of making something uglier than
it was to begin with goes against all romantic ideas that art should 'enrich the soul'.

Flying in the face of preconceived ideas about art and creativity is what has made this
art form so alluring for the past thirty years. Street art and graffiti both have the peculiar
ability to exist in the mainstream of culture and at the same time on its periphery. They

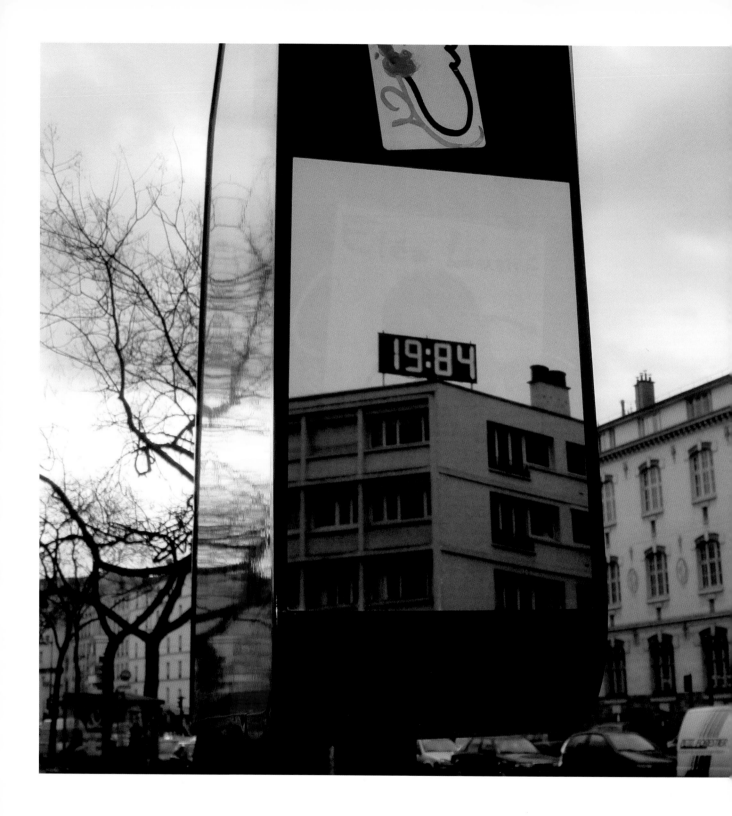

reside in the vernacular through their co-option by advertising, film and design, but although they can participate in mainstream culture in this way, they are never really understood by it. This anomaly means that you can see a tag on a model's T-Shirt featured on the cover of a high-fashion magazine, but have no idea what it actually represents or means. In this instance, the tag is seen as a 'cool' thing. But placed in its authentic context on the street, the same tag is interpreted as ugly and a nuisance. This has led to a situation where the mainstream understanding of graffiti is in fact a misunderstanding.

Graffiti writing is an activity completely reliant on the tag. Love it or loathe it, we have to accept that the tag is the core of graffiti, and a graffiti writer without a tag wouldn't be a graffiti writer. The majority of street artists, however, although they may have a pseudonym, are not involved in tagging. We can see graffiti writing as a genre that, generally speaking, revolves around typography and letter formation. This is annexed with the occasional use of figurative elements or 'characters'. Graffiti characters are generally done with spray paint by a graffiti writer who is primarily concerned with tag-based typographic issues.

It's important to note street art's break with the tradition of the tag, and its focus on visual symbols that embrace a much wider range of media than graffiti writers would use.

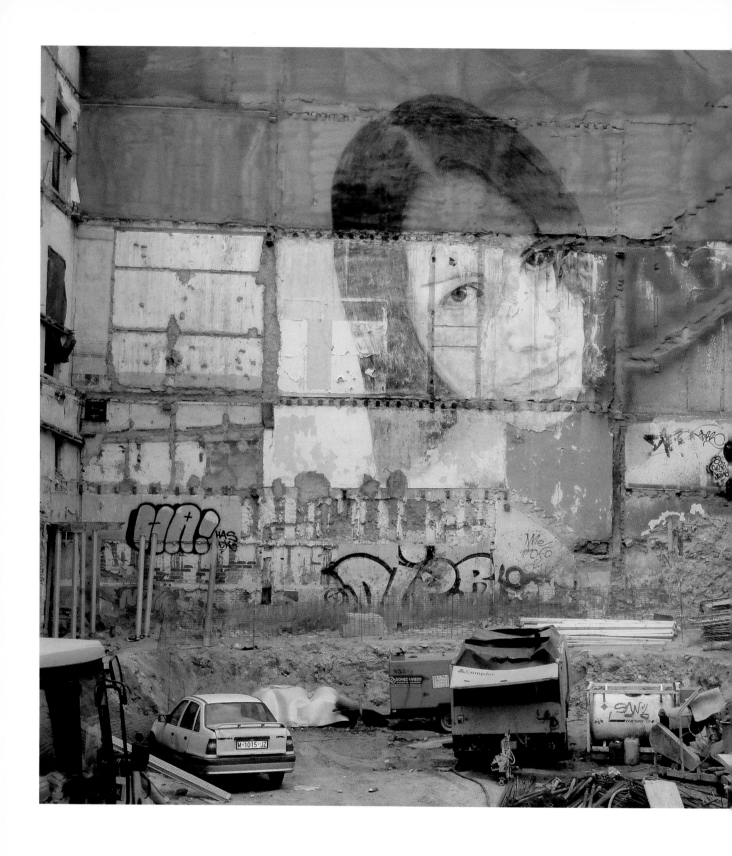

Charcoal wall
drawing by
Jorge Rodriguez-
Gerada, Madrid

When street artists work figuratively with 'characters', as they very often do, they are likely to use materials and techniques commonly associated with street art such as stencilling or pasting. This is not a water-tight rule, since there are many street artists who primarily work with figuration and who also use spray paint as a medium. Usually, just by looking at the style of the work, the viewer can distinguish whether it is more related to graffiti writing or street art. Occasionally, however, the genres do blur.

A complication in the identification process is that street art very often co-exists with graffiti writing. Fly-posted works and stencils etc are often placed on top of graffiti writing or in close proximity to it. The reasons for this are aesthetic: they improve the look of street artist's work. When street art and graffiti do co-exist on the same walls in this way, they will be speaking different languages to different audiences. Graffiti writers are communicating with themselves and their closed community; they have little interest in being understood by the wider world. In comparison, street art can be understood by any casual observer, since it is primarily a picture-led graphic art form.

Graffiti writing can potentially incorporate any of the techniques of street art, but when it does, it will do so while dealing with issues related to tagging. Street art, generally speaking, is not concerned with typography. Text may be used, but is seldom the subject of the work. Graffiti writers are working in a very similar conceptual manner from that of major corporations: reducing themselves to a brand – or tag – that comes to have a far greater meaning than the actual word itself (think of Coca-Cola or Nike). In essence, graffiti writers, through their use of tags, are reducing content down to an absolute minimum. Once they have distilled their content to its essence, they expand this purified form. This is done either through scale, by enlarging the tag to massive proportions with elaborate designs or 'pieces', or through repetition, by placing the tag in as many different places as possible. They may even do both. Street artists also use the devices of scale and repetition, but the difference is in the media and content of the work.

This distinguishing process may seem like an art form in itself, but it's actually quite obvious. Once the viewer takes an interest in the subject, it becomes clear very quickly what is street art and what is graffiti. Graffiti writing has a very specific aesthetic: it's about the tag, it's about graphic form, it's about letters, styles and spray-paint application, and it's about reaching difficult locations. If we think of street art as, to quote Fekner, 'All art on the street that's not graffiti', then the definition is extremely broad, and this broadness reflects the genre's freedom.

If, as *Stencil Graffiti* and *Graffiti Brasil* author Tristion Marco suggests, we were to 'Make a family tree of graffiti', we'd find that people who make stickers are related to those who write provocative sentences on the side of buildings, who again are related to artists who do 'subvertising' – the subversion of street advertising (see diagram, pp.16–17). There are practitioners who only write poetry texts in the street, and there are dedicated street artists who may also write sentences on a wall. Then there could also be a random person who finds a piece of chalk and writes or draws something. All these activities are connected, but fall outside of tagging-based graffiti.

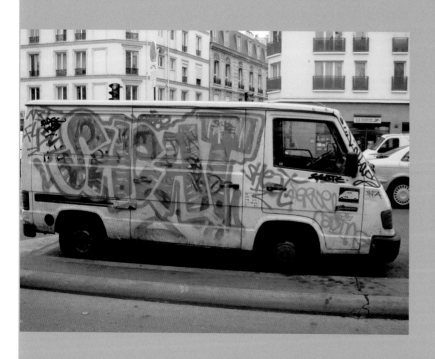

Graffiti

Live in Pompeii

The parameters of unofficial art are extremely broad, and could potentially include everything from cave painting to flash-mobbing. The question of whether or not cave paintings belong in the realm of unofficial art is a debateable one. Most experts on the subject will agree that cave painting had at least something to do with ritual, and therefore was in part a community-sanctioned pastime.

Some of the earliest graffiti is known to have taken place in Egypt, but examples are rare, and do not include hieroglyphics, which again, are socially sanctioned. If we move forward about 2,500 years, we find more than 11,000 examples of unsanctioned graffiti texts that have so far been documented in Pompeii. According to Kristina Milnor, Assistant Professor of Classics at Barnard College in New York, the word 'graffiti' was born in the late eighteenth and early nineteenth centuries, when visitors to Pompeii first started talking about the fact that there was graffiti on the walls. The graffiti had always been there, but nobody had shown any interest in it until the study of ancient art became fashionable during this period, bringing with it an interest in the concept of graffiti as an uncultured art form and as the product of a pure urge to create. William Wordsworth's poem, *Lines Left upon a Seat in a Yew-tree*, imagined as lines literally written onto a tree, celebrates this pure creative act. Lord Byron repeatedly wrote his name at the Temple of Sunium in Greece. By the end of the nineteenth century, we see the beginning of negative attitudes towards graffiti. 'The pure creative act' starts to be associated with activities related to lower elements of society.

The graffiti in Pompeii consisted mainly of words and poetry, with little imagery as we understand it today. It has been argued that in this period, there was less of a barrier between image and word: words on the wall were much closer to a picture than we might consider them now. There is evidence of words merging with pictures – a name transforming into a boat, for example. Another difference in the way graffiti was perceived in antiquity, in comparison to our contemporary viewpoint, was that ownership of space didn't exist in the same way. The relationship to property was also very different from our understanding of it. In antiquity, it was easier to think of a drinking pot or a slave in terms of property than a wall.

The subject of drinking pots is especially relevant to this area of research. According to Alan Johnston, an expert in Greek and Classical Archaeology at University College London, some of the earliest examples of writing known to etymologists are on Greek drinking pots. Johnston believes that this writing can be considered as a very early form of text-based graffiti. The pots were found in pubs, and it seems that the texts were messages. They ranged from accusations of devious sexual antics to warnings of criminal activities. This idea of Greek pots sharing a relationship with modern-day graffiti writing is not as crazy as it might at first seem. Kristina Milnor explains: 'If we consider the way the urban landscape was experienced in New York in the 1980s, the graffiti writing can at one level be considered as a war over space. The subway cars moved from one space to another, so tags moved from the Bronx and into Manhattan.

The pot acted in a similar way – having the quality of a message board.'

There are many examples of murals at Pompeii, but experts discount these as examples of graffiti since it is thought that people were employed to create them. They are therefore seen as official, sanctioned artworks. However, we can identify certain individuals who wrote on walls in Pompeii. Illyus Keller, a sign painter, appended his name to his murals, but he also wrote his signature without any mural, very much like a modern-day tag. In Pompeii, there are two different kinds of graffiti: scratched and painted. Keller's signatures were scratched onto various surfaces.

The modern association of graffiti with specific geographical areas in social decline are not applicable in Pompeii. The graffiti was not restricted to one area or a particular class of social dwelling. It was often poetic or obscene and there are even examples of love poems being written directly on the walls inside people's houses. It is thought that this was considered a form of decoration. Other examples of ancient graffiti include erotic notes, found on the Greek island, Thera.

Graffiti in the Roman world was often associated with politics and was a popular way of speaking back to authority. The city walls constituted a place where people would ridicule, or complain about, the authorities. It's difficult for historians to know the reactions of those in power to these poisonous messages; however, there are stories about the Emperor Nero taking action against the people who were responsible for criticising him in this way.

It is not clearly known what happened to graffiti after the destruction of Pompeii in AD 79, but it is believed that it may have hit its high point in the first century. The activity seems to have been at its most prevalent from the Julian period up to the reign of Nero (AD 14–68).

Graffiti becomes visible to historians again in the middle ages, particularly on the outside of churches. There is also evidence that graffiti was prevalent in Shakespeare's time. The more graffiti there was, the easier it is for historians to find examples. It is suspected that there was graffiti throughout modern history. However, as we have seen, public opinion turned against graffiti in the late nineteenth century. This was due to the relationship between the working classes, who are imagined to be the authors of the graffiti, and the elite, who dominated cultural production. During this period, people became much less sympathetic to those 'down below'. After the Romantic interest in graffiti as 'pure creative act', the Victorians returned to 'real art', losing interest in art that was being produced in the streets.

Brassaï

*The bastard art of the streets of ill repute that does not even arouse our curiosity, so ephemeral
that it is easily obliterated by bad weather or a coat of paint, nevertheless offers a criterion of worth.
Its authority is absolute, overturning all the laboriously established canons of aesthetics.*
Brassaï, writing in the Surrealist magazine *Minotaure*, 1933

Gyula Halász, better known by his pseudonym, Brassaï, is a canonical figure in twentieth-century photography, best known for his images of Parisian high- and low-life. He is also famous for documenting graffiti on the Paris streets in the 1930s. This graffiti was seen by Brassaï and many of the Surrealists, with whom he was friends, as a primitive, childlike art. For Brassaï, primitive art, children's art, the art of psychiatric patients and graffiti all shared a freedom and energy impossible for 'serious' artists to replicate.

Brassaï became interested in graffiti during his flâneur-like wanderings through the city at night. His enthusiasm for art on the streets was in some ways a revolt against the interest shown in African and Oceanian art by the mainstream taste-makers and other artists of the time. The idea that the art on the street, right outside people's doors, was equally as interesting as that being exoticised by the bourgeoisie was as radical then as it is now. In this sense, Brassaï was drawing parallels between these two forms of creativity. Both he and the Surrealists were greatly interested in anonymous art forms such as graffiti that were not considered worthy of attention, and this fitted with their ideas of how art should function.

Left: Brassaï, *Child
Writing Graffiti*, 1931
Right: Brassaï, from
the series *VII La Mort*,
1935–50 and
VIII La Magie, 1934

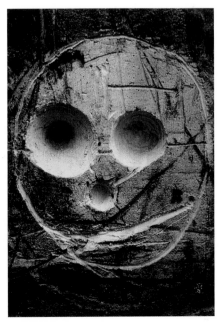

Brassaï was friends with Salvador Dalí, Pablo Picasso, Jean Dubuffet, Henri Matisse and many other artists who circulated around Paris at the time. He made their portraits and had long conversations with them about art and ideas. Many collected his work, and it is therefore likely that they would have seen his photographs of graffiti. We can only speculate as to how much influence they might have taken from his work, but all these artists inspired each other, and many shared creative concerns. The similarity of many of the mask-like faces in the graffiti that Brassaï photographed and those that appear in Picasso's work is undeniable. Picasso himself stated that when he was young he would often copy the graffiti from walls. Many viewers of Brassaï's work found it easier to accept his photographs of graffiti as art than to accept the graffiti itself. In this sense, his work encouraged audiences to look at graffiti on the street in a new light: as framing devices for the world, as a parallel voice of the city, and as a modern primitive art that is all around us if we just care to look.

The Evolution of Graffiti

Graffiti writers are the most influential artists of their time, in terms of the number of people they reach, and the number of people making work influenced by them. It never ceases to amaze me that whatever country I go to, I see the heritage of wild-style graffiti. It connects with movements in music and dance – hip hop, break dancing – and has probably become the most influential cultural innovation of the past thirty years. Jeffrey Deitch

Cedar *From 1975 to when you started in 1979, graffiti expanded incredibly fast from just being very basic tags to being this fully formed art form. Why do you think it developed so quickly?*
Lady Pink Because of the competition in the different boroughs. The subway trains would travel from Brooklyn to the Bronx and people would challenge each other, not verbally or physically, but for better work, bigger work, more work. By 1976, I think they'd achieved some of the biggest and best works that were done. So within a very short period of time, by '76, two different groups pulled out ten whole cars, top to bottom, end to end – that's an entire train.
Cedar *What do you think have been the most important factors in graffiti's development?*
Henry Chalfant Police repression. Hostility. The mayor and administration trying to get rid of it – and ineptly. That just spurred it on and made it even more fun.

Cedar *So you think people trying to stop it was what encouraged it?*
Henry Chalfant Sure, in the early years. Then after about ten years the crack-down [on subway painting] was serious enough for people to say 'It's not worth it.'
Cedar *1989 is seen as the end for subway painting in New York.*
Henry Chalfant I would say by '82, '83, there were really good artists dropping out. They'd work and work, and their stuff wouldn't run or it would get crossed out by some jerk. By '89 it was basically over in New York.

Tagging was invented in the mid-1960s. The type of graffiti that took place before 1965, famously visible in the film *West Side Story*, had largely been gang-related and has its own history and traditions. Aside from its practical application of marking territory, it is separate from graffiti writing. After around 1970, we can clearly start to identify people doing graffiti writing as opposed to gang graffiti. Some of the most famous of these included Taki 183, Eva 62, Barbara 62 and Tracy 168. (The numbers at the end of the name originally came from the writer's address and developed into a stylistic accessory. Taki lived on 183rd Street in Washington Heights, for example).

The evolution of graffiti writing from the invention of tagging up to the point where it emerges as a fully formed movement happened extremely quickly: over a period of five years. In cultural terms, this was a unique phenomenon. Its importance cannot be over-estimated. The phenomenon of dispossessed young people in New York City in the 1970s and early 1980s channelling their frustration and boredom into making visual art – not music, not sport, but *art* – is unprecedented. The art form they invented helped them to start to view the world in terms of all the visual languages that were available to them as sources to quote from and remix. We see this in piece after piece that happily steals from elements of pop culture. All of this activity happened completely spontaneously, with no initial financial backing or incentive, and the first group of graffiti writers had little or no art-school training or knowledge. This was a remarkable achievement, and it could be argued, the most culturally significant art movement of the second half of the twentieth century.

No other movement since Cubism or Surrealism has developed such a distinctly new language. Pop art, for example, used imagery that was already in existence with little mediation. Minimalism and Conceptual art worked in strict reaction to what had come before, primarily because the artists were mainly art-school trained and involved in the narrow art-historical discourse. The artists who pioneered graffiti writing in the 1970s and 80s were in the main completely free of art history and its limited concerns. Instead, they were using typography, comic books and mainstream pop culture as sources for their work. There is the occasional art-historical reference, but it is more 'Pop-art historical': images of Donald Duck, or Fab 5 Freddy's famous Campbell's Soup train. New York-style graffiti writing existed within mainstream language from its inception.

In parallel to sampling from pop culture, graffiti writing was also extremely inward looking, and a major element that quickly developed was the complex typographic forms of 'wild style' lettering, which were intended to be indecipherable and alien to the general public. The fact that graffiti writing was closely linked to music added to its populist appeal. Graffiti writing from the 1980s was undoubtedly a major factor in the iconography of hip hop.

Crucially, this was a bottom-up development. The graffiti writing had moved from the walls onto the outside of trains in New York, using single-line tags at first, which where done quickly while the trains sat at the stations as passengers got on and off. Because of the competition that existed among the graffiti writers, it wasn't long before

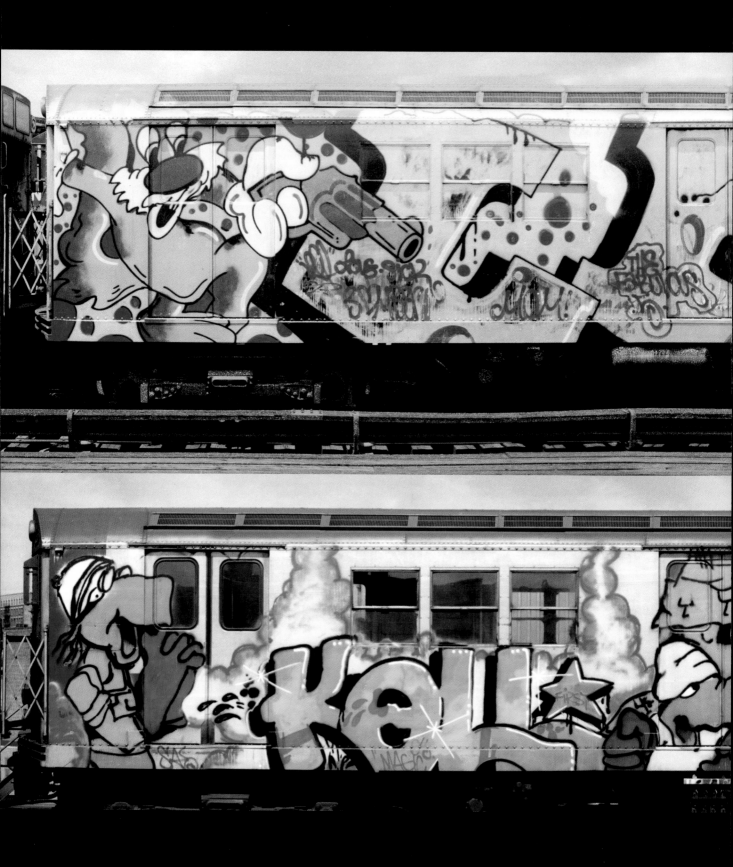

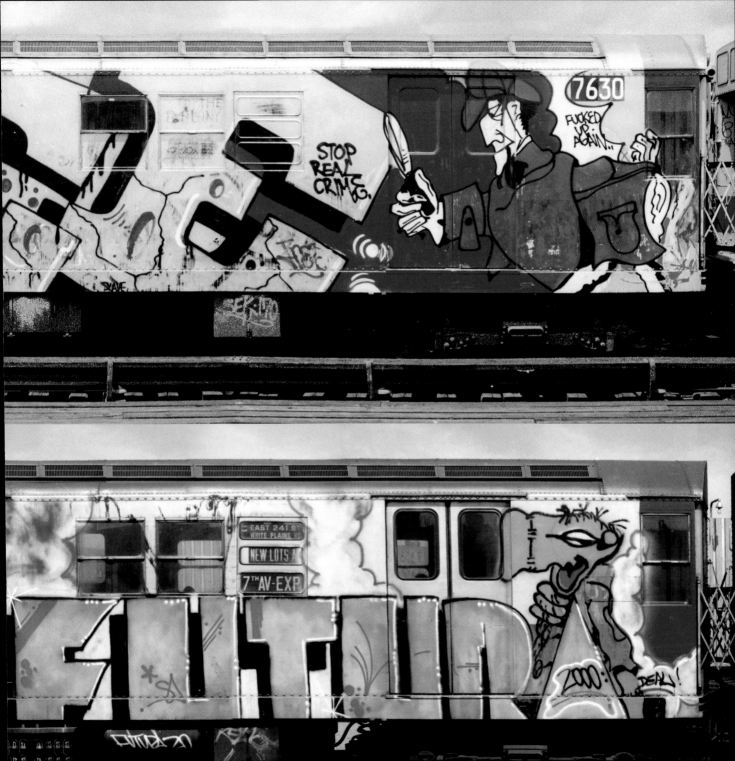

they started to jump down on to the train lines in order to tag trains that were parked for an hour or so. This was, of course, extremely dangerous, and many people have died in the pursuit. A train that is standing still, however, gives the writers far more time to write their tags. It allowed them to enlarge their tags and add more elaborate details, such as stars or coloured outlines. The words became bolder and more noticeable. In this competitive climate, it wasn't long before the writers worked out how to break into the train yards, where the vehicles were left overnight. Here, the writers had even more time, so their work

Mode 2 What changed things was the big boom in graffiti fanzines in the early '90s, because suddenly, cities didn't have an identifiable style anymore. Cities used to evolve around the strongest crews and the strongest style leaders in any given crew. So for local youngsters starting, that would be their history and those would be the people they looked up to. But the fanzines were available everywhere and anywhere, and people would buy them and pick and choose the style that they wanted. So there's no longer the evolution based on geography, which was the case before.

Cedar *How would you describe the development of graffiti lettering?*

Henry Chalfant There was a lot of inventiveness going on for the first three or four years. Then an interesting thing started to take place in terms of the evolution of wild style.

Cedar *Is Tracy 168 the inventor of wild style?*

Henry Chalfant Don't ask me who the inventor was.

Cedar *It's a debatable issue?*

Henry Chalfant Yeah, there are several people who could lay claim to wild style. It's subjective. It's history from a hundred points of view. In any case, wild style started to develop and I think it's significant that it developed on trains, on a moving object – that helped give it its kinetic energy. One thing about wild style is that the pieces do move. They've got directionality: the arrows take them some place or are in conflict. The kind of lettering that they used goes back to those 'Keep on Trucking' figures, the Robert Crumb figures, where these guys are

walking and one leg's way out in front of the other. It really gives you a direction and wild style evolved that way. It was kind of an interaction of comics and the rapidity with which it had to be done and the fact that it was done on a thing that moved. All that influenced what happened.

Cedar *Is there anyone you think of as particularly important in that development? You mention Phaze 2 in the introduction to* Spraycan Art. *Do you think he was important in the development of lettering styles?*

Henry Chalfant Yeah, I corroborate that. He's definitely one of the great fathers of it. His wild-style lettering is very important. Somebody a little later who had a great influence was Kase, who brought out his particular camouflage style, making it so complex that it was hard to copy. That's another thing that influenced the evolution of graffiti style: you had to be really complex to avoid being copied easily.

Cedar *Copied by who? Other writers or advertisers?*

Henry Chalfant By toys [amateurs]. No one had heard of advertisers back then. You know, writers were very jealous of their style and they gave it out in little dribs and drabs to friends and people that they were nurturing to become the next artist, the next master. They mentored people and they gave them the style, but they had a certain amount of control over it. Of course, when photographers came along, and I'm guilty, that changed all that. They had it fixed and people could sit and copy it.

developed quickly into the kind of complex designs that are familiar today.

Graffiti writing travelled from America to Europe around 1982, with writers such as Bando, Mode 2 and many others coming to the forefront of developments slightly later. There wasn't one particular boat that brought graffiti across the Atlantic in the way that Surrealism moved from Europe to New York with the onset of the Second World War. Graffiti crossed the Atlantic via the mass media: magazines, films and pop videos that showed graffiti in the background. Later on in the 1980s, the momentum filtered upwards, as galleries started to recognise graffiti as a valid genre. This unlikely form of social mobility led to the creation of several young stars, who were courted by the art world. Some of the first exhibitions of graffiti had taken place in Europe, and it's generally accepted that when graffiti writing came to Europe, it was given a higher status than had generally been the case in the US. The Europeans were perhaps behind the US stylistically, but conceptually they were taking things in totally new directions.

One of the largest factors in the spread of graffiti writing around the world was the increasing popularity of hip hop culture. This was a metaphorical juggernaut that simply could not be ignored. If graffiti in the early 1980s was limited to a relatively small insider audience, hooking up with a musical revolution that permeated every corner of the globe certainly had the effect of placing graffiti into the mainstream. The problem that faced early graffiti writers in Europe was how strict they should be in following the rules laid down by the American inventors.

When the public first saw this new graffiti as it began to surface in the early 1980s, they had no idea what it was. Now, graffiti writing is instantly recognisable. This may mean that some of its impact and power has been lost, much like a domestication process, but it still has the ability to be confrontational. It continues to make headlines and divide public opinion.

Since its inception, graffiti has developed both stylistically and in terms of the industry that has grown up around it. This advancement can be viewed in both positive and negative ways. Specialist graffiti publications, brands of spray paint and nozzles for variations of paint application, clothing brands, even computer games dedicated to graffiti are all positive advancements that support the movement, but the negative effect is that this industry can be seen to sterilise the art form. Many graffiti writers now feel that some of the magic of invention has gone.

Lee

This man was the Picasso of subway painting. Zephyr

Along with New York graffiti writers such as Seen and Blade, Lee Quinones, or Lee as he was known, was one of the pivotal train painters during New York's 'golden age' of graffiti in the late 1970s and early 1980s. Charlie Ahearn's film *Wild Style* (1983) was loosely based on his life and the legend that surrounded him. Ahearn remembers Lee as 'a shadowy figure', who wouldn't give out any personal details, let alone agree to appear in a movie. It

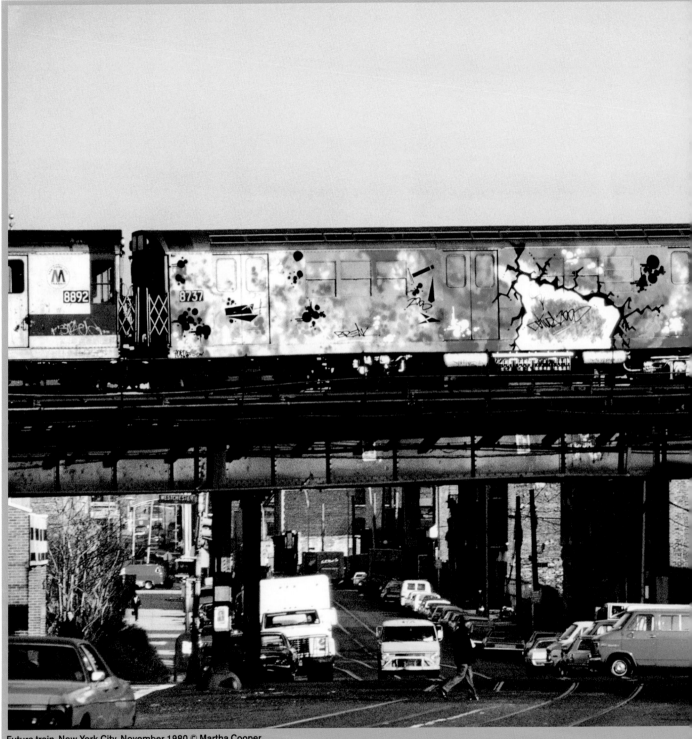

Futura train, New York City, November 1980 © Martha Cooper

Getting the Picture
Martha Cooper

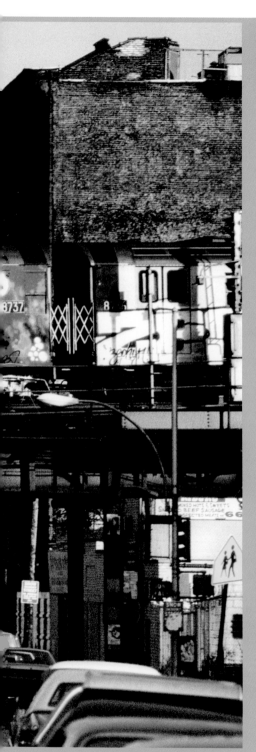

Cedar *Can you tell me about the process of taking the photo of the Futura train?*

Martha Cooper The Futura train was one of the later trains that I took. I had gotten interested in graffiti and wanted to take pictures of cars, especially the top to bottom whole cars in the context of the Bronx.

Cedar *How did you know the pieces were running?*

Martha Cooper The kids would call and tell me. And they would tell me which side it was running on, because the 2 trains didn't turn around, and the 1 train did. So if you waited for a train on the 1 line for three hours at rush hour, you could see every car on the track.

Cedar *How long would you normally spend, waiting to get these images?*

Martha Cooper It just would depend. Say I heard there was a freshly painted car and I would go up to the Bronx at seven in the morning to my predetermined spot, and I would stand there and watch the trains go by, until the one car that might be running among hundreds and hundreds of cars would go by. It might come by immediately, or it could take five hours. The kids also had to tell me, 'from the morning side or the afternoon side'. We had this language, because I didn't want the car to be backlit, I needed the sun to be shining on the car so the colours would look bright. If another train came along – and this happened a couple of times – it obscured the view and could miss the car with the piece. It was like fishing or hunting; I waited for hours, in these areas of complete devastation in the Bronx.

Cedar *How did you gain access to the scene?*

Martha Cooper My entree into the community of graffiti writers was based on my skill as a photographer. The kids had always tried to take photos of their trains, but they did not have professional camera equipment. They usually had cardboard cameras, and could only get a little fuzzy shot. But the pictures were what they showed around to their friends. The pictures were the evidence. So the photos were always important. I was able to tap into the fact that they wanted pictures and because my pictures were better, they wanted me to take them. And I was a nice person who wasn't going to report them to the police.

Cedar *The photos are now some of the main documents showing this movement ever happened. Was the ephemeral nature of what you were photographing an important motivation?*

Martha Cooper I was always aware that the photos would last longer than the pieces, and I shot in the spirit of historic preservation.

Cedar *How do you think it affects the way we view this art movement, that we know the work primarily through documentation?*

Martha Cooper I think that's a really interesting question, and without over emphasising it, I would ask whether if the pictures weren't available, would a lot of what has happened now have happened? Because the photos, both Henry's and mine, enabled people to view details in ways that you simply couldn't see before. The only way to view these pieces and study the details, is by looking at the photographs. That's why *Subway Art* struck this immediate chord with kids all over the world, because they were able to study what these pieces looked like. So you can't underestimate the importance of photography in the movement.

Cedar *Do you see your photos as artworks in themselves?*

Martha Cooper I don't like to say that I'm an artist and I'm not trying to elevate my images to high art, but I do see them as my work. And I'm a documentary photographer, a visual anthropologist. It's not like this is their art and my art, that's not what I'm trying to say. I'm just saying that the photos are as much my work as theirs. I added context to the pictures of the trains and I saw them in a way that other people weren't seeing them. I would like my photos to be viewed as a collaboration between me and the writer. In the photos, I was saying, let's look at the trains within the context of the environment from where many of these writers came.

Cedar *Did you see a big difference between photographing the graffiti and the street art?*

Martha Cooper Yes, I've continued to document street art and it's been interesting to watch it evolve. But photographing a moving subway car in the South Bronx is not the same as standing in front of a wall in Manhattan snapping a picture, which is a very easy thing to do and everybody is doing it. Around 1982, I saw that artists were beginning to use the tools and methods and techniques of graffiti writers and in fact I published the first piece saying that in the *Village Voice*. But in terms of the photography, it is completely different.

was finally through Fred 'Fab 5 Freddy' Braithwaite that Ahearn was able to persuade Lee to collaborate with him. While the movie was instrumental in propelling the graffiti movement to new world-wide audiences, Lee was already being looked upon as one of the key style 'kings' of the subway.

The graffiti writer Zephyr was overwhelmed by what he saw: 'Lee was possibly the most brilliant subway painter that ever lived in terms of his thoughtful approach.' Mare 139, who along with Zephyr was also part of the original school of New York train writers, also rates Lee as a style master, but points out that there are many other unsung heroes of the movement: 'Taki, Stay High 149, Phaze 2, Riff 170 and Noc 167 really laid the foundations down. Everybody else contributed, but these guys broke it down.' Lee himself describes writers Cliff 159 and Blade as 'monumental catalysts' for what he was doing. But the majority of writers from the time champion Lee as a true master. As Zephyr puts it: 'We were always trying to impress our friends, the other graffiti writers – "I'm better than you, look at my new piece." Lee was clearly leap-frogging way beyond that community and was much more interested in speaking to the city at large.'

Lee agrees that although he does not dismiss the graffiti-writer's fascination with the name, he wasn't interested in the competitive elements of writing, but instead made work with non-graffiti viewers in mind. One of his methods in making his work accessible to the general public was to go against the prevailing fashion for unreadable wild-style lettering and instead work with 'more friendly' block letters. And he was less interested in pure letter formation than in narrative. Much of his work was similar to political murals, the only difference being that his images were painted on hardball courts and the side of subway trains.

Lee's approach to form and content often reflected the turbulent political situation in New York at that time. In post-Vietnam America, as he says, 'The Bronx was literally on fire', and the country was coming out of the civil-rights and women's-liberation movements. New York in the early 1970s was a city dominated by 'power outs' and 'a serial killer on the loose'. All these external stimuli went into the work, mixed with pictorial influences such as the Works Progress Administration (WPA) murals that the American government had funded in the 1920s. The WPA social murals often had overtly political messages that dealt with the staunch race issues of the time. Impressed by the way this large-scale painting conveyed a message of 'unity with beauty and colour', Lee was interested in the 'physical and psychological' challenge of painting something similar on a train.

The way in which art could be perceived on a moving vehicle was also an issue that Lee took into consideration. The images were designed to be seen quickly and 'move away from you as fast as they came at you'. For Lee, graffiti is always evolving and always should be. He compares this philosophy to that of the Italian Futurists in the early twentieth century, who were inspired by the machine age. His work has now developed into commercial design and gallery-based painting, but to the original generation of new subway painters, Lee will always be the 'king of kings'.

Watching my name go by

Documented by Mervyn Kurlansky & Jon Naar. Text by Norman Mailer

Style Wars

Style Wars *was the bible, and* Subway Art *was the psalms book.* Goldie

Watching My Name Go By (also known as *The Faith of Graffiti*), published in 1973, with an essay by Norman Mailer of the same name, is one of the earliest examples of a book of images of New York-style graffiti. The book *Street Writer: A Guided Tour of Chicano Graffiti* by Gusmano Cesaretti, published in 1975, similarly explores early Los Angeles tagging. Jean Baudrillard's text 'Kool Killer, or The Insurrection of Signs', first published in the book *Symbolic Exchange and Death* (1976) has an intellectual credibility that is very rare in graffiti publishing, which generally focuses on images of the work with little theoretical backing.

Another important early document of graffiti is the film *Style Wars* (1983) produced by Tony Silver and Henry Chalfant, often referred to as 'the graffiti writer's bible'. The film is now more than twenty years old, but still looks fresh and cutting-edge. Along with *Wild Style*, it is an essential starting point for anyone researching graffiti writing, as well as the clothes, dance and music associated with it. Through such films, as well as Chalfant's books *Spraycan Art* (co-authored with James Prigoff, 1987) and *Subway Art* (co-authored with Martha Cooper, 1984), New York-style graffiti writing spread from America to Europe, and they are a vital factor in the history of the movement.

Unlike many other artworks from the same period, which were so often shown and recorded in neutral settings, graffiti writing is a visual language that incorporates the world around it. The viewer of these documents can get a real sense of the urban landscape in which it existed. The spread of graffiti writing around the world through media such as film and print is a perfect reflection of an art form that moved at the speed of MTV and pop culture rather than with the slowness of art history. Other art movements of the twentieth century are more likely to be disseminated through the standard mechanics of the art world, such as art magazines and exhibitions. Graffiti writing in the 1980s was an art form made by teenagers and has entered into worldwide consciousness through the language of teenagers and youth culture.

A lot of us were thrust into our celebrity status very quickly. That felt strange. At night, we're lurking around in the shadows, trying to evade the police, and the next day, you have a bunch of rich people patting you on the back and giving you wads of money, and telling you, 'Great work, wonderful.' It was a bit surreal, dressing like a little bum, all dirty and disgusting, and the next day in high heels and a silk dress to a party. It was a very unusual time. Lady Pink

These early films and publications had a huge effect on graffiti artists. Suddenly, the world opened up to what a kid in New York's South Bronx and a small clique of friends were doing. The newspaper articles and movies brought some of them overnight stardom, and the graffiti writing movement as a whole was catapulted onto the world stage.

'I could never see an adult putting that much energy into something that isn't going to pay or has the possibility of them getting arrested.'
Dondi, speaking in the film *Style Wars*

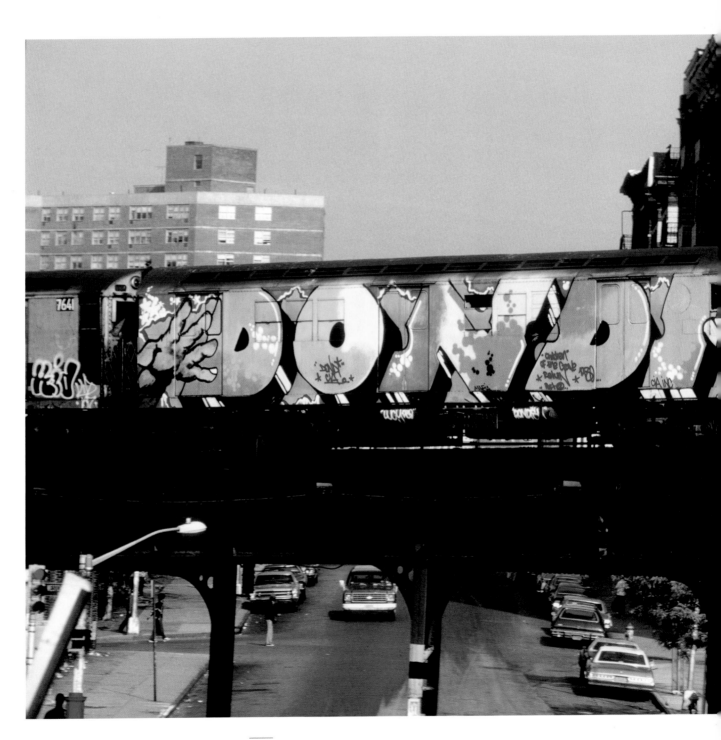

Futura 2000

Futura did probably one of the most important modern paintings on a train. The break-out train. He broke it open with that. Mare 139

'If you look at graffiti in New York in the early 70s, it was whack, it was very crude. I'm speaking unholy words – because we're talking about the Mecca – but it took us time to work out what we were doing, since we were inventing as we went along.' Having started writing graffiti in New York around 1970, Futura 2000 is one of only a small number of people who can make this statement with authority. Though firmly embedded within the graffiti-writing movement, Futura was one of the rare writers, along with Rammellzee, to work very early purely with abstract forms on trains and walls. Later on in his career, he merged this abstraction with his unique brand of figuration, the abstraction becoming a ground on top of which his alien-like figures could exist. His trademark circular constellations and electro hip hop aesthetics hint at an alternative solar system of asteroids and comets.

As one of the few writers to achieve gallery success in the 1980s, Futura has been asked if he thinks that graffiti writers were exploited at that time. 'I'm a survivor of that exploitation', he laughs. Having exhibited in many of the pivotal exhibitions relating to graffiti of this period, he has seen the art world from all sides and he credits figures such as Fab 5 Freddy and Hugo Martinez as highly instrumental in moving graffiti from New York's trains to galleries.

Futura's path has set a template that would see creative graffiti writers moving freely between the worlds of design, fine art and music. After designing record covers for the Clash in 1982, he recorded with the band as well as famously painting live on stage with them. His musical connections would again come to the fore in the 1990s, through collaborations with the Mo' Wax record label, for which he designed covers and helped to provide an over-all visual identity. The links between graffiti writing and design are many: a preoccupation with fonts and spatial placement, the ability to communicate complicated ideas with visual simplicity, a way of looking at the world in terms of possible locations, and the ambition to connect with audiences. These, as well as many other factors, have meant that there is a constant two-way relationship between graffiti writing and design, and Futura's work now circles largely within these fields, whether designing clothes or limited-edition toys for companies such as A Bathing Ape, appearing as a digitalised character in Marc Ecko's computer game *Getting Up*, or constructing his own highly innovative websites. His name was conceived as a combination of the title of his favourite film, *2001: A Space Odyssey*, and the Futura typeface, and he has always had his mind on the day after tomorrow. Now firmly established as a cult figure within the world of graffiti and beyond, he is still pushing boundaries and confounding ideas of what's possible – with a can of spray paint, or without.

Dondi train, New York City, May 1980
© Martha Cooper

Early Shows

Some of the first galleries in New York to exhibit graffiti were the Razor Gallery, run by Hugo Martinez with the United Graffiti Artists (UGA); Patti Astor's The Fun Gallery, which showed Jean-Michel Basquiat, Lee, Keith Haring, Dondi, Futura 2000, Fab 5 Freddy and Revolt; Above Ground; and Fashion Moda, based in the South Bronx and run by Stefan Eins with William Scott and Joe Lewis. Fashion Moda mixed artists and styles of work in a way that is familiar today, but at the time was considered cutting edge. Artists who exhibited there included Jenny Holzer and Lady Pink, who collaborated on an exhibition, Tim Rollins and KOS (Kids of Survival), Crash, Daze, John Fekner, David Wells and David Finn. In addition to producing its own shows, Fashion Moda worked with Colab (Collaborative Projects) on the *Times Square Show* in 1980 and exhibited at Documenta 7 in Kassel, Germany, in 1982.

Later exhibitions at venues such as Tony Shafrazi and The Sidney Janis Gallery became important in the transition of art from the street to the museum. The *New York New Wave* exhibition organised by Diego Cortez at P.S.1, New York in 1981 featured a mixture of graffiti writers, artists who had been working in the street, and gallery artists such as Andy Warhol, Lawrence Weiner and Robert Mapplethorpe. *New York New Wave* also included cultural figures including William Burroughs, Larry Clark and Lydia Lunch, who are still influencing new generations of artists working outside of the conventional gallery system.

What many of the early exhibitions involving street art and graffiti showcased was a less precious approach to exhibiting art. The works were often hung salon-style, in a carefree fashion, pinned directly to the wall and placed in close proximity to each other. John Ahearn, who worked as part of Colab with Tom Otterness and Colleen Fitzgibbon in curating the *Times Square Show*, remembers artists working underground and doing their own shows throughout the 1970s in New York, but is philosophical about the art-historical reverence placed on exhibitions such as the *Times Square Show*: 'It's one of those shows that's either considered the end of one stage or the beginning of the next stage. But it was definitely a show that was at a turning point in the development of art that was going on with young artists in New York City.'

Cedar *Lots of the graffiti writers showing in galleries in the early 1980s didn't really cross over into the art world for long.*
Henry Chalfant Some did. There were the people who crossed over and stayed, like Crash, Daze, Lee, Futura. Others went in opportunistically and got bored and left. They thought, 'This is dull. I'm going to go back to bombing.'
Cedar *Do you think that's what happened, or was it just a fad that was picked up and then dropped?*

Henry Chalfant As far as the galleries went, yeah. But as far as the writers went, most of them got bored with it anyway. Most of them went on until about 1984, when The Sydney Janis gallery put on a show [Post Graffiti, curated by Dolores Neumann]. And you know, that was the Big Time. He'd been responsible before that for Abstract Expressionists and Pop artists.

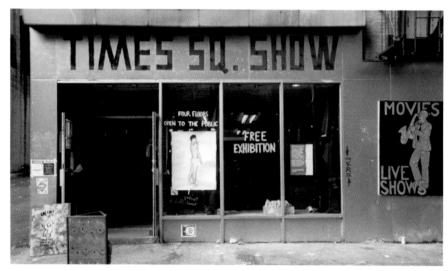

Times Square Show,
New York City, 1980

What made the *Times Square Show* different from other artist-organised exhibitions of that time was its placement in a prominent location, which had the effect of bringing together a wide range of people from various different sections of the community. Open twenty-four hours a day over a month-long period, and taking place in a former massage parlour, the show was described by Ahearn as 'a fun house'. While the first exhibitions of this sort happened in New York, the trend quickly spread, and soon exhibitions where taking place in various locations around Europe as well as far-flung quarters such as Japan.

I am Somebody!

Fame is the name of the game in graffiti writing. But this has nothing to do with personal identity: it's purely about the brand. Fame can come either through mass coverage (putting your tag everywhere) or through style (having the freshest technique). Taki 183 was the first graffiti writer to achieve fame. In 1971, his hobby of writing his nickname and street number around the five boroughs of New York was immortalised in an article in the *New York Times*, which quickly led to hundreds of copycat writers taking up the same activity. The matter of who was the very first New York-style graffiti writer is a hotly debated subject. It is known that there were others writing tags at around this time or before – primarily Cornbread, in Philadelphia. These early graffiti writers are important because what they were doing was separate from the gang graffiti associated with territory, or what might be called 'toilet' graffiti, that had gone before.

Graffiti writing in this period gave people from marginalised areas of society the opportunity to 'be somebody', if only in their own sub-sect. You could literally make your mark in the world, be a creative individual, be cool, and most importantly, be a star. What's most exciting about the invention of graffiti writing is that it was done by a small group of teenagers. Through graffiti, their aspirations changed entirely. Suddenly they wanted to

draw and paint; they wanted to be artists, and because the art that they were doing was a magpie-style, remix art that borrowed from culture at large, they started to look at the world as a place from which to take inspiration.

Fame was once all about being the 'king' of a subway line and for some people it still is. It's all about self-affirmation: 'I am the best at what I do.' But with the growth of mass media and the internet, graffiti writers can now achieve 'fame' more easily and more effectively than ever before, and the concept of fame has changed within the world of graffiti. Now that the audience is potentially global, a graffiti writer might feature on the cover of a specialist magazine or publication, or be commissioned by a sports company to design a pair of trainers. What hasn't changed is the importance of working your way through the ranks. Graffiti writers might well land trainer deals, but if they're not still out there 'bombing', or if they've never painted a train, then they won't have the same credibility as those who are still visible on the street.

Cedar *What attracted you to graffiti writing back in the '80s?*

Goldie I felt compelled when I first saw graffiti. It was large, it was beautiful, it said everything that I wanted to do. It was something that I could express myself with, in a way that I never thought I could. So you're inspired to be part of something you don't really understand.

Cedar *Did your ideas change as you got more involved?*

Goldie I realised it was about the social voice of it all. It was about the movement and getting people noticed and the way the kids had nothing to do in New York and were being completely victimised by the state.

Cedar *Do you think it was a bit like punk, then?*

Goldie Totally like punk. There were people being arrested. Ten people hanging out at a bench would be condemned as graffiti writers. It became ruthless. People died; people got shot

Cedar *Its difficult to relate all that to the massive industry that evolved from those beginnings.*

Goldie If you think about something like the bubble letter, just a letter with an outline — graffiti, in its beginnings — that's like thinking about a club that only has one record deck. It's very hard to go back and think about how it evolved. A graffiti writer learns his skill in fonts and function. Graffiti, in its purest essence, is exploring the letter form. There are purists who explore the letter form alone. They adapted a simple language, the alphabet, and manipulated it, backwards, forwards, inside out, twisted it and took it to another level.

Cedar *Has your graffiti background affected your approach to making music?*

Goldie If I didn't learn graffiti the way I did — letter forms and outlines — I don't think I could do music the way I do now. It wouldn't be the same. In that sense of purist graffiti, it was always about moving forward with the letter form and how we can apply it.

Cedar *As a graffiti purist, how do you feel about its evolution in relation to street art?*

Goldie I don't think the art world has opened its doors to graffiti in the same way it has to street art. I think street art will probably help break down those barriers that graffiti couldn't necessarily get over. Graffiti had a difficult time. It's like Drum & Bass: cutting edge music had a very hard time trying to get into the music world; now it's very accessible. Street art seems to be more acceptable now. But just because we changed the name, is it more acceptable?

Regret tag, London. SMC
is an abbreviation of the
crew Seventies Magic

Graffiti is Addictive

The train tracks at night, the danger, the buzz: these are things most people will never know. The experience of writing illegal graffiti is difficult to describe. Essentially, the attraction is one of breaking the law mixed with the opportunity to be creative. There is also the afterglow the next day, when the work is in the public domain. The general public has no idea who has made these anonymous scrawls or why, but the graffiti writers see their work and feel great pride in what they've done. We can imagine this as a secret society or secret language of the city. To be involved in that language and the conversation that the city is having with the public can be seen as an exhilarating opportunity, especially for people with little other voice in society.

According to Norman Mailer, alienated man must 'put himself in positions of great danger in order to remove himself from himself'. For a graffiti writer, going out tagging provides this life-affirming element of risk. Tagging is an often dangerous and potentially deadly pastime, but it is on this perilous illegality that the activity thrives. There are many differences between making legal and illegal graffiti. These differences are conceptual, stylistic and time based. When the illegal element is gone, so is the adrenalin rush of illegality; all that's left is the adrenalin rush of creativity. This is when graffiti really has to be looked at purely as art. The idea of being an artist is very different from the idea of being an outlaw rebel or Robin Hood character, with which many graffiti writers identify.

Graffiti writers' obsession with lettering styles and typographic form cannot be emphasised enough. For many graffiti writers, the letters they draw and paint start to take on human characteristics, not visually or physically, but conceptually. If a letter is painted in chrome paint, it may be read as mechanical or robotic, for example. If the letters are curvy or bubbly they may be read as being 'old school' or 'retro', referring to graffiti writing's 'golden age' in the early 1980s. This area of letter design goes beyond a creative act into an obsessive pastime that can take over the writer's life. For many, writing graffiti is addictive. This is perhaps linked to the mindset of the people who are attracted to graffiti: people who want to be destructive and creative at the same time. Another possible reason is that it's an egotistical act. Spending years repeatedly writing your name is a highly narcissistic activity. An analogy can be made with extreme sport. Adrenalin junkies will always be attracted to dangerous and apparently pointless pastimes, and writing illegal graffiti is certainly an adrenalin-fuelled activity. Graffiti writers value the placement of their work, so putting a tag or piece in a difficult-to-reach location, such as on the side of a police car or the top of a high building, will gain the writer notoriety within the community. This is one of the reasons why graffiti writers often look down on exhibiting in art galleries: it represents no challenge, whereas placing your work on the side of a train is perceived as not only creative but also valued because it outwits the authorities. If a graffiti writer could paint the White House or 10 Downing Street, they would, because these places are highly guarded and consequently prized targets. The mentality is similar to that of an advertising executive who wants to see the company brand in the place where it will gain most attention. The iconic image of the Hollywood sign painted over by Seen in

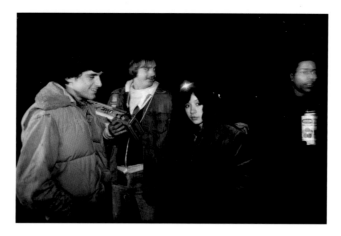

1986 is a classic example of this. The constant challenge to reach harder or more dangerous locations drives the adrenalin rush for recidivist offenders. It's a criminal activity, where there is no discernable profit other than the 'high' of committing the crime itself.

The documentation of graffiti is also important for graffiti writers, and feeds the obsession. Graffiti writers will take photographs of their own work, as well as other people's, and this habit can become as imperative as the act itself. Due to its transitory nature, graffiti must be photographed as soon as it's finished. If a graffiti writer paints the outside of a train, for example, the painting may well be washed or 'buffed' away the next day, so the documentation takes on almost as much relevance as the actual work.

Another way to look at the driving force behind the act of graffiti writing has been to consider it as a modern rite of passage. As Chalfant suggests: 'Western culture doesn't really have rites of passage that involve danger, tests of strength and endurance, etc, especially for urban kids. A driver's licence is sort of your transition into personhood; urban kids don't have that because they don't drive. But this did it: danger, achievement, creating your own identity.' This idea is, however, disputed by Roger Sansi Roca, professor of Anthropology at Goldsmith's College, London. He states that a rite of passage is something forced on adolescents by adults: the concept of 'going to the woods and being starved and beaten, and then when you return you're a man'. So, as Roca puts it, 'If graffiti were an initiation, your father or uncle would take you by the ear and make you do graffiti on the street.' But the near universality of such forms in cultures everywhere would indicate that grafitti does fills some kind of need in the adolescent male.

Graffiti writing has always been a male-orientated activity. From the beginnings of the movement, there were notable exceptions to this rule, but overwhelmingly it is something that has attracted young men. Lady Pink is generally regarded as the first woman to have made a significant impact on the movement. Many female graffiti writers preceded her, but none of them can be said to have had such a lasting impact. The reasons for the macho nature of graffiti have often been attributed to the physical characteristics of graffiti production, which can be a dirty, cold and late-night activity. As Lady Pink herself comments: 'It's very hard, gruelling manual labour; it's scary; it's not as appealing to females and not as many females have that criminal streak that I do.' She compares female graffiti writers to women in the military: it's simply not perceived as 'woman's work'. As the one of the few female writers among hundreds of males, Lady Pink was often treated with mistrust and suspicion. She did, however, paint trains with the best of them and earned respect. 'I had to work harder, just like most women in the feminist movement. You have to prove yourself twice as hard to even be considered an equal.'

Several studies have been made by organisations such as the British Transport Police (BTP) as to why young men in particular become involved in graffiti. As inspector Chris Connell points out in the documentary *Kings and Toys*, their findings have generally concluded that males are more likely to form sub-cults with their own rules and accepted patterns of behaviour. Once a male has joined a sub-cult, he will either be put under peer pressure to pursue an activity, or in his desire to impress the group will commit more and

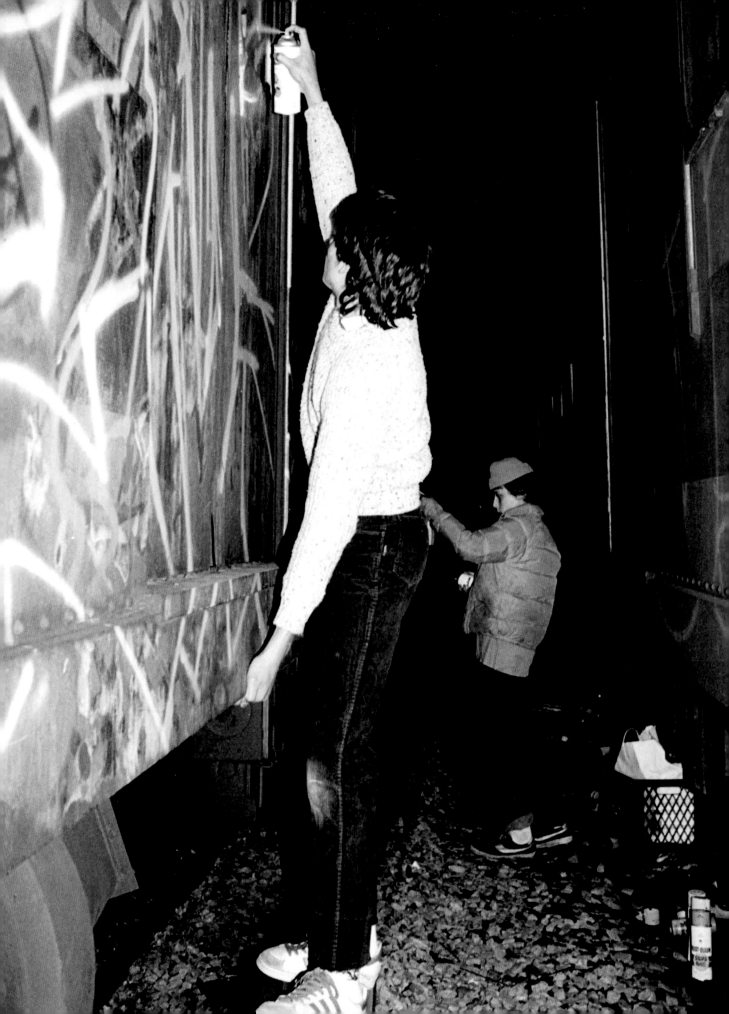

more acts, each time with a higher level of risk attached. BTP's research indicates that 'self actualisation' is also an element among graffiti writers, who simply enjoy the results of their activity.

With books and websites such as *Graffiti Woman* and www.graffgirlz.com, things have moved on to a certain degree, but it's fair to say that graffiti is still something that largely appeals to young males. With street art, the issue of gender is less marked. One difference between the production of graffiti and the production of street art is the lack of a clear narrative in graffiti; street art often involves an element of storytelling. It is perhaps the more accessible nature of street art, then, that closes the gender divide.

Tags (Noms de Guerre)

The writers were taking the letters and changing them totally to become reflections of their lives. Lee

Tagging is at the core of graffiti as we know it today. It's the entry-level starting point, and as such can never be fully dismissed as mere vandalism. There are many artists for whom tagging was a first creative outlet. For some, it's enough to continue to devote themselves to this intricate letter work, never progressing beyond the desire to write their pseudonyms. For others, it's a first introduction to drawing, but a drawing that anyone can do, since it only involves writing letters.

Tagging is the aspect of graffiti that the public finds the most difficult to accept. This is perhaps because, as graffiti writer Mode 2 puts it, 'It's up in your face.' The tag is graffiti writing in its purest, simplest form, but to the majority of people, it's ugly and indecipherable. It's common to hear people say, 'I like the big colourful graffiti; it's just those messy tags I can't stand.' To the graffiti connoisseur, this is equivalent to saying, 'I like rock music; it's just those noisy guitars I can't stomach.'

The theory that tagging is a reflection of a 'dogs marking their territory' mentality does have some validity, if we think of these acts as an attempt to claim public space. But this was more the case before the advent of the graffiti-writing movement, when graffiti on the streets of New York was associated with gangs and claiming territory. The New York graffiti writers moved away from this aspect when they went 'all city' around 1972. There is still a broad sense of the territorial underlying the mentality of tagging, but this is more related to the concept of 'fame' than to the marking out of boundaries. Where gang graffiti has a practical function, sending out the message: 'Do not come into this area', graffiti writers want to put their names everywhere, to advertise themselves and re-inscribe the city.

Crews or groups of graffiti writers who hang out together have always been a big part of the graffiti scene, but it's important to note that these have nothing to do with gangs. There's a community aspect to graffiti, hostile at times, but a community none the less. Being in a crew is something like joining a club or society, and allegiances are strong. Members of crews paint together, put each other's names up in their absence, and have a competitive approach to other crews. Their main object is to do graffiti and have some fun. The street-art world doesn't have crews in the same way, but it does have 'collectives', who

are not only concerned with making art on the street, but also with realising exhibitions and artists' projects.

Graffiti started on the street and then moved to the trains and then it went back to the street. The way that the authorities have tackled graffiti and one of the reasons why graffiti has just become uglier and uglier is because of the methods that the authorities have used to clamp it down and clean it off. Eine

For Graffiti writers, tagging is at the centre of their universe. They see it as an art form like calligraphy, where the letter formations are reflective of an individual's personality, and they consider those who refuse to understand the elegance of their letters to be philistines. As Mode 2 puts it: 'If you think of Japanese calligraphers, these people are treated with some reverence. There are some people out there who can do some amazing shapes with letters of the alphabet.'

As the authorities have become more adept at removing graffiti, so the graffiti writers have become more creative in finding ways to apply it. Scratchiti is one such example of the graffiti writers' response to 'the buff'. Here, tags are scratched onto the windows of tubes and buses with carving implements, which might include etching devices, rocks, or pens filled with acid. With these tools, they scratch away at the glass, carving their block letters, each character requiring a multitude of scratches. Each scratch a scar, every word a victory.

Barry McGee

As a fine artist, Barry McGee, has been involved in some of the most memorable installations of the last ten years. Under the tag Twist, he is also highly respected in the graffiti-writing community for his tagging style and characters. He first became involved with graffiti in the San Francisco of the early 1980s, which at the time had a vibrant scene of artists and activists placing work in the public realm. Some of McGee's early influences included Survival Research Lab, who would appropriate billboard space to publicise their political events. Despite all these left-field activities, however, McGee was drawn more strongly to the traditional tagging-based world of graffiti writing: 'It made the most sense to me, it was more immediate'.

Though he had always been interested in drawing, McGee had no interest in 'art' at this point and would not go to art school until much later in the 1980s. The world of graffiti offered excitement, and once it became visible to him, he was hooked. He remembers: 'I had no real interest in graffiti before. I never even noticed it, but once I was introduced to it, I was fascinated.' More than the adrenalin rush of writing illegal graffiti, McGee was attracted to the entire culture: 'All the different weird people that would do it, the whole society of it was intriguing to me.' Aside from artists working purely within the realm of graffiti, McGee was also inspired early on by 'the weird stuff' that artists such as David Wojnarowicz had been doing on the streets in New York. It's easy to see how Wojnarowicz's works, which were painted over smashed glass and in dilapidated surroundings, would

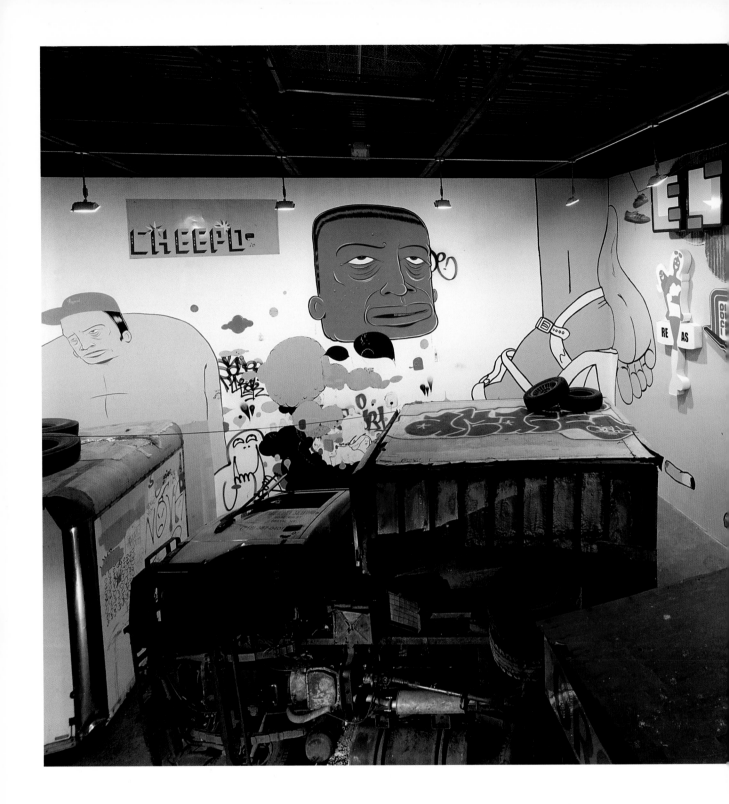

Left: Installation by
Barry McGee, Stephen
Powers and Todd James,
Street Market,
Deitch Projects,
New York City, 2000
Top right: Image painted
by McGee outside
Modern Art, London
Below right: McGee's
'Amaze' throw-up,
San Francisco

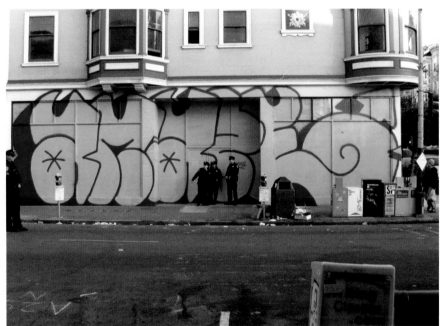

Barry McGee

appeal to McGee, who moved away from the slicker 'bling bling' aspects of graffiti. If we think of the worlds of graffiti, street art, and the museum/gallery system as being separate entities, then McGee's practice, perhaps more than that of anyone else, sits happily in all three. In terms of offering a model of activity where rules of classification simply don't apply, he's the ultimate genre hopper. As to how he manages to negotiate these different universes, McGee is typically self-effacing: 'I'm stuck in between all these places.'

In the art world, McGee is primarily known for his sprawling installations and contorted figures that reference comic-book artists such as Basil Wolverton. Among graffiti aficionados, however, McGee is considered to have one of the best tagging styles in the world. Writers credit this lettering skill to his subtle manipulation of the spray can, which produces letters that are impossibly fat and skinny at the same time; they adhere to 'old-school' traditions while also appearing slick and futuristic.

Though the gallery world is now 'work' for McGee, and everything else a 'hobby', he's still passionately excited by graffiti and believes the streets will always be the best place to see these art forms. As he comments, 'Its nearly impossible for graffiti to be a commerce; that's what I love about it: you can't capture this thing.' He envisions a 'huge and messy' future for street art and graffiti, citing the current trend where graffiti writers fill fire extinguishers with paint and use them to 'take out buildings'.

Brazil Style

Graffiti in Brazil is unique for many reasons. It developed in relative isolation owing to political and economic factors, but rather than having a detrimental effect, isolation has led to a style and approach that is extremely original. The roots of the art on Brazil's streets are a mixture of the New York-style graffiti of the 1980s, Brazilian protest art and the stencil scene that was instigated by art students in the 1970s and 80s. As early as 1970, the conceptual artist Cildo Meireles was making interventional work that involved placing subversive messages on Brazilian banknotes and Coca-Cola bottles. Meireles refers to these works as 'graffiti', though they may today also be seen as part of a politicised strand of fine art culture jamming. This type of politically motivated practice is combined with a sense of figuration that is particular to Latin American culture. Coming out of the strong tradition of woodcarving as well as mural painting, such as the famous works of Diego Rivera, art on the streets is perceived differently in Latin America. Though often illegal, it is still the people's art and is treated as such. For reasons of availability, the graffiti writers in Brazil initially worked with acrylic paint instead of spray paint; added to this is the fact that in much of Brazil it has been possible to make graffiti on the streets during the daytime. All these factors have added up to a vibrant and original visual sensibility. The book *Graffiti Brasil* (2005) by Tristan Manco, Caleb Neelon and Lost Art gives an excellent insight into key figures from the scene.

The best-known artists coming from a graffiti background in Brazil are Os Gêmeos (The Brothers). Twins Otávio and Gustavo Pandolfo have been painting graffiti since 1987, and

Work by Bugre (main image) and Shock (bottom right) beneath a motorway underpass in São Paulo

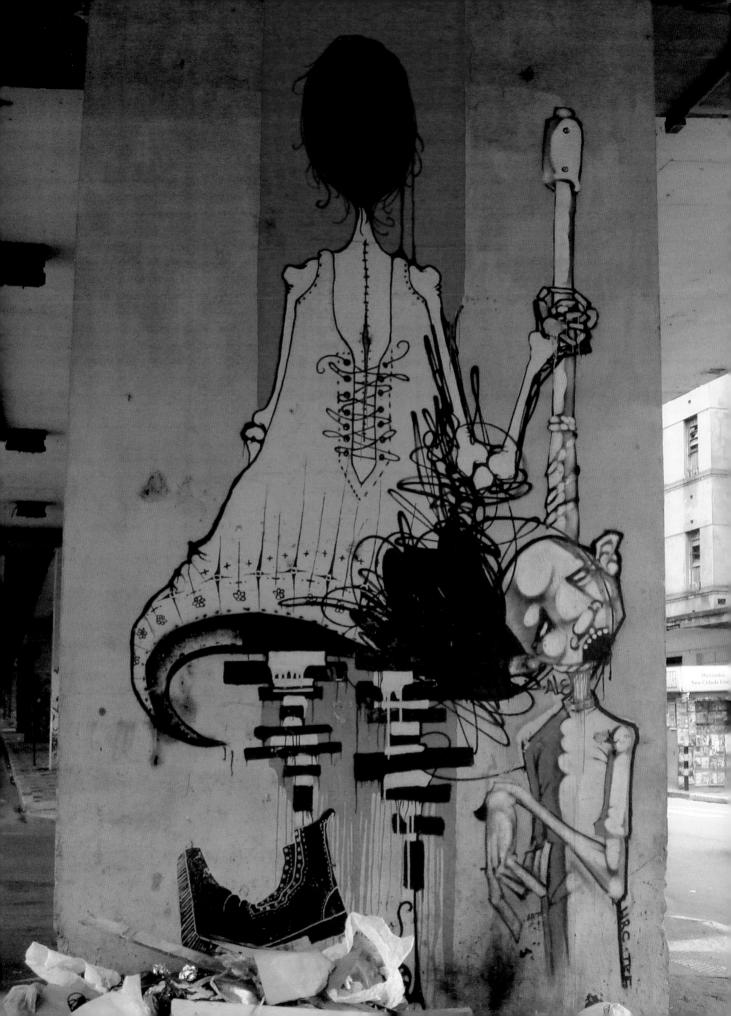

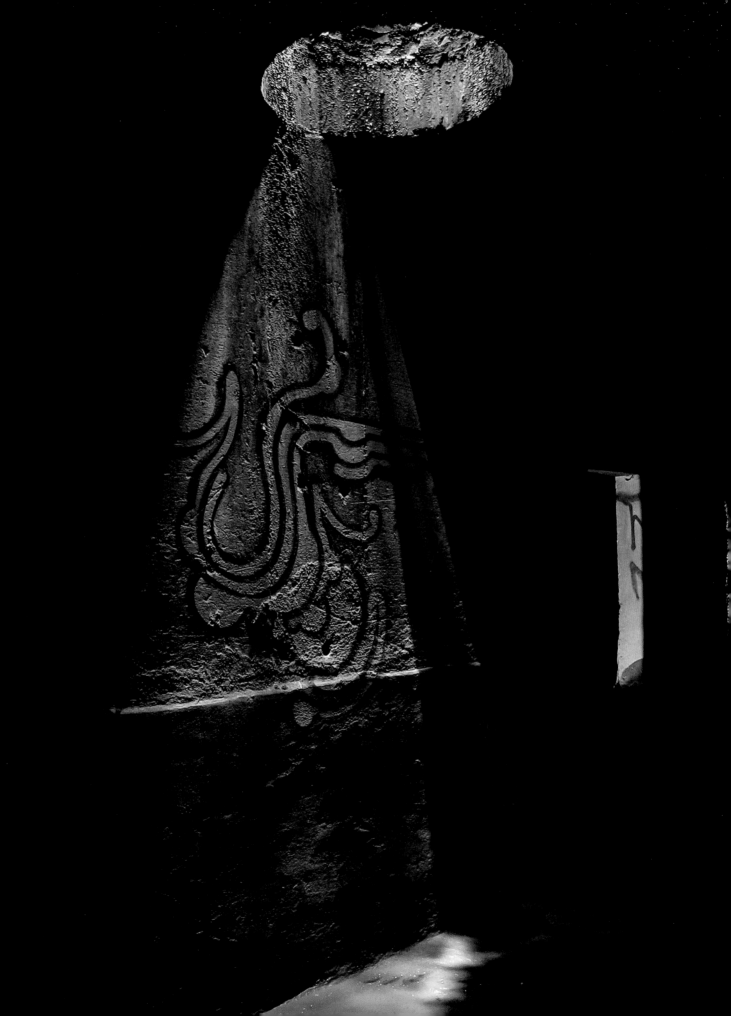

their work is now equally at home in the museums and biennales of the world as it is on the streets of their neighbourhood, Cambuci, in São Paulo. Commenting on why graffiti from Brazil developed in such a different way from that of the rest of the world, Otávio Pandolfo says: 'We wanted to try to break from tradition and make it different from graffiti that can be seen in Europe or the US. We tried to search for more Brazilian roots, not just folklore or popular Brazilian culture, but something that myself and my brother always believed in, the other world that we created.' While adhering t o many traditions of New York-style graffiti, Os Gêmeos bring a sense of lyricism and romanticism to the form. When asked why their work is so often made in a particular tone of yellow, Gustavo Pandolfo's response is as poetic as the images the duo produces: 'When we dream, everything we dream has yellow tones. This is something of ours, myself and my brother. We use it in our painting. We can't use another colour; we have to use yellow.'

Another aspect that has made the graffiti in Brazil so distinctive is *pichação*: a uniquely Brazilian form of tagging that developed out of New York-style tagging, mixed with the letters from heavy-metal album covers. *Pichação* now covers many entire buildings in Brazil and is an extremely harsh visual language. Mariana Ribeiro of Choque Cultural Gallery in São Paulo, though an admirer of the form, explains *pichação* in pestilential terms: 'Like termites, they come to a place that is rotten. They show that this place stinks; this place is dead, it's a dead corpse. We are now the flies around this dead corpse. People hate to see that their city is full of dead corpses.' Os Gêmeos are not directly involved in this form of tagging, but they see the cultural value in the movement: '*Pichação* is one of the best things that exists in São Paulo and in Brazil, because the style is something completely original to Brazil. It's something that was created in São Paulo.'

An artist working in São Paulo whose practice has developed out of *pichação* is Zezão (Big José). He started out working as a motorbike courier, writing *pichação* after dark.

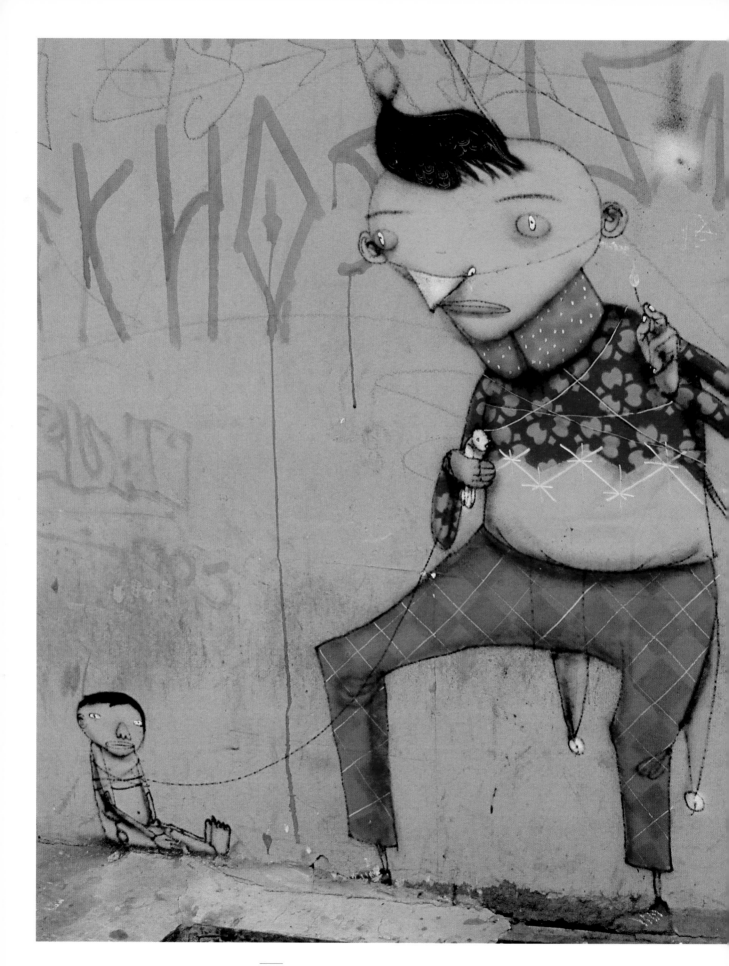

Os Gêmeos

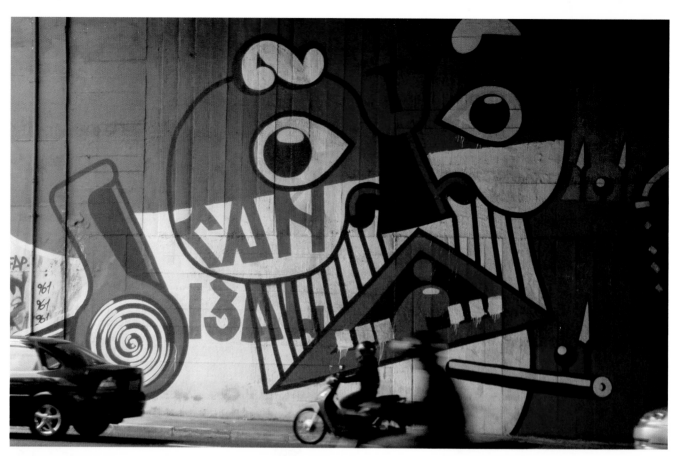

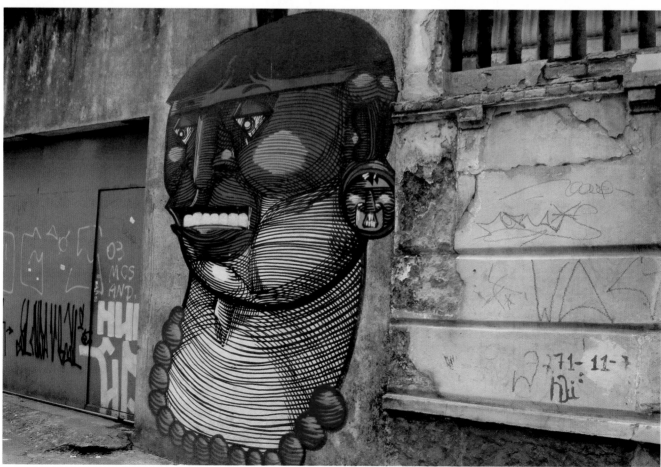

These are two extreme activities in Brazil, each with its own set of dangers. By day, Zezão would risk his life on the mad roads of São Paulo; at night, he would write *pichação* on buildings. Writing *pichação* was much more than an adolescent rebellious act for Zezão, who viewed the activity as a fiercely political statement. For him, it was a way of talking back to a society that he felt wished he didn't exist. His letter style was extremely ornamental, and eventually this expanded to such a degree that the work became completely abstract.

Zezão now makes his abstract graffiti on and underneath the streets of São Paulo. Working in abandoned buildings and in the sewage systems, he often paints in highly isolated locations. He explains: 'I couldn't paint well on the streets because painting on the streets was a performance. I couldn't create or produce something under such pressure, so I started looking for abandoned places. For me, it was a way of reflection, of venting my frustration without the pressure of having to perform.' He has also spent much time amongst the homeless of São Paulo, underneath the motorway passes and in other locations where they take temporary refuge. After getting to know the inhabitants of these 'ugly, deteriorated' sites, he would often ask their permission to paint his works in the areas where they'd set up camp. 'I started looking at these places where homeless people burnt things, ate, slept. I started painting these places so that a person living there would find it more beautiful.'

Nunca (Never), started writing graffiti and *pichação* on the streets of São Paulo when he was twelve. Over the years, his work developed into a more pictorial form of communication that through its use of colour and style strongly evokes the ancient traditions of the Brazilian people. He explains, 'I like to look more to indigenous art, because for me the Brazilians still have something of the Indians, in the culture, in the blood.' By placing his images of tribal people in contemporary settings such as motorway underpasses, Nunca creates a timeless dialogue between the modern world and our common ancestors.

As well as making large-scale works on the streets and in galleries, Nunca has worked in sculpture. A recent project involved a collaboration with the Carajá tribe from central Brazil. The Carajá crafts people provided him with sculpted totems, which he painted. In the tradition of the Carajá, the totem or talisman endows the owner with special powers of luck and good fortune.

Nunca's works on the street, which often focus on faces, are based on members of the public whom he sees while walking around the city. Even though made with spray paint or acrylic, they often have the look of ancient woodcuts or etchings: 'This was the first way of depicting people when the conquerors came here.' His works, whether letters or figures, are often made in a dark red ochre. This also refers to Brazilian Indian influences. 'They use *urucum* [a red pigment] to paint their faces and bodies in rituals.' Often improvised, these works reflect what the artist sees as the inner character of the Brazilian people fighting for survival in the modern metropolis: 'I like to use cannibals, because in the streets, everybody is like a cannibal. If you work, you have to be a cannibal; you eat smaller things than you. If someone is bigger than you, he's gonna eat you; he's gonna bite you.'

Street Art

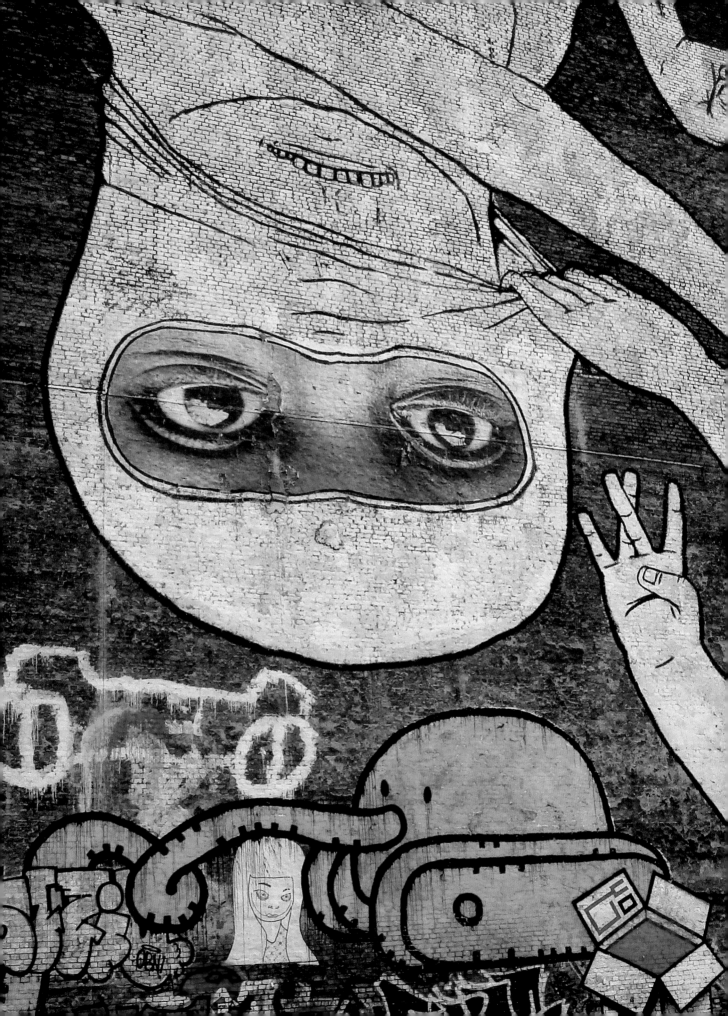

Global-style Graffiti, Local-style Street Art

Graffiti is a code. Graffiti isn't easy to decipher unless you're in the world of the artist. The whole point of doing graffiti is to encode your name in a very unique style that not many people can decipher. So that polarises people. You either understand graffiti and you're like, 'That's fucking awesome', or you're like, 'I don't get it'. The people that don't get it aren't necessarily not interested, they just can't decipher what graffiti is about. Street art doesn't have any of that hidden code; there are no hidden messages; you either connect with it or you don't. There's no mystery there.
The Wooster Collective

To return to the argument distinguishing graffiti writing from street art, an important point to make is that street art is often reflective of the place where it is installed, whereas graffiti writing is representative of a more standardised universal language that was set in place early on in the movement's history. Street artworks can be displayed in highly emotive locations, such as Keith Haring's painting on the Berlin Wall in 1986, which was not only a comment (literally) on one of the most visible symbols of the Cold War era, but also saw the artist aligning himself with the political freedoms and ideas of democracy offered by the West. The text-based, New York-style graffiti that appeared alongside Haring's work, however, is far less to do with its context and location, being an autonomous language. This is in no way a criticism of graffiti writing; in fact, it can be considered a positive attribute that graffiti writing is such a stubborn genre that it refuses to take on any of the conditions of its placement.

The main reason for the universality of graffiti is that since its inception the genre has been largely governed by stylistic concerns and the pushing of boundaries within its own rubric. Graffiti came out of New York as a complete stylistic package. It advances, but it advances within its own rules. This has led to the fact that graffiti often looks very similar (or aspires to look very similar) no matter where it is in the world. Currently, rules are being broken down and street art and graffiti are cross-fertilising, opening up the genres into new directions. This development is welcomed by some, but dismissed by other more purist graffiti writers. Zephyr sees the development as positive: 'The whole idea of the ego only can go so far, and at a certain point you like to think that something a little bit more subtle takes flight. I think with these artists, that's what we're seeing. We're seeing a progression in terms of art/street art/public art that's a very healthy one.'

A further reason for the aesthetic similarities of graffiti around the world is that it has also been governed to a very large degree by the materials used to produce it. Spray paint and marker pens lend themselves easily to certain aesthetics, and the advancements that have been made within the graffiti lexicon have been driven by pushing the boundaries of what these materials are capable of. An example of how the use of materials can affect the development of graffiti is visible, as we have seen, in Brazil. In the 1980s, spray paint was not easily available to Brazilian graffiti writers for

Collaboration between Blu and JR, Berlin. The work of other artists is also visible

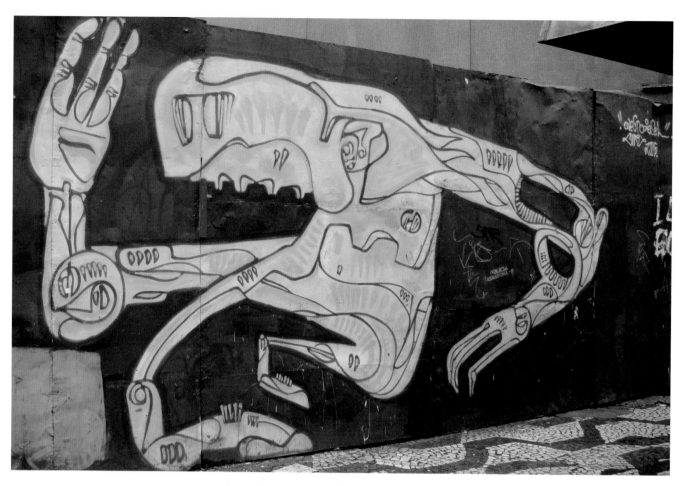

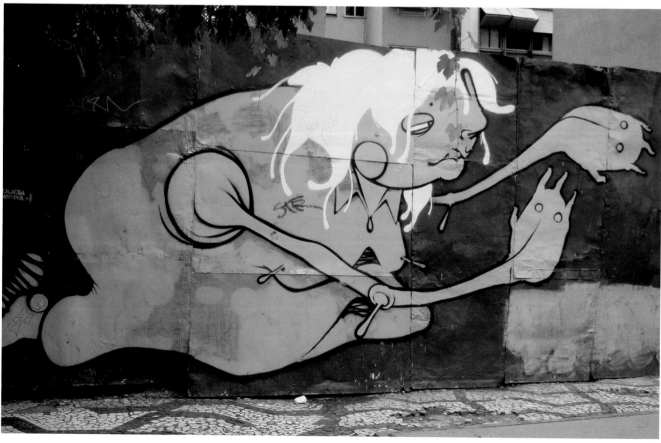

financial reasons. As is so often the case, poverty breeds creativity, and the graffiti writers in Brazil sought out other, more easily accessible materials with which to work. The simple act of working with household acrylic paint and small paint rollers instead of spray paint had a huge affect on the development of Brazilian graffiti. The paint rollers lent themselves more easily to a square type of line, as opposed to spray paint, which is easier to curve. When working in household paint, it is harder to blend and fade colours as one can with spray paint. These restrictions resulted in many positive effects, and Brazilian graffiti is now easily recognisable through its straight lines and blocks of colour that are often not mixed. Now that spray paint is easily available in Brazil, we see both styles and techniques blending together.

Despite the different aspects taken on by street art depending on context and location, there are also many similarities in the imagery. Cartoon figures, stencils of collaged graphics and black-and-white photocopies have become something of a global archetype for street art. The democracy of the genre, where anyone can put their work up, has inevitably led to massive disparities in quality. But the really good artists who are doing something original easily stand out from the crowd.

A further important distinction between street artists and graffiti writers is that street artists often make their work before they put it up on the street. This preparatory process – making a stencil, for example – which takes place in the studio, brings street artists closer to studio-based fine artists than to graffiti writers. It is, of course, true that graffiti writers will often make detailed preparatory sketches or 'outlines' before realising their more complex works outside, but, aside from stickers, they will rarely put up something that has been prepared in advance.

It could also be argued that street art is reflective of its creators' political opinions and creative desires, and these change from country to country, even from district to district. Just as art in museums is a reflection of the cultures that produced it, street art reveals the hidden narrative of those who make it. Street art in London, for example, has to compete with an extremely media-saturated environment, and the artists are aware of and responsive to that environment. They are in competition with the fly posters and advertisers. They also know that as soon as they put their work up on the street, the advertisers and marketers are going to attempt to appropriate their ideas. So the street artist in London must build a defence-shield against corporate theft. It's a constant cat-and-mouse game of artists innovating and advertisers assimilating.

In Melbourne while the street art is also preyed upon by over-zealous advertising executives, it is often reflective of Australian culture and issues. If street artists in the UK feel they are acting out a Robin Hood-like activism, then their counterparts in Melbourne relate to their own outlaw heroes such as Ned Kelly.

What graffiti writing shares with street art is a basic sense of appropriation: making the city your own by claiming the space. Where street art differs from graffiti writing in terms of motivation is that it is less destructive and rebellious in nature. Street artists are perhaps motivated, to varying degrees, by some of the same 'fame' issues of acceptance that drive graffiti writers, but they may also be concerned with the very

Left: Paintings on the streets of São Paulo by Ciro (top) and Onesto (bottom)
Overleaf: Various artists' work in São Paulo, including Boleta, FSE, Jana, Joana, Highraff, Kboco, Lelê, Nina, Popo and Vitché

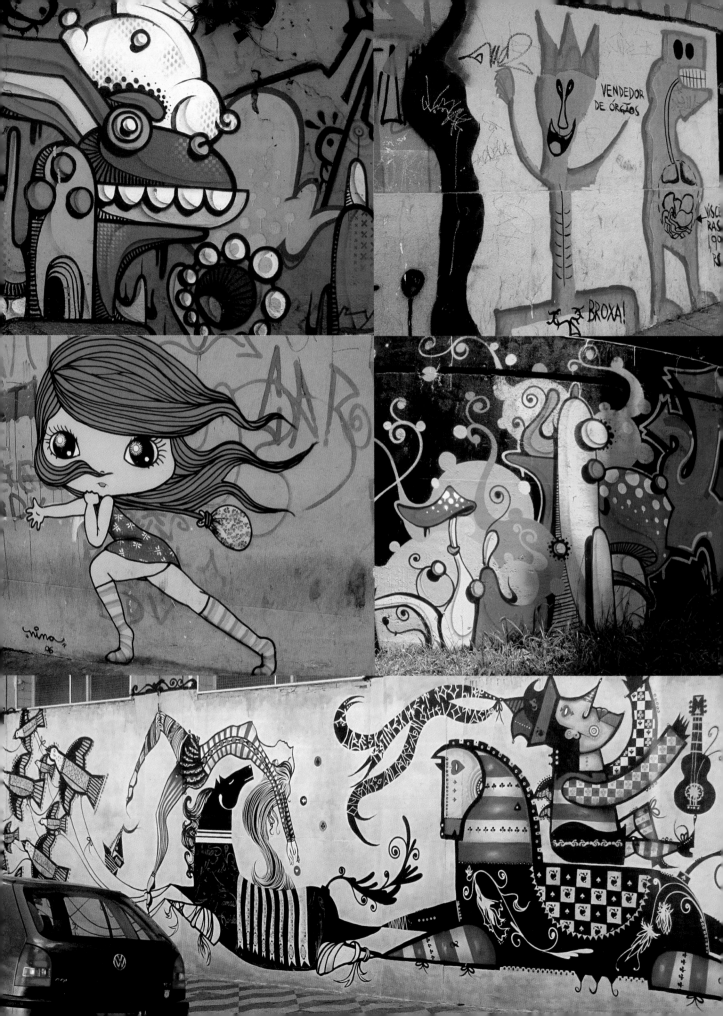

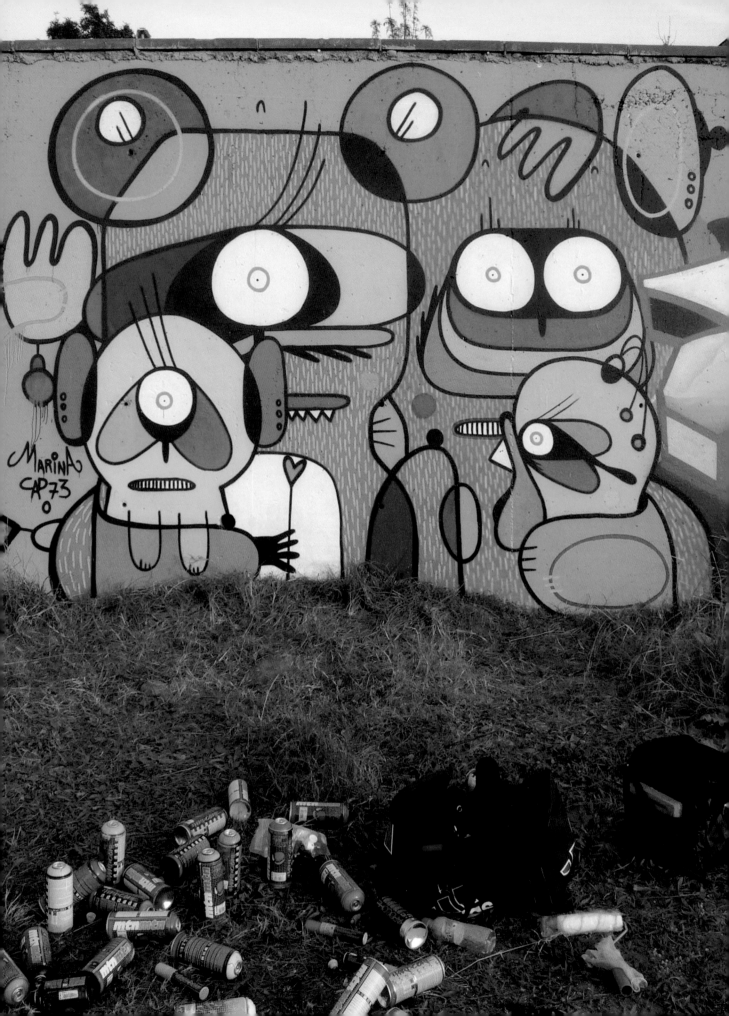

many issues applicable to any other artist working in a studio context.

Since graffiti writers and street artists are all individuals, and will all have individual answers to questions of motivation and aspiration, it would be wrong to apply broad over-arching rules to their practice. We can, however, ask why some people choose to work with one set of materials and techniques and why another group working in the same context and location choose to work under a very different set of material and conceptual conditions.

Practitioners who have moved away from tagging-led graffiti writing might simply find the atmosphere and process more open than that of the hard-core graffiti-writing community. According to Eine, whose work has moved between graffiti and street art, 'The street-art movement is lots of kids who don't necessarily want to go around vandalising everything and they're more into art, and art college. This movement is a lot friendlier and a lot happier and not so hardcore. Stencils are more friendly than tags.'

Ernest Pignon-Ernest

The French artist Ernest Pignon-Ernest's first artworks on the streets date back to 1966, and were inspired in reaction to the France's 'Force de Frappe' (Nuclear Strike Force). 'This subject was about nuclear weaponry', he comments, 'and a kind of terrible contradiction that exists between the lavender landscape of Provence and the idea that buried underneath it were thousands of Hiroshimas or Nagasakis.' His first thought was to respond to the subject through painting, but he found it 'impossible to deal with on a canvas. It was at that point that I felt it necessary to work *in situ* and to try and consider the poetic and dramatic potential of the place itself.'

Pignon-Ernest's drawing process begins with location and concept. He physically acquaints himself with his environment by walking the streets and by reading about the history of his chosen location. He conceives the outside world in terms of visual material: everything from the colour of the walls to their texture and the varying light conditions are taken into account. In true psycho-geographic style, he attempts to capture the soul of a space. He wants to give the impression that the location itself has produced his images.

After first working with stencils, Pignon-Ernest moved to screen-printing on paper. It was at this point that the deterioration of the images became an important element in his work. The fragility of paper installed outdoors evokes what he describes as 'death foretold'. In his project commemorating the poet Arthur Rimbaud, made in 1977, he travelled from Charleville to Paris, posting up screenprints of Rimbaud's portrait along the way as a reflection of the poet's literal life journey; the rapidly disintegrating images symbolised Rimbaud's brilliant but brief œuvre.

Pignon-Ernest's work is far from the conventional idea of what street art should be. He cites paintings such as Caravaggio's *The Death Of The Virgin* as important predecessors to his practice. For him, this work 'treated the great sacred rituals as if they were experienced by the common people ... by removing the angels and all the bowing and scraping, it transferred them to the street'. The bleak and sombre mood evoked by Caravaggio is also

evident in many of Pignon-Ernest's works, which make dramatic use of light and shade in order to hint at his subjects' internal state of mind.

Pignon-Ernest has attracted some very well-regarded fans: Jacques Derrida and Jean Baudrillard were both regulars at his studio, and philosophers such as Régis Debré, Paul Virilio and Michel Onfray have written about his work. And yet, despite these esteemed admirers, and a body of work that still seems so vital, his name remains unfamiliar to many in the art world. Not that this seems to matter to Pignon-Ernest himself: he is more concerned about the public power of art than about the small clique of people who make up the 'art world'.

Blek le Rat

Blek le Rat is widely regarded as one of the primary pioneers of early stencil graffiti (or *pochcir*) in Paris. For him, the history of graffiti starts with the Second World War, with the famous 'Kilroy was here' messages that were written in the numerous locations to which the soldiers travelled. The Kilroy graffiti was so omnipresent that even Joseph Stalin and Adolf Hitler both allegedly inquired as to exactly who this mystery person was. For Blek, however, it's the idea of soldiers engaging in this creative pastime that is of interest. Placing an emotional reading onto a situation associated with harsh social reality is typical of Blek's practice, which often humanises the barbaric aspects of the human condition.

Though Blek credits the artist Gerard Zlotykamien as an early predecessor for his street art, the New York graffiti-writing movement was a major inspiration. He first saw graffiti in 1971 in New York when he was a student of architecture at Bause Art in Paris. The early tags on trains and walls in New York had a profound effect on him. Ten years later, the fascination was still there, and drawing further inspiration from children's chalk drawings, he started to make his first works on the street.

Blek has dedicated his whole life to working in the street, and working illegally is a vital aspect of the activity. As Blek says, 'When you take the decision to go into the street and to make this art, you take a lot of risks. You can go to jail; you can pay a lot of fucking money.' He was inspired by the Situationists (see p.oo) and events in Paris in 1968, seeing the current street-art movement as a consequence of their ideas and actions. Pop artists such as David Hockney have also influenced him, and the constant use of the figure in his work pays homage to Pop's rejection of abstraction.

Blek himself often features as the model in his work, and his images are frequently oblique reflections of his own life, which he translates into a wider social or political context without being party-politically focused. Though his works carry seemingly political messages, he is frustrated by conventional political processes, a frustration that has motivated him to continue making art in the way he does. Now that a new generation of street artists has discovered Blek's practice and taken him to its heart, it seems that his 1981 prediction that 'This is the future of art' may yet be proved correct.

**Blek le Rat stencil,
Paris, 1992**

Art School of Hard Knocks

While it's true that street artists appropriate aspects of graffiti in very knowing ways, the idea that street art is made by people with 'proper' art-school training and is therefore more intellectually rigorous than graffiti would be too much of a generalisation. There are various formalist aspects to graffiti that primarily revolve around technical and stylistic concerns: how it's made and the way it looks, the quality of production, its placement, fading colour combinations and other virtuoso painting techniques. Above these practical issues there are the political ramifications of the act, with which graffiti writers may or may not be concerned. The formalist concerns of graffiti writers and street artists are generally speaking very different languages. Graffiti writers highly value the skill of the hand. Even the most basic tag, for example, should be well executed; if not, it's simply dismissed as the work of a 'toy' or amateur. Graffiti writers also admire proficiency in the use of spray paint. A piece or tag with drips is likely to be an unskilled writer's work. Street artists in comparison are far less concerned with these 'skill of the hand' issues.

This leads to the question, why is it that street artists are more likely to have art-school backgrounds than graffiti writers? The answer to this is perhaps due in part to the fact that graffiti is initially a text-based form of communication. You don't need to be able to draw to become involved; you don't even have to have an interest in art – just a curiosity or impetus and the ability to write your name. This is a major equalising factor for newcomers, who can start doing graffiti at a younger age or with no arts background. Another reason has to do with the changing perceptions of what art is. In the past, if you were at art school doing graffiti on trains and claiming it as part of your art practice, it's doubtful how seriously you would have been taken. It's now a far more acceptable mode of operation for students within an art-school setting to make work that they place on the street, document and present as part of their studio practice. A third reason might be that people with art-school backgrounds start to work on the street because they are trying to find a place for their work that is not forthcoming in terms of galleries. Or they simply may not want the hassle of having to deal with what is perceived as a very elitist art world. They want to communicate with the public in a quick, direct way, and working on the street is a fun and fashionable method to cut out the middleman. It's also true that many street artists come from a graffiti-writing background and move over into working in more experimental modes. The reasons for this can be anything from fear of arrest to simply feeling restricted by the constraints of an art form primarily devoted to typography and glorification of the name.

Gordon Matta-Clark

Though he operated very much within the museum-led art world, Gordon Matta-Clark's continued influence on street art is unquestionable. The link dates back to around 1964, when the artist was in Paris studying literature, and was at some point around this time introduced to the ideas of Guy Debord and the Situationists. The Situationist concept of *détournement* (the rerouting of imagery from mass culture) would later prove a crucial

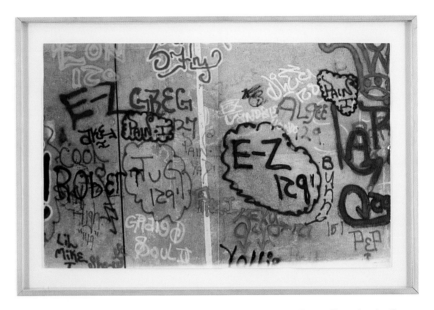

Gordon Matta-Clark,
Graffiti: E-Z 29 1974,
colour photograph,
78.7 x 104.1 cm

factor in his practice. Matta-Clark's projects were conceptual as well as physically sculptural in nature, often adding an eccentric twist to what would normally be considered banal or uninteresting situations. In this sense, his work was very much in tune with what street artists were doing in the 1970s and continue to explore today.

His projects included buying small plots of land between structures that were impossible to build on, then simply exhibiting the legal papers concerned with the sale. But he is best known and admired in street-art circles for his works that altered property in various dramatic ways: splitting buildings down the centre, and famously cutting a conic section from the wall of a warehouse at New York's piers in 1975.

One of the first houses that Matta-Clark split was owned by Horace Solomon, a property developer and the husband of the gallerist Holly Solomon. The property had been brought with the intention of demolishing it. When Matta-Clark was given access to the house, he decided to make a sculptural extraction. According to Lynne Cooke, curator of the Dia Foundation in New York, the architectural intervention itself was not meant to be viewed by the audience; photographs of the project were exhibited. As Cooke says, 'The documentation is the work.'

Matta-Clark was of the generation that immediately followed Land artists such as Robert Smithson. Where his approach differed from this previous generation is that he worked with the urban landscape as opposed to the isolated rural locations favoured by the Land artists. Matta-Clark also took an early interest in the tagging-based graffiti that was happening in New York in the 1970s, documenting it in what he called *Photoglyphs* 1973, which were assembled into 30-foot rolls, mimicking the exterior of subway cars. In 1973 he also made the work *Graffiti Truck*, in which residents of the South Bronx were offered the opportunity to graffiti a truck that the artist had purchased.

Gordon Matta-Clark,
Splitting 1974,
colour photograph,
50.8 x 80.6 cm

For Cooke, part of Matta-Clark's interest in graffiti was 'quasi-sociological'. She also believes that what street artists working today may admire in his work is the low-key way in which his projects operated: 'People looking back see it wasn't market driven and was done without a lot of preciousness, which is disarmingly direct.' In this sense, Matta-Clark is, as Cooke puts it, 'an exemplary figure' for people working with ephemeral art in the street today.

Street Art Avant-Garde

Street art draws from many diverse sources. Some of the key art-historical references are Situationism, Pop, and the ideologies of radical cultural movements such as punk.

The Situationists

They were the focalised remains of Dada and Surrealism and made art into a political event that really shocked you. Malcolm McLaren

The Situationists were a group of artists and political thinkers who wanted to break down barriers between art, politics and other forms of what they saw as social oppression. Their art actions often brought cities to a standstill, and their sloganeering and political presence is closely linked to the student riots that took place in Paris in 1968. As well as encouraging people to adorn the streets with statements such as 'Free The Passions', 'Never Work', 'Live Without Dead Time' and 'It's Forbidden To Forbid', the Situationists also inspired people to rework or *détourn* metro posters, thus being an early prototype for what we now call 'subvertising'. Guy Debord described *détournement* as 'The fluid language of anti-ideology'.

The Situationists constantly challenged ideas of ownership and creativity. Debord's concept of the 'society of the spectacle' sought to explain Karl Marx's ideas of alienation to a new generation. The group believed in the immediate transformation of everyday life, taking action here and now. If you want to put art in the street, do it. If you disagree with an advert, *détourn* it. These are attitudes that many street artists still share today.

Pop Art

As gallerist Tony Shafrazi has said: 'Pop dealt with street.' At one level, it is possible to consider the success of Pop art as the success of the common vernacular, the triumph of the real world over the abstract world of the high modernists. This is one reason why artists working on the street all over the world relate to it so strongly. In Pop, they see an art that embraced everything from advertising to billboards to tabloid trash. The real world, in all its tacky glory, was celebrated and dissected. James Rosenquist, Roy Lichtenstein and, of course, Andy Warhol, are heroes to the current generation of street artists because their concerns and subject matter are often so similar. Many street artists think of their practice as being part of a natural lineage from Pop. They feel that unlike the conceptually inspired art championed by museums, their work communicates to general audiences in simple ways and that they are the true 'popular' artists of their time.

David Wojnarowicz,
Abandoned warehouse,
Hudson River,
New York City, 1983

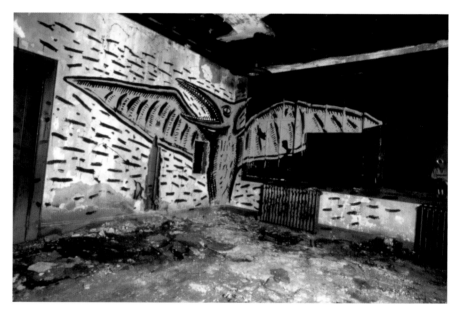

Punk

Street art in general was punk, the act of doing street art was punk. You were risking getting thrown in jail. I actually was thrown in jail. Kenny Scharf

Looking back on the punk era, Malcolm McLaren has commented: 'Pop culture is so commodified today that it doesn't have any sense of the outlaw spirit. Pop culture existed in the beginning as a form of outlaw spirit. Why the hell did you ever listen to rock and roll? Because it spoke against an established view. It represented the outlaw spirit.' In the downtown New York art scene of the early 1980s, punk and new wave were driving forces. More than just music, these were ways of life, and this was reflected in the art that people made. Certain artists of the time particularly illustrate this, as artist Kenny Scharf remembers: 'David Wojnarowicz was linked to punk, but it wasn't so much the music; it was more like the attitude towards life. Scrounging, sleeping rough, being outside of society. It was all really bohemian.'

This attitude, though different today, is still reflected in street art. McLaren believes that street artists 'relate to punk because it didn't ever feel like a commodity; it had this romantic feeling of never being for sale. You were NOT for sale, and when you saw a punk poster, that poster shined out because you knew that poster wasn't trying to sell you anything ... other than declaring a sense of outrage.' Street artists today, who were teenagers in the 1990s, connected to punk sensibilities through skateboarding and slacker culture; they felt aligned with that sense of uselessness but chose not to be apathetic. Punk and DIY culture are a way to speak back to the society that produces these feelings of

disenfranchisement. But we might ask if artists working today who feel strongly connected to punk have an over-romanticised view of that era. Are they simply marrying an aesthetic of anti-ideology to the commodity-driven world we inhabit now? Is it actually possible for art or culture to be opposed to anything in a system dominated by commerce?

Dan Witz

Dan Witz has been making some of the most original, well-considered, and often humorous art on the streets for over twenty-five years. Around the same time as legendary New York graffiti writers such as Seen and Lee were covering subway trains and ball courts with tags and large-scale paintings, Witz was hand-painting tiny, delicate acrylics of hummingbirds onto carefully selected exterior locations. Where graffiti writing was dominated by the conditions of speed of production and a system of scale in which bigger was better, Witz's 'tags', as he called them, would take up to four hours to complete and were not more than four inches in size.

Witz made his first work on the street in 1978, choosing this as his arena owing to his disenchantment with New York's 'elitist' official art scene. He has always sought to place his work in areas outside of the 'art ghetto', which in the late 1970s and early 1980s meant working anywhere but Manhattan's Soho. He remembers: 'It was very disappointing to me, being the guy in school who always wanted to be an artist and then coming to New York and finding out what the art world is, which is basically a business.'

Witz readily admits that he drew much inspiration and energy from the graffiti writers at the time, with whom he shared the city walls, and gives them full credit for getting him started. 'I decided I needed a tag', he explains, 'so I painted these realistic humming birds'. The images where painted directly onto industrial 'fucked-up' surfaces, creating a contrast between the ornate nature of the applied image and its naturally corroded setting.

In the mid-1980s, Witz exhibited with graffiti writers such as Lee, Daze and Lady Pink. The punk-rock posters that were pasted onto the city walls in the late 1970s were also a big influence on his work, and he now sees a close link between what these art-school graduates were doing at that time in promoting their music, and the street-art scene of today. Other artists working on the streets included Jenny Holzer, Charles Simonds and Gordon Matta-Clark. Aside from leading the way for Witz, they showed that the outside world could add a powerful dimension to the meaning of an artwork.

Witz has always seen himself as a street artist as opposed to a graffiti writer. For him, the difference is the same as 'Elvis singing the blues'. By this he means that the street artists have taken certain aspects of graffiti and popularised them without the angst or deep-rooted traditions. Aside from what he calls his 'serious' practice, he has also developed a strand of work that he categorises as 'pranks'. These include activities such as turning houses into faces with the addition of weather balloons, and placing sets of gloves in unlikely situations to create the illusion of a trapped person. For Witz, this 'trickster'

element is a vital part of street art, and follows on from a long history of the artist as clown in art and literature.

Twenty-five or so years down the line, Witz's view of the art system has mellowed: he now does put his paintings in galleries 'for rich people to buy', but he's still very much involved in putting art on the street. In many respects, he is guided by the same principles as when he started: he believes that 'the business of art limits the potential of art to have any effect outside of the art world'. And for him, the most important factor of art on the street is that it's 'not for sale ... It can't be bought, and it can't be owned.'

UnderCulture Gone MainStream

I think Shepard Fairey and Barry McGee and even Banksy are all taking note of what I saw way back: that their audience is much bigger than just one scene. The political atmosphere is ripe for people who want to listen to art as the first word of a collective consciousness. People know what's going on, but they need to see it in the arts to confirm it. That's where a good thing has got even better, with people who haven't necessarily come from the subway movement, but people who have looked at the subway movement with respect and said, 'Wow! this is a new outlet', just like it was for Jenny Holzer and John Fekner back in the early 80s. Lee

The funeral song of New York train graffiti came in 1989, by which time Mayor Ed Koch had won the battle to keep the subway virtually spray-paint free. But from the ashes of this defeat rose a movement that was tougher, more hardcore, more dedicated, and by this point, worldwide. It would therefore be easy to assume that the transition from graffiti writing to street art was an early 1990s phenomenon. There is, however, a much earlier history of street art that developed quickly after the graffiti writers in New York had made an initial impact.

While in the early 1970s there were artists in Europe such as Ernest-Pignon, who were working in a way that we would now classify as street art, these are rare, isolated exceptions and cannot be understood as a movement. But in New York, from around 1975 onwards, artists such as Jenny Holzer, Dan Witz and Richard Hambleton start to appear, followed slightly later by figures like Keith Haring and Jean-Michel Basquiat, who weren't working in the same way as the graffiti writers, but were operating in parallel with them. Many of this first generation of street artists in the USA were documented in Allan Schwartzman's book *Street Art* and went on to gain major gallery recognition later on in the 1980s.

From around the same time in Europe, artists such as Harald Naegeli (The Sprayer of Zurich), Gerard Zlotykamien and Blek le Rat were also making artworks that would fit under the title 'street art'. There were some overlaps between these two separate worlds, with collaborations and cross-pollination, but we should be clear that if it wasn't for the graffiti writers upping the ante to such a large degree, street art as we know it now could not have happened.

In the 1990s, the emergence of a new generation further blurred the boundaries

Left: Dan Witz,
hummingbird,
New York City, 1979,
acrylic on metal door
Right: Dan Witz, hoody
sticker, New York City.
Photo by Cedar
Lewisohn, 2007

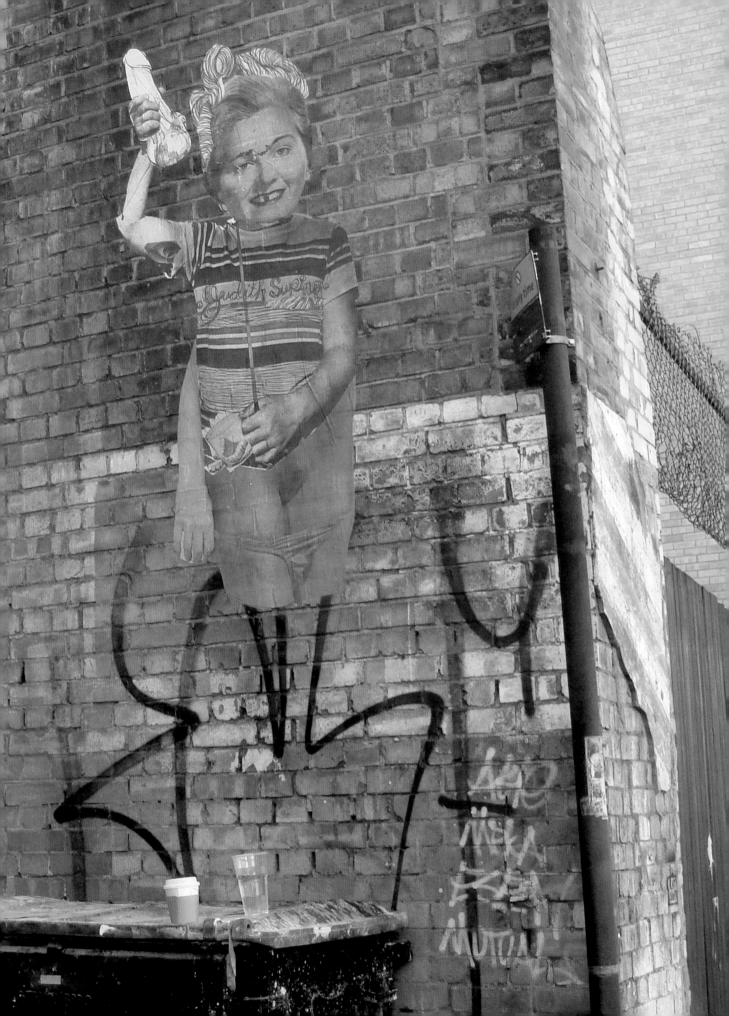

between street art and graffiti. Artists such as Shepard Fairey (Obey), Banksy, Barry McGee (Twist) and Phil Frost were and still are highly influenced by graffiti, and often started out purely as graffiti writers. The generation of street artists in the 1990s was influenced by many diverse sources such as skateboard culture, punk and even folk art. Through these influences, they lost some of the values and associations of the purist graffiti writers and their own hybrid developed. The exhibition *Beautiful Losers*, curated by Aaron Rose, which opened in 2004 at the Contemporary Arts Center in Cincinnati, showcased many of the artists from this generation while exploring their relationship with the past.

Though street art was happening throughout the 1970s, it perhaps only really started to seep into the general public's consciousness in the late 1990s. This was due to some extent to the rise of the anti-globalism movement with which street art became closely associated, and to the many guerrilla tactics that street artists have used to put their message across. Some street artists have taken corporate sabotage or culture jamming as the main element of their work. This has created associations between street art and anti-globalist politics in the public consciousness.

Artists who work in the urban setting are all highly individual, and though many may share political opinions, it would be a mistake to claim that the sheer number of these artists working throughout the world share any one set of beliefs. What is relevant with the aligning of street art and anti-globalism in the 1990s is that street art became symbolic of a certain attitude. Just as graffiti writing was a visual symbol of all things hip hop in the 1980s, street art is inextricably linked with a caring, sharing 'no logo' anti-capitalist rebelliousness.

This moment, when the notion of individual artists had given way in the public understanding to a universal standard, is the same moment that street art became a mainstream phenomenon. By the late 1990s, street art, graffiti and hip hop were all big business: the graffiti writers had opened the door to the corporate world, and street artists quickly followed. Through the support of large fashion and sport corporations, street art became visible to a more general audience. The corporations used it as a marketing tool that helped bring the genre to mass audiences.

Another important development in the spread of street art in the 1990s was the release of many books on the subject, which were first published by artists themselves, often supported by private sponsors, and then by larger publishing companies such as Thames & Hudson. The sadly ironic factor in this process is that as soon as the very marketing executives and advertising agencies against whom the artists had been protesting caught up to the fact that street-art-style imagery had a hip-by-association rebelliousness attached to it, they started using the format to sell their products.

Judith Sulpine

URNS
TRUCKS
CAL DELIVERIES
·EXTRA·

The Bones Royal

wtc7.net
6/11 WAS AN INSIDE JOB
911Truth.org

WHEN I WAS
A CHILD,

I WAS NEVER
A TEAM PLAYER

-ELBOWTOE

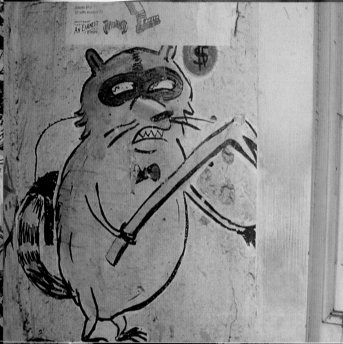

NECK FACE
HAD AN
ABORTION!!!
FROM'

PARCEL POST | CONTENTS, MERCHANDISE
RETURN REQUESTED

PEOPLE
SUCK

BANNING

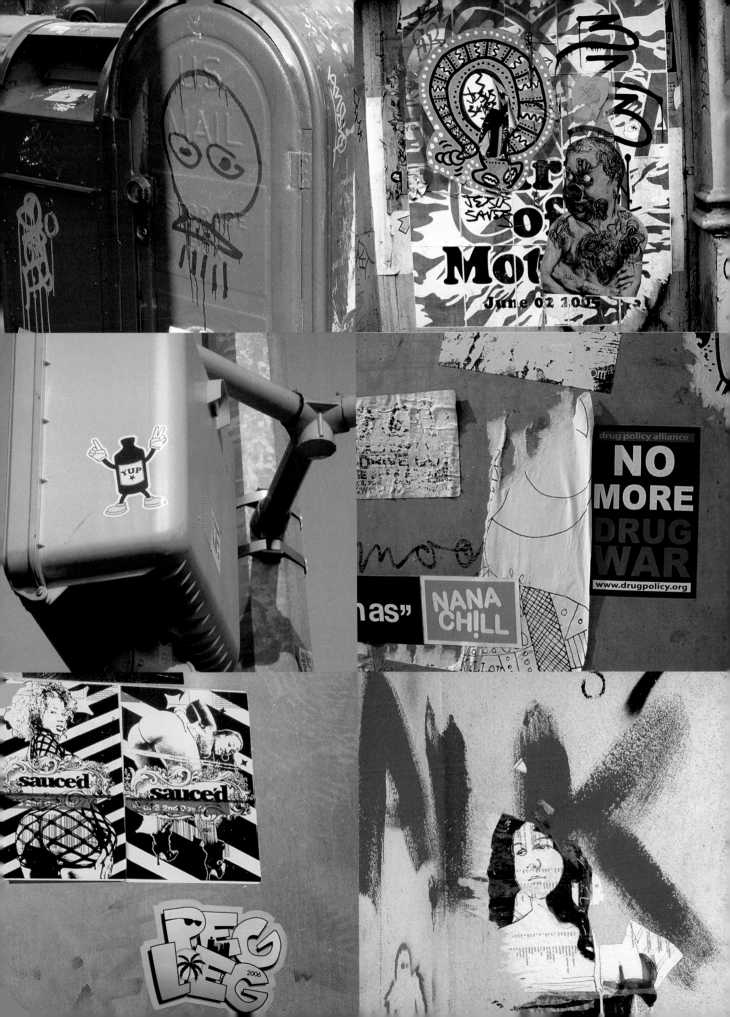

The Politics

Mixing it up

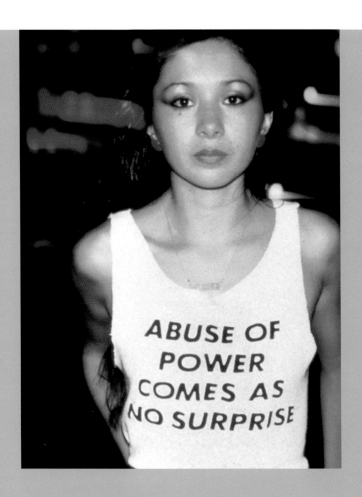

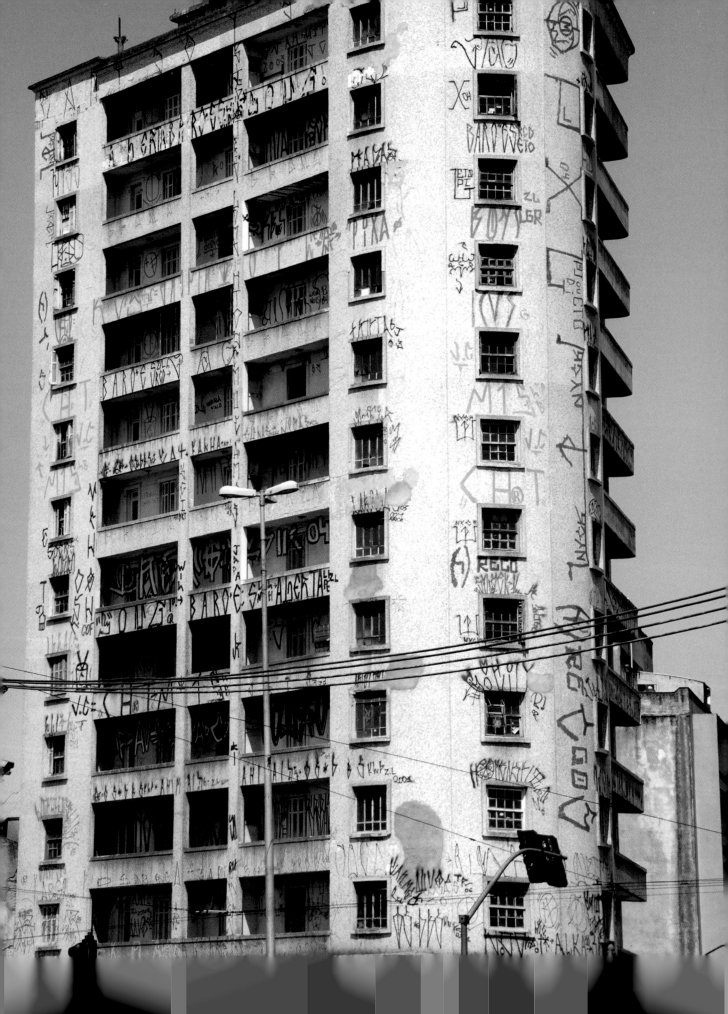

Anti-Modernism
(The Barbarians are at the Gates)

If graffiti seems barbaric, then it is a reflection of the world in which it exists. Graffiti writers are at war with the urban developers, the architects, and all the other faceless decision makers. The city walls stand for ownership and authority, and graffiti is the voice of the unelected, fighting back against systems that are imposed on them. In many ways, graffiti writers see themselves as at war with society and they see their activities very much in terms of aggression. They are at war with the police, at war with the train authorities, at war with everyone. This attitude is reflected in the language of graffiti: writing graffiti is 'bombing', a tag is a 'hit', and advanced letter formations are 'burners'.

If artists in museums and galleries had the same mentality as graffiti writers, then Picasso would hang his painting up, and ten minutes later, Matisse would come by, say to himself, 'I don't like that' and paint over it. Then Picasso would say to Matisse, 'You've been looking at my girl. I'm going to paint over everything you do.' It's territorialism and bravado. If graffiti really is at war with anything, however, then perhaps without even knowing it, it is at war with modernism.

The ideal of modernism was the design of social architecture, such as the productions of the Bauhaus, aiming for the perfect living space in post-war reconstruction. The modernists loved clean white walls, and put forward the view that new is beautiful and therefore for the benefit of society as a whole. The idea was a noble one, but by the time it trickled down to the masses, it translated to concrete jungles, cheaply made and badly designed housing projects, places of exclusion and isolation. Those involved in the pioneering graffiti of the 1970s were part of the first generation to grow up in this social architecture. Graffiti writing can therefore be considered a literal critique of modernist ideologies, an anti-modernist tendency that symbolises the failure of modernism, created by those whom it directly affected. The tags and images of those working in direct reaction to their architectural surroundings, fighting for a sense of individualism and territory in the face of an ever-expanding metropolis, can be seen as a by-product of the system that they are attacking.

The emergence of graffiti writing and street art coincided with many social failures. The mid-1960s and early 1970s were the apex of the idealist hippie period, the height of the Vietnam War and the social protests that accompanied it. The financial recession underway at this time in the United States was also a major factor in the expanded social networks of disenfranchised youths who turned to graffiti. This unique set of social conditions also led to what might have previously been 'inside' cultures, such as drawing, dancing and generally hanging out, encroaching on 'outside' culture. The streets and trains were a home away from home, and the actions of the writers can be seen as a way of bringing these 'inside' activities to the outside world.

The attitude of being at war with the world is less prevalent in the street-art lexicon. If anything, street artists want to save the world, not destroy it. But in many ways, street art is

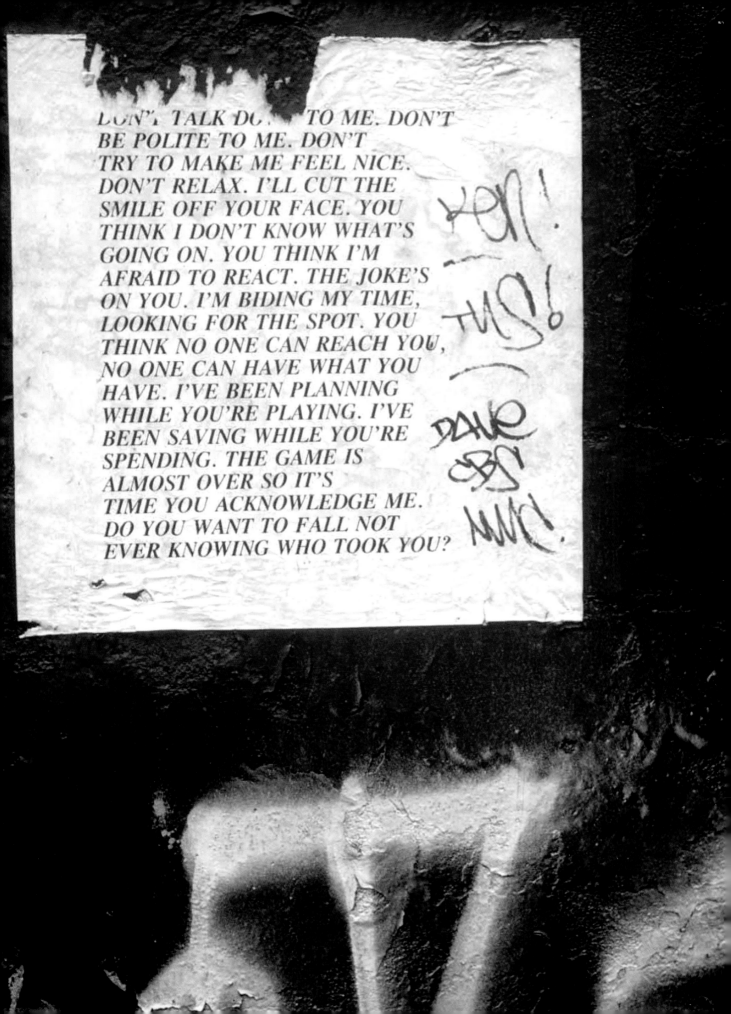

also a direct reaction to modernism and its notions. Where typically modernist architecture sought to be pared down and simplistic, emphasising function and form, graffiti writing that was attached to the emblems of modernist design – tube trains, and city walls – was complex, convoluted, decorative and ultimately completely unnecessary. Modernism had one thing in common with graffiti, however: that of being essentially elitist. Street artists, on the other hand, are populist in their ambitions and methodology. They have moved even further away from what is currently considered highbrow, instead presenting what is seen as kitsch.

With the spread of graffiti came a new kind of social intelligence that helped those who understood it to navigate and comprehend cities with an alternative set of apparatus. For these individuals, the walls of a city reflect its sophistication. While graffiti is a symbol of the dominance and omnipresence of American culture, street art – because it is in essence a sub-genre of graffiti – also reinforces this cultural dominance. But owing to the fact that youth culture is ever expanding and constantly evolving in meaning, street art also manages to reflect the local dialogues of the cities that produce it.

Public opinion towards street art, rather like street art itself, changes from city to city. In London, people marvel and scoff when works of street art sell for large figures; they believe it to be some kind of elaborate hoax that will later be exposed. They cannot understand why a work of art should sell for hundreds of thousands of pounds, but have no problem when football players make the same amount per week. In Melbourne, van drivers are competitive about the graffiti on their vehicles, and seem to welcome more colourful works involving pictures, but dismiss the tags on their vans as a waste of space. In São Paulo, people are proud of the colourful graffiti around their streets. When tourists come to photograph the work of local heroes like Os Gêmeos, residents pose next to the paintings and smile, as if to say: 'These paintings are part of our culture. Look how creative we are.' Recently, in cities such as New York and Bristol, there have been outcries and public protests when street art has been removed or damaged.

Jenny Holzer

Widely regarded as one of the most significant artists of her generation, Jenny Holzer began her art career in 1977, placing posters on the streets of lower Manhattan. The work had come about while Holzer was participating in the Whitney Independent Study Program. She explains, 'I had begun writing a number of short sentences, and I didn't know what to do with them, because they weren't poetry and they wouldn't go in a book proper, so I came up with the idea of doing street posters.'

It was also around this time that Holzer became involved with the artist collective Collaborative Projects (Colab), which included Kiki Smith and Tom Otterness. Working with the group further developed her interest in the street as a platform for open dialogue with the public. As she says, 'The people in Collaborative Projects were interested in subject matter that could appeal to a general public and was about big topics.' Though Holzer was not directly influenced by tagging-style graffiti at this point, she was aware

Jenny Holzer, from
Inflammatory Essays
1979–82. Offset
poster with graffiti,
43.2 x 43.2 cm

of the unfolding developments on the subway system and was in awe of it.

Later on in the 1980s, Holzer and Lady Pink would collaborate on several projects. Though Holzer says she was aware of the work of Conceptual artists such as Daniel Buren, who had been using the urban landscape as a setting for some time, and although artists like Barbara Kruger were working with posters, she did not necessarily see the placing of her *Truisms* on the street as an art gesture, since she wasn't initially convinced she was even an artist. Her aim was simply to start a debate and raise these topics with the public: 'like Speakers' Corner, or the equivalent to making pronouncements about what one thinks important'.

Charlie Ahearn, who was closely involved in the street-art scene in New York throughout the 1970s and 80s, saw Holzer's early work as being greatly influenced by the fly-posting used to promote rock gigs: 'There were a lot of people at that time that were not really postering shows, they were putting statements up on the walls. And those statements had art and political reasonings behind them.' Holzer saw this activity as more than an artistic endeavour; she thought of it as a social undertaking with political implications. As far as the implications of working illegally on the street were concerned, New York at the time was an almost bankrupt and massively dilapidated city: putting up a few posters wasn't going to cause much of a stir among the local law-enforcement agents, though Holzer was 'hauled in' on one occasion.

Holzer placed her *Truisms* not just on posters but on T-shirts, stickers and LED displays. Her first gallery shows were in Germany and as she puts it, 'After I became vaguely respectable there, I started showing in the United States.' She achieved international acclaim for her text pieces on electronic billboards. Ahearn remembers how his wife Jane Dickson introduced Holzer to the format when she was working for a sign company in Times Square, and invited her to make an artwork for them. Working outside of the galleries was never a stepping stone for Holzer, but a choice. Her work now crosses between the public realm and the museum and gallery world. This balance is important: 'While it's wonderful to show in galleries, and a privilege, it's also very nice to be absolutely free and to be presenting material for anybody that's walking by.'

John Fekner

In 1968, John Fekner painted the words 'Itchycoo Park' in large white letters on an empty building in Gorman Park, New York. Inspired by the Small Faces song of the same name, Fekner was only eighteen at the time and hardly considers the act an artwork at all; in fact, he describes it as a random act of hooliganism. Still, there is a certain resonance in the twinning of a park from what was at the time one of East London's roughest areas, Ilford, with a park in Queens.

In 1977, Fekner officially started to make art for external settings; he began with a project called *Random Dates*. This involved spraying inconspicuous stencils of calendar dates around various industrial areas in the vicinity of his own neighbourhood of north-western Queens. The idea was to 'play conceptual mind games' with the viewer. By this

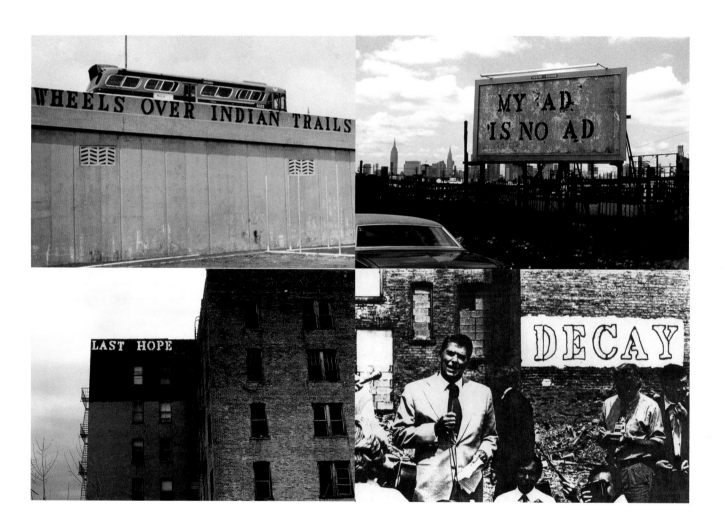

John Fekner, New York
City, 1970s–80s

point, Fekner had already had several successful gallery exhibitions, but what he describes as his 'rebellious nature' led him to 'turn on that world' and start to work outdoors.

Fekner's early art on the street was inspired by the world of New York teenage gangs from the 1950s, who would mark their territory with names such as 'Park Side Gents' or 'Fordham Baldies', and paint tattoo-style images of, for example, skulls and dice. Aside from these influences from the street, artists such as Robert Smithson, Laurence Weiner, Richard Artschwager and Gordon Matta-Clark also had an impact in suggesting the possibility of using the city as a context in which to work. What Fekner added to the equation was an exploration of the crumbling infrastructure of locations in the South Bronx or Queens. His texts would be stencilled on decrepit buildings or abandoned vehicles, on a motorway underpass or other bleak and neglected areas in the urban/industrial landscape. Fekner's minimal but caustic choice of words added to the resonance of the work. He explains: 'My responses to conditions could be ironic and cynical or piercing and literal.' The look of the letters in which the words were inscribed evoked a feeling of gravitas and age through the Times New Roman font, and something more industrial and technological with the Liquid Crystal Display font.

In 1980, Fekner's work hit the headlines when President Ronald Reagan made a speech in front of his *Broken Promises* text work in the Bronx, thus illustrating perfectly the idea that everything a politician says is a lie. Though Fekner's work has little in common with tagging-based graffiti writing, at its lowest common denominator it is still illegal and it is still graffiti. A detail that was important to the way in which Fekner perceived his environment, in comparison to the early generation of New York graffiti writers, was that he travelled everywhere by car. This led to working both in areas of isolation and in reaction to the highway system, as opposed to the writers whose activities were centred around the subway system. Given the decay of the structures in which much of Fekner's work took place, political readings are inevitable. As well as being a straightforward description of deprivation, Fekner's work is also a celebration of this squalor. Like L.S. Lowry, Fekner turns a mirror onto the grim industrial landscape and reveals (to paraphrase Baudelaire) delightful aberrations.

Disrupting Systems of Thought

Graffiti and street art are now a common part of the endless flow of information and constant 'noise' of the world. Both can be seen as subversive forms of advertising or self-promotion in an environment that is more and more virtual, and in which we become like avatars negotiating our way through computer-generated landscapes, constantly bombarded by instructions and symbols, road names, billboards, fly posters, shop signs, cars, road markings, bollards, railings, pavements, and every now and then, a piece of dog shit. And all we really want to do is move from A to B.

So in order to travel through the world, we have to put ourselves into a mild trance; we let this flood of information wash over us, and simply choose that which is relevant directly to us. Advertising in the public realm is constantly attempting to snap us out of

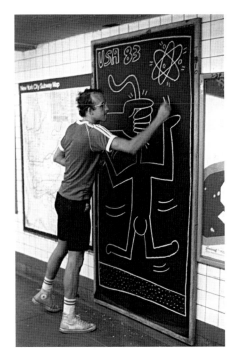

Keith Haring, *Untitled
(Subway Drawing)*
c.1981, New York City

this trance and make us focus on something other than reaching our destination. With its various devices, such as repetition, scale and the use of seductive images, it often succeeds. When advertising does distract us from our path, however, it immediately steers us towards a moment of purchase.

What differentiates street art and graffiti writing from the symbols of the outside world is the lack of a logical conclusion to the viewing process. Unlike all other symbols that we encounter in the outside world, illegal art in the street does not exist to instruct us in any practical way. Of course, much street art is morally instructive, but the propositions are conceptual. They say 'Think about this' as opposed to 'Do this'. In this way, when we look at art forms that have been illegally placed on the street, we momentarily break the spell of reality, and are confronted with the artist's alternative reality. The quality of the work also affects this process: if the work is good, it will have a greater effect on us. If the work has little effect, then perhaps it lacks quality. In this respect, the same rules apply for art in a gallery setting. We have to trust our own judgement. These rules don't apply to graffiti, however, because graffiti writers are primarily speaking an encoded internal language.

By physically engaging with the city, graffiti writers and street artists enjoy a special relationship with it. They forge a very physical and intimate negotiation with space by altering it. They possess it in a way that the majority of people would never think to do. It's a survival tactic in hyper-reality, a means of confronting the numbing effect of non-space hyper-modernity and resisting the effect of becoming a simulation. It's a refusal of apathy: being a creator instead of a consumer, forging an identity on the walls of the city. The fact that street artists often tell us what we already know, in terms of opinions or political attitudes, is why their messages are popular. If they made obscure statements, they wouldn't have the same level of public support, interest or understanding. In some respects, they are making the adverts that the advertisers can't make or wouldn't publish. In this sense, street art is free of the layered editorial complicity that we experience in so much of the media. There's just one editor – the artist – in direct dialogue with the viewer.

Jean-Michel Basquiat and Keith Haring

In 1981, the Washington Project For The Arts held an exhibition entitled *Street Art*, which included John Fekner, Fab 5 Freddy, and Lee. Although other exhibitions such as *New York New Wave* had brought these artists into museums, it's fair to say that during the 1980s, artists working purely in the urban setting were generally ignored by the art-world establishment. Only the artists from this scene who started to work within the gallery system were acknowledged.

For this reason, many very talented artists from this period remain little known. More celebrated figures such as Keith Haring, Kenny Scharf and Jean-Michel Basquiat emerged slightly later than the likes of Fekner and Holzer, but all featured in the legendary 1980 *Times Square Show*. Haring and Basquiat can clearly be defined as street-art pioneers, as opposed to graffiti-writing pioneers. Basquiat's moniker 'SAMO' and 'SAMO shit' stood for 'same ol' shit' and is also a play on the name 'Sambo', which has racial associations.

Writing 'SAMO' on the walls of New York's gallery district was therefore both a humorous and a slightly distasteful act. Examples of what Basquiat wrote around the art district of New York include:

SAMO as a neo art form.

SAMO as an end to mind wash religion, nowhere politics and bogus philosophy.

SAMO as an escape clause.

SAMO as an end to playing art.

SAMO as an end to bogus pseudo intellectual. My mouth, therefore an error. Plush safe he think.

SAMO as an alternative 2 playing art with the 'radical chic' sect on Daddy's $ funds

From these statements, it is clear that Basquiat's writing in the street had very little to do with tagging and doesn't function in the same way. He obviously wanted his writing to be read by the general public and not only a graffiti-writing audience. Like many of the artists working in the street scene in 1980s New York, Basquiat and Haring were actively pursuing gallery careers. While some of these artists preferred more alternative neighbourhoods and locations, many who started off working in outside settings deliberately made their work in areas of New York where gallery owners would see it.

The entry of the graffiti writers into the downtown New York gallery world in the 1980s seems to have been a fad. Almost as soon as they came into fashion, they were out of fashion. Very few of them went on to have prolonged art-world careers. If we were to compare the prices for their work with those achieved by Basquiat and Haring, or other high-profile artists associated with the downtown street-art scene, a radical difference would be clear. This is a sad reality of the often fickle, profit-led art market. As author and art adviser Allan Schwartzman puts it: 'Artists get dumped all the time after there's a flirtation with them; its just that it was more tragic and annoying when it happened to these kids because it really did promise them an out.'

The artists from this time with links to what we now consider street art never did New York-style graffiti pieces with text or spray paint. Even Haring only worked with spray paint on canvas and for club backdrops, never illegally on the street. By 1982, Basquiat had left the street-art scene behind and was doing major museum shows around the world.

At a certain point in the 1980s, graffiti writers became particularly purist and severed their links with street art. The prevailing attitude among graffiti writers was that street art was merely an 'art fag' waste of time. They perceived street art as something that requires no skill, in contrast to their strong technical concerns. It's possible to parallel this break of street art and graffiti with the strengthening and increasingly hardcore nature of hip hop music that also occurred in the mid-1980s.

Without doubt, Haring and Basquiat were two of the most important predecessors of today's street art. While Basquiat explored the fractured world of the artist, placing himself

at the centre of an expressionist universe, Haring captured b-boy dance moves and disco frenzy and turned them into line drawings. In terms of stylistic influence on visual culture as a whole, and in terms of their career paths (starting out as 'art-school kids' working on the street, moving into the gallery world and then taking on much wider commercial projects than the standard gallery-orientated artist, Haring and Basquiat are true leaders. They are both innovators without question, but both extremely different personalities with different stories to tell. Along with Kenny Scharf, they were amongst the first artists to be influenced by the aesthetics and methodologies of graffiti writing, while at the same time doing something totally new.

Haring arrived in New York from Pittsburgh around 1978; Basquiat was already there, hanging out at the bandshell in central park and writing his cryptic SAMO messages around town with his partner in crime, Al Diaz. By 1980 and the *Times Square Show*, Basquiat was working with black-and-white drawings, and SAMO was already famous. It seems that he didn't want to be a celebrity pseudonym, however: he wanted to be an art star in his own right. As legend has it, to this end he began stalking Andy Warhol and curator Henry Geldzahler. According to graffiti writer Freedom, 'He would follow them around and try and sell them his work for five dollars.' Eventually, Geldzahler in particular saw the vibrancy and originality of what he was doing, and went on to become one of Basquiat's great champions. By 1983, at the age of twenty-three, Basquiat had achieved his goal, and was one of the most sought-after art commodities on the planet, surrounded by a string of sometimes contradictory mythologies: bohemian, ladies' man, outsider, genius, savage, drug addict, alcoholic, pauper, millionaire, poet, inarticulate. While success brought with it many difficulties for Basquiat, Haring used his fame to propel himself further into the heart of mainstream culture. By the mid-1980s, he was working on pop videos that would be shown on MTV and opening his own Pop shop, a fun boutique where his art could be accessible to everyone.

The consensus amongst everybody who was there at the time is that Haring and Basquiat were not graffiti writers. They were down with the scene, but they were doing something distinctly separate. According to Scharf, the artists themselves referred to what they were doing as 'street art' and were constantly trying to clear up the misconception that they were graffiti artists. As far as the graffiti writers themselves where concerned, as Lady Pink points out: 'We loved them, and yes we hung out together, but because Haring was so very white he didn't run the same kind of risks that we did. The same thing with Jean-Michel Basquiat. He tagged up a little bit. But he was definitely one of these snooty artsy people from a different world. He wasn't ghetto.'

The street art of Basquiat and Haring was far closer to that of Jenny Holzer and Dan Witz. Even Basquiat's 'tagging' on the street was more akin to street art or poetry than to the competitive 'all city' thrust of the hard-core taggers: he only made art on the street in the downtown gallery district of New York. In a 1983 video interview with art historian Marc H. Miller, Basquiat states: 'My graffiti was separate from other graffiti. I didn't go to the yards, I didn't hoard cans of spray paint.' Perhaps separating himself from the graffiti scene was a necessity for him at the time, ensuring that his work would be looked at as

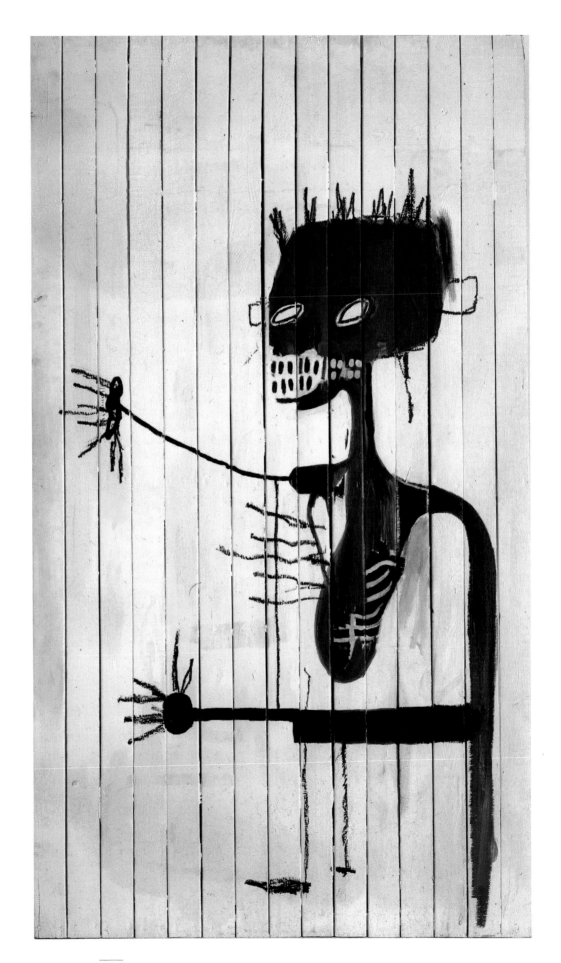

Left: Jean-Michel Basquiat,
Boone, paper collage,
felt-tip pen and coloured
oilsticks on masonite
mounted on panel,
104.1 x 30.5 cm.
Mugrabi collection
Right: Jean-Michel
Basquiat, *Untitled (Lung)*
1986, acrylic on wood,
244 x 140 cm.
Mugrabi collection

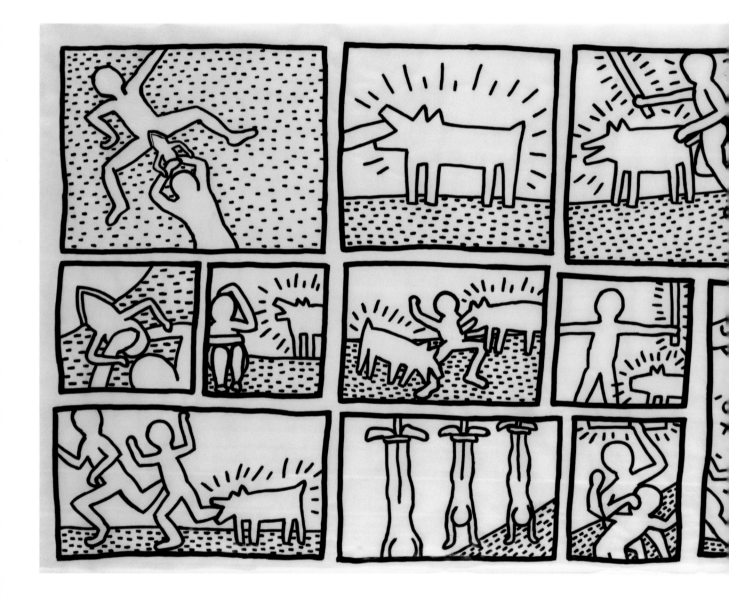

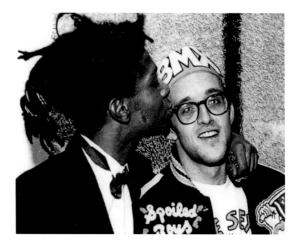

Left: Keith Haring, *Untitled (A Blueprint Drawing)* 1981, Sumi ink on paper, 106 x 206.4 cm. Mugrabi collection
Right: Jean-Michel Basquiat and Keith Haring, New York City, 1987

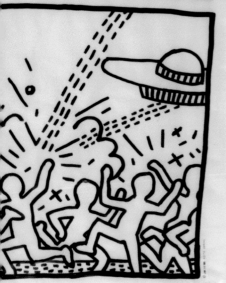

more than simply the daubs of a gifted street kid. As Futura 2000 says, 'Once he became the fine artist that he'd become, I think he rejected graffiti as anything to be taken seriously because he wanted people to be very serious about looking at his paintings. Paintings that went on to sell for a couple of million dollars are apparently very serious.' Malcolm McLaren, who was involved in New York's downtown scene in the early 1980s, also sees Basquiat as someone who connected to pop culture and the rise of hip hop and graffiti but 'removed himself from that. He wanted recognition for something more than being an art terrorist. He wanted to say he had more value. He wasn't just purely painting his name in the headlights. He was creating a language, and he felt he had the right to be treated alongside any contemporary artists of that period.'

Scharf met both Haring and Basquiat at the School of Visual Art in New York, though Basquiat was not enrolled as a student there. He remembers Basquiat as someone who was 'extremely motivated for success and incredibly talented and very reckless'. He continues, 'He had this crazy energy, where he'd walk into a room and knock everything over. His hands were just out of control. When you look at his work all these years later, there's this crazy energy coming off the line. It's so electric.' Scharf also remembers the complexity of his character: 'He could be the sweetest thing in the whole world, so loving, then you'd turn around and he'd just stab you. He was really scary like that.'

Haring was a very different type of person. According to Tony Shafrazi, his approach to making art on the street was almost Zen-like in its specificity and altruistic in its scope. As Shafrazi points out: 'Twenty million people travelling through the subways got to see his work and got to know it, and Keith considered that world to be almost a museum of his own kind. He thought that many of those people didn't have the means or the knowledge to go to museums, so he was bringing the art to them.'

For Haring, exhibiting in the *Times Square Show* had been a turning point; it was here that he first met graffiti writers such as Fab 5 Freddy and Futura 2000. Freedom recounts Haring's first experience with subway drawing after meeting the writers: 'He had a white Pentel marker, like a graffiti writer would, and found the space in the subway. He wanted to draw the "radiant child" on it, but the ink sucked right in and so he ran upstairs and brought some chalk. He came back down and drew his first chalk figure. It was so bold.

He knew automatically what he was going to do.' From that point on, and for the next two years or so, using the skills he had learned from the graffiti writers, he went to almost every train station in the city to repeat this process. In terms of influences outside of graffiti, both Basquiat and Haring were interested in Art Brut practitioners such as Jean Dubuffet and the artists of the COBRA movement, as well as African tribal art. Early on, Haring was also inspired by the more directly political work of artists such as Barbara Kruger and Jenny Holzer.

Basquiat and Haring are both now recognised as art gods of legendary proportions. They lived fast and died young – by 1990, tragically, they were both gone. They left behind unique bodies of work. They also left behind a world that has been changed because of them.

Setting and Anonymity

When people go to contemporary museums and galleries, they expect to see art that shocks them and confronts them with ideas to which they are not accustomed. People don't, however, expect to be confronted by those same experiences when walking down the street. If artists by-pass the sanctioned gallery context when exhibiting their work, but continue to challenge ideas of beauty or culture or politics, it becomes harder for the audience to understand or take their art seriously, since it has been stripped of the contexts that help qualify it.

For over a hundred years, context has been a vital factor in the construction of artworks. The very fact that something was placed in a museum or gallery was enough to give it credibility. This related to the reputations and perceived good judgement of those institutions. This system of qualification is also reflected in the material value of things and what the context says about that material value. People might not like Picasso's work, but they appreciate that it's worth a good deal of money, and therefore understand that it's important as a work of art. If you remove that financial worth and the imposing museum setting, what are you left with? Only the artwork.

Art is a primary mode of expression, an unmitigated aestheticising of how people see themselves in relation to the world and as integral to their immediate space or surroundings. Physically connecting with the street through art or graffiti is a uniquely corporal way to integrate with the city, or with your neighbourhood. The philosopher Jacques Rancière talks about individuals in terms of 'the body of our condition' in the developed world, a statement that evokes hyper-modern society: an excess of information, of capitalism, of money, of time, of indulgence. Street art and graffiti are very basic acts that try to negotiate and make sense of these things. Whether it's appropriating advertising or sticking a funny picture on a lamp post, it's a way of affirming individual status and standing apart from the expected. Everyone negotiates the city in their own way; street art disrupts our negotiation of the city, and its success can be measured by how much it does so. For the artists, it's a form of dissent and self-affirmation, a way of not accepting the lot you've been given. Making art becomes a way *to alter* the body of your condition. It could be argued that these gestures are a political act. It would be deluded to think that viewers might look at works of art on the street and say to themselves 'Let's reclaim the buildings! Let's storm the corporate offices!' Participating in street art may in fact be more of a lifestyle choice than a serious act of political defiance, but what more can we realistically ask of any artwork?

Street artists and graffiti writers gain a certain power through their anonymity. The street artists are able to comment on social issues or even make nonsensical joke-like statements, without any fear of reproach. They are also free of analysis from art critics. Though criticism is to a large degree a dead form, critics still have a certain power in terms of what they choose to write about. Working anonymously, artists are free of the fear that a bad review might upset their future prospects. As the artist Shepard Fairey comments: 'Doing something I didn't have to own up to was very liberating.' Working outside of the

gallery, street artists are more likely to receive feedback from other sources, even from people who do not know they have made the work they are praising or dismissing. When critics write about street artists who work anonymously, they usually have only the work to discuss, since the personal element of the artist's character is removed. This is very different from the celebrity-style portrayal to which many successful artists in the gallery world are subject. Instead, artists who work in the street have a dialogue revolving primarily around presenting the work to the public and the public's reaction to it.

Obey: Shepard Fairey

Obey started out as a propaganda-style street-art campaign, and has developed into a clothing company, graphic-design agency, magazine publisher and all-round alternative empire. The original campaign featured a sinister image of the American wrester Andre the Giant, often juxtaposed with the word 'OBEY'. The project was started in 1988 by art student Shepard Fairey. Drawing inspiration from skateboard graphic design and image-production techniques, Fairey took to pasting his bold iconic images around his hometown of Charleston, South Carolina, and making trips abroad with the express intention of spreading his 'non' message. He also took the innovative step of sending his posters to a network of collaborators around the world, who would paste the images up for him.

The effect was phenomenal, and soon Obey images could be seen in almost every major city on the planet. Fairey remembers, 'It became so unavoidable, that it was seared into your brain.' It was more than repetition that made the project exceptional, however. Added to the mysterious nature of the imagery, with its oblique symbolism, authoritarian colour schemes of red, white and black, the images often confused and even angered the public, who would regularly mistake the work for fascist propaganda. As Fairey comments, 'A lot of really paranoid people hated my images; people fear something they don't understand.'

Inspired by graffiti writing, but working with methods and techniques such as fly-posting and screen-printing, Fairey's project evolved in what was at the time a unique trajectory. The original impetus for the Andre the Giant sticker was a 'Dadaist, nonsensical joke'. Later, when Fairey started to notice people's reactions to the stickers, the power of art in the public space that could compete with advertising became apparent to him. This was how the Orwellian 'OBEY' came about. He explains, 'The project had the connotation of sinister indoctrination, whereas advertising usually has the connotation of, "If you don't buy this product, you're less of a good American", which to me is much more sinister than the artworks I use.' What the artist found most empowering was the new-found ability to affect large-scale audiences with very low budgets. Like many other artists who started out working in this way, Fairey says he hardly considered the project art: 'It was too much fun'.

From previous generations of artists who have worked with similar issues, such as government indoctrination and abuse of power, Fairey's work is particularly in debt to Barbara Kruger, who also has a history of working on the street and challenging the power of advertising. Both Kruger's and Fairey's works highlight, as Fairey puts it, 'how easy

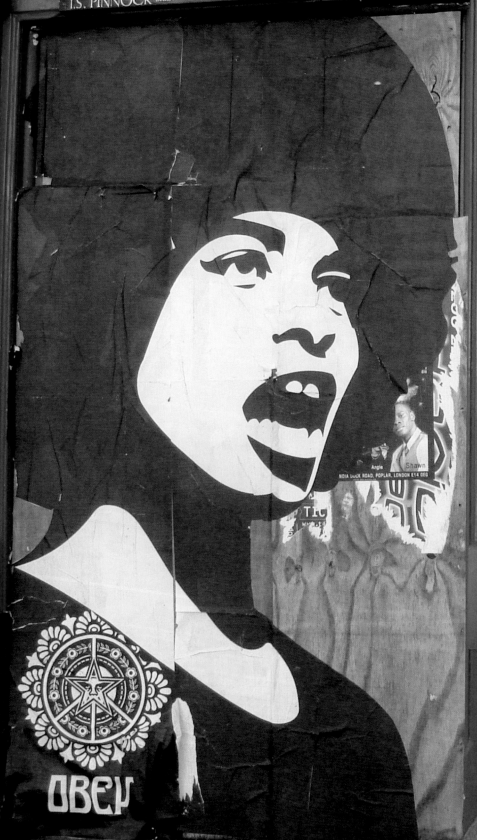

I.S. PINNOCK *licensed to retail beer, wine & spirits for consumption on or off the premises.*

OBEY

symbols are to manipulate'. He cites artists and designers such as the Sternberg Brothers, Alexander Rodchenko, Barry McGee and Robbie Conal as further influences.

What the success of Obey highlights is the often diverse way in which artists coming from street-art backgrounds develop their careers. Having two sides to his practice gives Fairey the freedom to do what he wants on the street and in galleries without having to worry about commercial interests, while he can choose the work he does as a designer on its merit and interest. His work is characterised by the desire to place engaging and challenging images in the public domain that will always make the viewer question what exactly it is they are looking at. As he explains: 'When you're a street artist, you need to make work that grabs people and makes them want to look at it and interpret it because it's going to get under their skin if they try to ignore it.'

Survival in Hyper-Reality

I was about half way between a mad person making pronouncements, a politician, and an artist.
Jenny Holzer

Do graffiti and street art arise from a political motivation? Do they have to be specifically politically motivated in order to be political acts? The answers to these questions depend upon how we look at the subject of politics and art generally. The reading of these activities also depends greatly on the geographic location. Painting an image on a wall in Chile, for example, has very different ramifications from painting a wall in Copenhagen.

Above and beyond any political motives, the main reason why people become interested in graffiti and street art is that they want to be creative. These pastimes are a means of artistic expression for people who don't necessarily have any other outlet. This desire to be creative in itself can therefore be understood as a political act in a broad sense. Many street artists and graffiti writers do have direct political motives and messages behind what they do. All graffiti and street art is a battle over public space: who controls it and what it is used for. There's also something militant or anarchistic in the act of graffiti that seeks to destroy public property. This 'smash the system, smash the state' mentality is in opposition to street artists, who are more often in a dialogue with the city. They use their work to communicate a particular message.

Rancière, elaborating on Aristotle, has said, 'Man is a political animal because he has the power of speech.' If we consider this in terms of graffiti, it could be argued that the general public who never reply to establishment forces are simply passive receptacles. They merely consume the visual language of the public realm – advertising and architecture – without ever answering back. There's no dialogue: it's a monologue delivered by the corporations and governing bodies to the public. When people take it on themselves to speak back, no matter what they say, they become 'political animals'.

At some point it is necessary to make a separation between the act of doing something and what that act actually signifies, above and beyond itself. What artists are expressing in their work can be understood separately from how we understand their actions. The

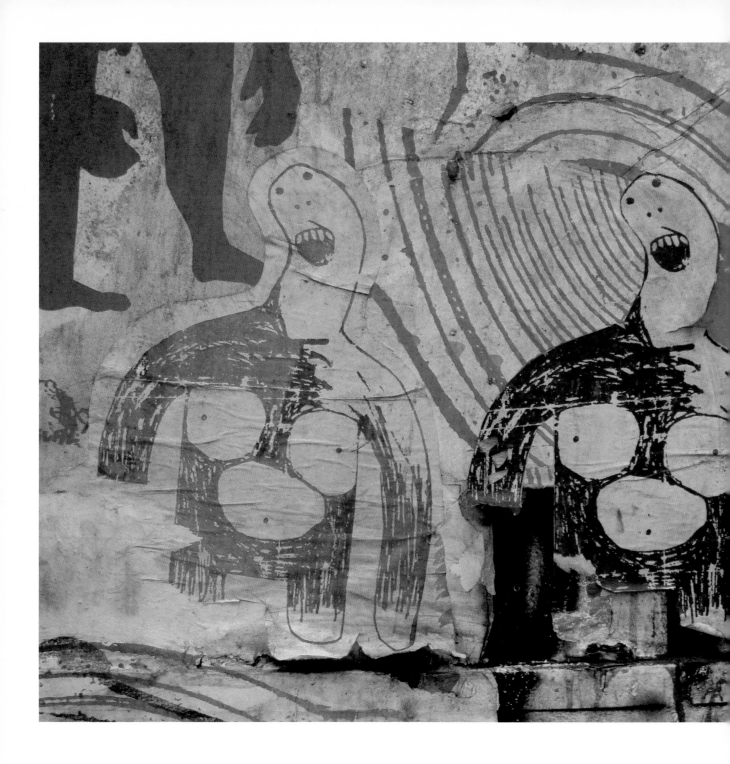

São Paulo,
anonymous

meaning of Jenny Holzer's *Truisms*, for example, shifts according to the various external factors that can influence their reading. The same is true of asserting direct political readings on to street art, where various points of view are expressed, from the banal to very specific social or political concerns and everything in between.

The Medium is the Message, Sometimes

One of the main focuses of fine art that emerged throughout the twentieth century was the importance of materials in relation to the artwork. Minimalist artists such as Carl Andre or Donald Judd, for example, made works that were purely about their own production and materials, resisting narrative readings. Although street artists often use narrative or recognisable images to make their work accessible and populist, their 'material-orientated' approach reflects some of these issues. The materials they choose can become a factor in the meaning of the work. If a street artist is working with fly-posting, for example, the work may become just as much about the process of infiltrating the devices of dissemination as it is about the image on the poster. Artists like Swoon, who cuts images out of paper and pastes them onto walls, or Faile, who see their fly-posting process as a frame for other people's work, are examples of this.

Graffiti, however, is most associated with spray paint as a medium, but very rarely is this medium the subject of the graffiti. For graffiti writing to function as graffiti writing, it has to adhere to certain rules. One or two of the rules can be broken, but if they are completely dismantled, it becomes harder to read images as graffiti. Factors such as style and intention become vital in assessing such images. These stringent codes of conduct for graffiti writers are further confused by the fact that artists such as Futura 2000 and Rammellzee, unquestionable pioneers of the movement, worked early on largely with abstraction. But when graffiti writers do work purely with abstraction, they will have come to the style of imagery through a development of text-based work.

Faile

Faile is an artists' collective with graphic-design roots that has been 'wheat-pasting' walls around the world since 1999. The group's imagery is an ever-expanding catalogue of classic comic-book propaganda and romance-novel-cover schmaltz, all spliced together with fragments of sentimental pop dialogue. They view their work on the streets as a starting point in the development of an image process over which they will ultimately have no control. Much the same as the *décollage* or torn-poster technique of the French Nouveau Realistes, who where active from the 1960s, Faile welcome decay, other people pasting over their imagery, and the ripping and tearing of their work.

Bizarrely, all the members of the group seem to be called Patrick. Patrick number one remembers how they first became involved in working on the streets: 'The urban canvas was really appealing to us because of the way it would effect the image break down.' Their first projects on the street had the title *A Life*, of which their name Faile was an anagram.

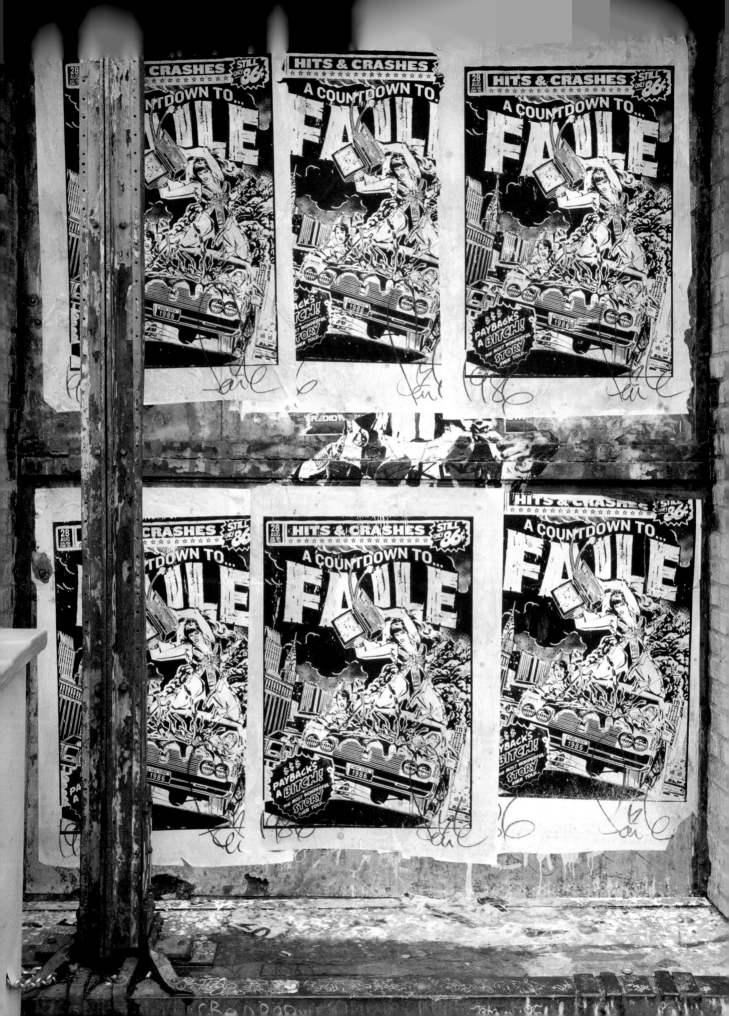

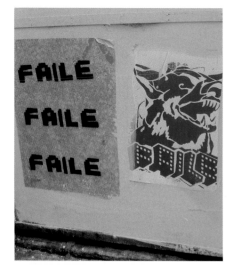

The title was also a nod to the life of the artwork when it is subject to the elements on the street. None of the Faile collective come from traditional graffiti backgrounds. Patrick number two recalls: 'In the beginning we didn't understand what graffiti was. It was pretty background shit; put a naked woman over it and it looks nice. But then you start to understand, this is another art form, and if I go over this dude, he's going to start bombing all over my shit. And if he's with a crew, then his crew's going to wreck my shit. Then you're screwed.'

Faile were inspired early on by a diverse mixture of artists, from Cy Twombly to innovative graffiti writers Cost and Revs from New York, whose approach to tagging involved working on a massive scale with paint rollers. FAILE are still working on the streets, but their work now focuses more on painting in the studio, and gallery exhibitions. Commenting on their general aesthetic, Patrick number two says, 'Our style is about mixing things together. Trying to be emotional and impactful, rather than cerebral right away.' Their image constructions recycle the dreams and nightmares of American pulp-fiction culture, reminding the viewer how sexy and stylish the propaganda was. By illegally inhabiting public space, Faile assume the responsibility of advertisers, but would-be consumers expecting the normal directions to a perfect world are instead confronted with benign love and romance comic-strip-style graphics, where the message is the product and the act of looking is equal to the act of consuming.

Kaws

Kaws started out as a conventional New Jersey graffiti writer, bombing the streets with his friends, and was influenced by skateboarding and studying animation at art school. His taste for vandalism waned, and around 1993 he started to paint on large billboards. Where a standard reaction from a graffiti writer would have been to paint over the adverts, what was interesting about Kaws was the way he worked with the imagery. He left details of the billboard visible, thus creating a hybrid of advertising poisoned by graffiti. The reason for doing this was that he believed the images would date when seen in photo documentation, providing a sense of time and place. The attraction to the billboards was purely based on opportunity: 'You had these spaces, giant billboards on highways that were the most visible locations and I just wanted to take that.'

In 1995, when Barry McGee provided Kaws with a key to open the advertisement spaces in bus shelters and phone booths, a phenomenon was born. Now, Kaws was able to remove the adverts from their frames, take them home, alter them at his leisure and replace them in the original spots, all new and remixed. By only altering small details of the adverts, Kaws kept much of the advertisers' original messaging, along with their fake sexy chic. Calvin Klein models were groped from behind; children in Guise ads had their faces reconstructed to look like aliens; a kid in an advert for milk was given a gimp mask. Kaws was wreaking havoc. While doing all this, issues of genre classification were of little interest to him, and that attitude still holds true today: 'I never like being labelled into any one thing. If I do something on a Wednesday and something on a Friday it could be totally

different.' The bus-shelter project was noteworthy for many reasons: the crossover it effected between advertising and graffiti, the clever use of and access to the space, and the ingenious strategy of stealing the adverts, so that he could alter them at leisure. Kaws was hailed as a hero and cultural saboteur in the ad-busting world. These were labels that Kaws quickly shrugged off, however; he didn't want to be a political spokesperson for the disenfranchised. 'It was never anti-advertising. That was the biggest misconception about what I was doing. It was more in the vein of graffiti, trying to get up and get out there, and the fun of taking these spaces.'

After many visits to Japan, which the artist says had a massive influence on him, Kaws eventually opened a shop in Tokyo selling customised clothing and limited-edition toys. The shop was designed as an installation in collaboration with designer Masamichi Katayama. In this respect, Kaws sees himself as following in the line of artists such as Claes Oldenburg, Tom Wesselman, and other Pop artists who have made multiples. Where editions are seen as something rather lowly in much of the museum and gallery world, Kaws's attitude is typical of those from the graffiti and street-art community who embrace the opportunity to reach broader audiences by making work that larger numbers of people can afford. The advert paintings came to a halt around 2000, and Kaws is now more likely to be offered money by a corporation to doctor an advert for them in an official capacity. The irony of this doesn't escape him: 'You spend half your life getting arrested for something and then people start offering you money to do it. It's weird.'

Advertising

It's interesting the way advertisers use street art and street artists destroy advertising. Eine

Logoism aims for public recognition of a brand and everything that brand stands for simply through an image. For most people, this is second nature; whether we like it or not, certain brands and their ideologies are ingrained into our subconscious. Much street art now also functions in the same way. Street artists, instead of concentrating on a name or tag, concentrate on an image. Invader and Toaster are perfect examples of this, since their logos are symbols, with no text, which the viewer is easily able to understand. This method of communicating is in line with pop culture and mass culture. The images function like advertising, but without a clearly defined product. Tagging functions in the same way to a certain degree, but artists who have dispensed with words altogether have taken the concept a step further. One difference between street artists and corporations working with a logo is that corporations use the same logo for many years, whereas a street artist will regularly change the look, but not the message, of his or her logo. It will be interesting to see how long it takes for those working in the branding industry to realise that what the street artists are doing is a highly effective method of branding.

It's often been said that street artists are better at advertising than many advertisers. Advertising is a parasitic craft: it borrows from any subject it needs to, and if it borrows from a subject that it considers too raw for its purpose, then it sterilises it. Most street artists have an inherent understanding of the issues around intellectual property and

being ripped off by the advertising industry. To quote D∗Face: 'It's par for the course. These things happen. It's like anything that starts to become recognised as some form of movement: advertising and design people jump onto that bandwagon and realise there's scope to play with there, in terms of achieving or reaching a new market or audience.' According to curator Aaron Rose, there are two different schools of thought within the street-art and graffiti communities. There's the 'Screw the man, avoid commercialism at all costs but at the same time get your name up' mentality. Then there's another philosophy, which is 'Get paid'.

This second way of thinking is a reflection of a hip hop culture cliché, where the prevailing attitude would be, 'Get the cars, get the bling.' Considered in this respect, the mentality of the graffiti writer and the mentality of the advertising executive are in some ways similar. They want to get their name or their product in the hottest spot. In this school of thought, designing a Nike shoe is the ultimate achievement. Street art often speaks the vernacular language of advertising, but doesn't seek to dominate space in the same way. A work of street art is far more likely to react to its setting.

Advertising has been using graffiti for many years because of its 'cool' associations. It's possible to see graffiti-style lettering on any manner of products, from chocolate bars to air-fresheners. Over the last few years, street-art-style imagery has become a more evident feature in advertising because the cool associations are virtually the same as graffiti. There are, however, noticeable distinctions between the use of designs inspired by street art and those inspired by graffiti. Broadly speaking, graffiti-inspired designs have been used to convey a feeling of 'the urban', whereas appropriations of street art are more likely to convey a sense of individual rebelliousness within an urban context.

Certain advertisers also use graffiti writers and street artists to fly-post and stencil their adverts on the street for them. This kind of guerrilla marketing is an attempt to appear hip to certain demographics. Now that graffiti and street art are such recognised symbols of rebellion, we might well ask if they will simply become institutionalised shells, detached from their authentic self when appropriated by advertising. But Rancière argues that there is in fact creativity to be had in negotiating our way through the flood of visual images

Cedar In terms of advertising and graffiti, those two specific moments of strangeness in the street, how do you explain the way that graffiti is rejected by the viewer but advertising is accepted?
Jacques Rancière I'd say that's a kind of aesthetic instruction through advertising. We say we're snowed under with images that intimidate us to do this and buy this, but that's not true. It's precisely the multiplicity of images and the multiplicity of spectacle that allows us to create our own focus and to find strangeness. You have only to shift your gears and what was supposed to be an invitation to be a subjective consumer becomes a possibility for framing your own picture. You must think of the relationship between imagery and imagination in both senses.

put in our path.

Because of the proliferation of street-art-style imagery in advertising, it would be easy to assume that all street artists are happily working hand in hand with advertising agencies. The truth is that though many street artists will work with agencies, it's also very common for the agencies to mimic the style of street art without actually working with the artists themselves. When advertisers use the style of street art, it has a very different meaning: it becomes a tool working in the service of another object, instead of a tool working for itself in the way pure artworks function.

In sociological terms, however, the use of this style of art by advertising only helps the art form become more popular, giving it visibility and acceptance with a much wider and broader audience. The hope would be that these parasitic uses of street art by advertisers will encourage audiences to seek out the real thing. After being exposed to examples of watered-down street art through advertising, viewers might, when confronted with the authentic work on the street or in a gallery, be better equipped to view it with a heightened sense of sophistication.

Mustafa Hulusi

Mustafa Hulusi is not directly associated with the street-art scene, though he does make works outside that often test the bounds of legality. These are sited on billboards and use image and text. With a history of working in the billboard industry, Hulusi has an intricate knowledge of the laws of outside advertising as well as access to the people who make and distribute billboard posters. His work *London is a Shit Hole* is a good example of the subversive nature of his practice. It came about as a reaction to a government advertising campaign that followed the '7/7' terrorist attacks in London. The original advert contained the words, 'We are Lond-ONE-rs', but Hulusi found this municipal exercise in public relations sinister. He explains, 'It was trying to say "We're all one big happy family and there are no problems and there's social equality and everyone's got freedom of speech, and tourists, please don't flee", which was their big anxiety.' Previously, Hulusi had been making street posters that were more abstract and as he says, 'cryptic'. For this project, however, he decided to 'cross the line' and make the most 'aggressive, offensive, unacceptable poster' he could think of. It was installed on a billboard in Hackney, East London, and was originally designed as the first in a series of three equally provocative statements. Unfortunately, the reaction was so strong and negative, both from the billboard company and from the owners of the building on which it was placed, that they not only removed the image, but took the whole billboard down as well. Because Hulusi's project mimicked the original adverts so effectively, his images had an official quality that, as he points out, could have led to major financial implications for the companies involved.

Surprisingly, Hulusi sees little relationship between his project and the world of street art and graffiti, or even subvertising, although he does share some interests with the latter: the idea that 'all property is theft, so everything is up for grabs', which he mixes with his

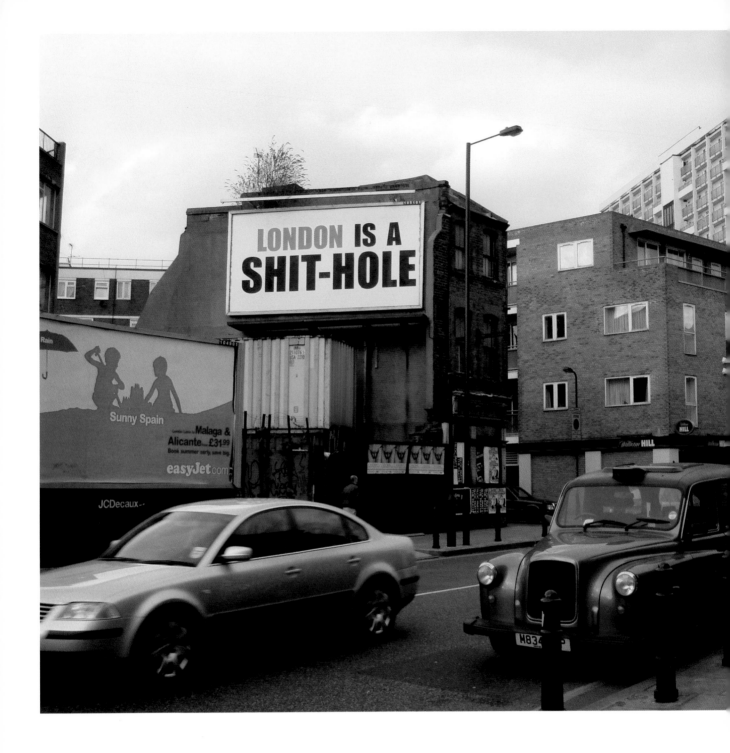

'scale, content and form' formula. In this sense, he is perhaps subverting subversion, making publicly consumable images that offer a world view more sinister than the adverts they parodied, while still leaving room for interpretation. But, as he points out, the difference between his Hackney work and subvertising is that 'subverting adverts normally has a moral overtone to it: "Nike exploits Chinese kids" or whatever. But there's a right-wing nastiness to this piece, which isn't moral or nice. It's saying, "Make it worse. Drop more bombs."' For this reason, he believes his work stays within a pure art context and avoids being a political statement. This response to overtly political or liberally minded art is reflective of a perhaps more sophisticated view that finds fault with those proposing altruism. As the artist says, 'The problem with those types of things is you see them coming a mile away, they're ineffective. They don't serve the purpose, they're not good advertising.' Hulusi has long been engaged with the arguments for and against all forms of political art, and his opinion, that 'ultimately, if you want to change the world, you should become a politician, and not an artist', also reflects a more autonomous view of creativity.

Subvertising

The task ahead for humanity is to détourn the unsustainable consumer culture, the unsustainable paradigms of economics that we have today. Right across the board we have a global system that needs to be détourned in the most fundamental way and many culture jammers, like myself, see it in those terms. We basically want to have a cultural revolution and détourn the whole current system into a new one. Kalle Lasn, Founder of *Adbusters* magazine

Culture jamming or culture hacking is essentially speaking back to the media, back to governments and back to corporations. Any activity that does this – graffiti, street art, flash-mobbing, mobile-phone raves – could fit the term. Many ideas relating to culture jamming stem from the philosophy of the Situationists, and one of the main terms used, '*détournement*', comes from a Situationist text. Examples of cultural *détournement* include the Reclaim The Streets campaign and Buy Nothing Day.

One of the primary forms of culture jamming is 'subvertising', which involves the *détournement* of an advert to turn its meaning back on itself. Subvertising is often grouped together with guerrilla advertising and guerrilla marketing, but major distinctions exist between these various activities, the main one being motivation. Subvertisers, as the name suggests, seek to subvert adverts that are already in existence. Guerrilla marketers, conversely, are advertisers who use the methods of culture jammers to sell or raise awareness about their product. Highlighting political messages, subvertisers are often anonymous individuals working against what they see as intrusive media and multinational corporations who pollute the environment with invasive capitalist propaganda. In their mission to 'de-brand', subvertisers will use any technique or medium at their disposal, from remixing corporate logos to over-pasting words or letters to alter an advert's meaning.

Street artists will often use similar slang and language to graffiti writers, such as

'bombing' and 'getting up', but they also mix this with language borrowed from the world of advertising and the internet, terms such as 'campaign', 'going viral', and 'hacking the city'. This is a reflection of the hybrid nature of the form as well as the diverse sets of sources from which inspiration is drawn. Unlike street artists, subvertisers value the political message over the aesthetic elements of their work.

Subvertising is a form of political messaging that at its purest isn't street art at all, but its own distinct genre. There are often crossovers, however: a street artist, for example, may subvert an advert and turn it into an artwork with a political message in exactly the same way as a subvertiser would. The distinctions between subvertising and graffiti are far clearer. If a graffiti writer puts a text on an advert, the text very rarely has anything to do with the advert itself. When subvertisers write on billboards, their text will be a comment on the advert. More than an art form, subvertising is a type of social activism. But as with everything that relates to counter culture, the lines are often blurred because of the variety and vast quantity of activity taking place. Some acts of subvertising may therefore have truly artistic credentials, but as a general rule, the over-arching motive and understanding of this activity is a political one.

What street artists share with subvertisers is that they have to compete with the visual noise of the external world. Their viewers haven't entered a gallery with the intention of looking at art, so they must capture their audience's attention within an over-stimulating environment, and make an impression that will resonate long after the viewing experience is over. This is much closer to the way in which advertisers work than artists in galleries.

While it's true that any artist placing work in the public realm has to take such issues into consideration, an artist whose work is commissioned or sanctioned and placed outside should also be viewed differently from those who take it upon themselves to communicate in the public realm. Sanctioned public art is the product of a group process, and a clear reflection of art that is shown in galleries. Unsanctioned activities such as street art or subvertising send out the message of an individual who has chosen the location he or she desires without having to seek permission or make any compromises.

The magazine *Adbusters* is at the forefront of ideas and theory relating to culture jamming and subvertising. Founder and editor Kalle Lasn cites 1970s feminist actions in the UK, the BUGA UP movement in Australia and the Billboard Liberation Front from San Francisco as important elements in the development of subvertising. For Lasn, subvertising is a way of 'turning corporate energy back on itself in order to get consumer culture to bite its own tail'.

One of the underlying messages of subvertising is how easy it is to change the meaning of an advert simply by crossing out a few words. Due to the success and simplicity of these grass-roots activities, more and more corporate companies are now copying the methods of street art and subvertising as a means of promoting their products. As might be expected, street artists and subvertisers respond badly to this mimicking of their style and such adverts will often be the first to be defaced.

It would be easy to say that street artists are more aware of these types of issues, whereas graffiti writers have political connotations applied to them by theorists. It would be wrong,

however, to assume that the activity of a person putting up a tag is less politically aware than someone putting up a sticker or a fly-poster. In a way, graffiti writers, by making their activity harder for the public to understand, are more extreme. There's no concession to the audience, so the statement is purer. It could be argued that people who go out and graffiti public transport vehicles are making a stronger statement against society than street artists, who often act in a more decorative fashion.

Banksy

Banksy's work polarises opinion; people really do love it and hate it in equal measure. To his detractors, he is merely a chancer, juxtaposing loaded images in a formulaic way; not clever or original, nothing but a graphic designer and talented self-publicist, he adds to the banality of everyday life. To his fans, he's the cunning voice of dissent, staking the claim of the individual in a media-obsessed capitalist society. Whatever the opinion of the work or the mythology that surrounds it, it has to be said that Banksy is the best-known street artist working today.

Whether making a tiny stencil of a rat or staging a large-scale media stunt, his sense of placement is always highly considered and highly effective. As Shepard Fairey puts it, 'Banksy is the best. He's got the best concepts and executions of anybody.' Where many street artists simply put forward their surreal messages in a 'take it or leave it' fashion, without presenting any discourse with their work, Banksy offers some form of critical opinion time and time again. This is perhaps where the divided opinion on his work becomes most evident. For the people who don't like it, the message is the main problem; they find it simplistic and patronising. The idea of taking well-known imagery such as the Mona Lisa and juxtaposing it with a loaded image like a rocket launcher has been dismissed as a trite formula. Banksy's supporters argue, however, that people who see the work in this way are not the target audience. As Fairey says, 'They already "get" how capitalism and pop culture manipulate the bewildered herd.' In terms of lineage, Banksy's work owes as much to the politically motivated collages of Peter Kennard as it does to the mad-cap antics of Project Mayhem, as portrayed in the film *Fight Club*. In terms of scale and ambition, Banksy's work certainly has an edge.

Banksy comes from a graffiti-writing background, but his work now fits much more into a street-art model. To purist graffiti writers, Banksy typifies the 'art fag' stereotype, but they admire the shrewd business team he has behind him and the fact that rich patrons now collect his work. In a rare interview with Fairey for *Swindle* magazine, Banksy stated that his early interest in graffiti came through seeing the work of 3D (now of Massive Attack fame), on the streets of Bristol where he grew up. The move to working with stencils took place around 2000 because his freehand pieces, which where highly elaborate, were taking too long to complete. Banksy does still work in the street, but in some respects the primary site of the work is now the media.

Much the same as other contemporary artists in the UK, Banksy is viewed with suspicion, but he is given much editorial space. The work is not considered strictly as

Above: Banksy deteriorated sticker, London
Following page: Banksy works, Liverpool

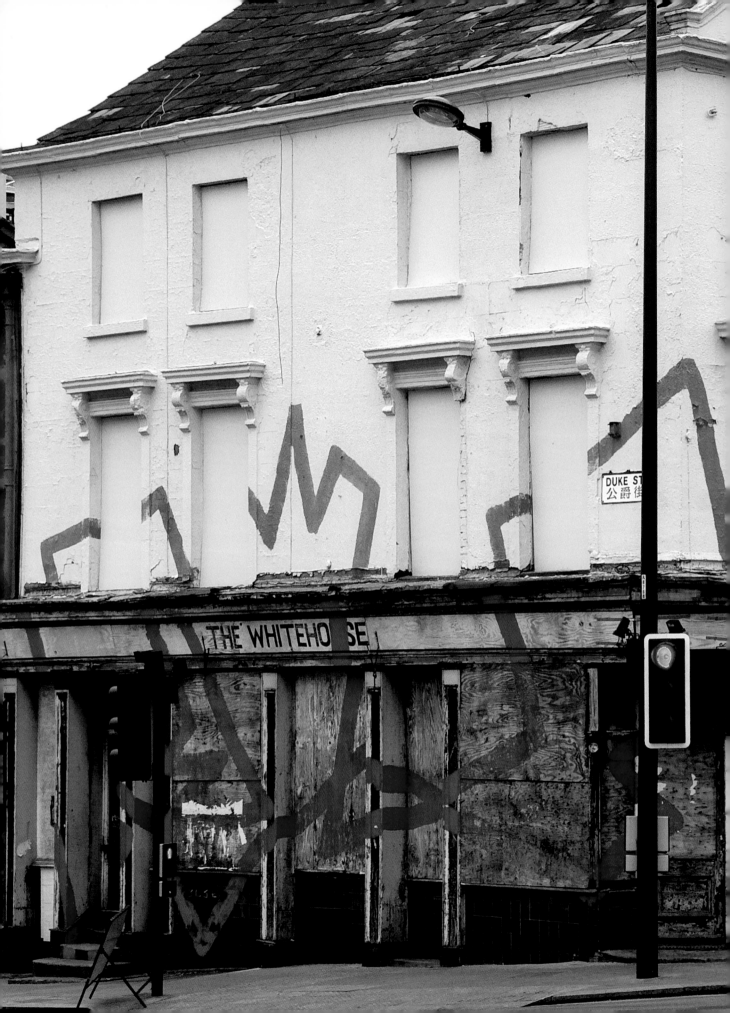

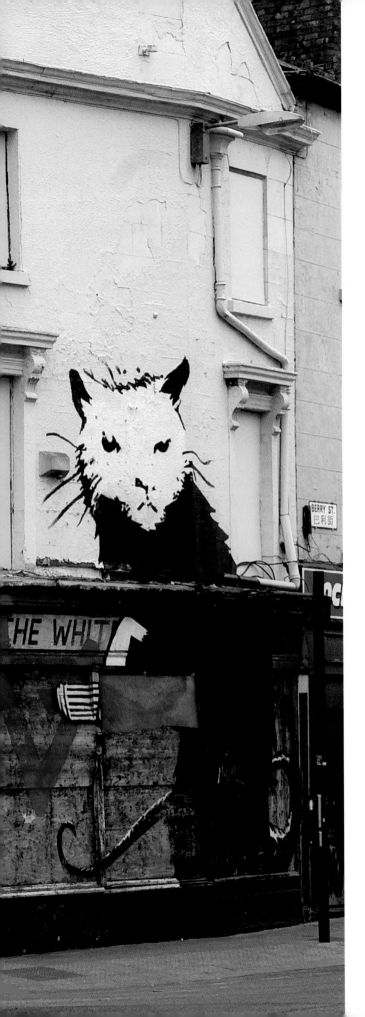

vandalism, and nor is it fully embraced as art. More often than not, it is discussed by journalists in relation to sales prices, the underlying implication being that it's some kind of elaborate rip-off. What is mentioned far less is the fact that a large percentage of the profits Banksy makes are donated to charity. Another often overlooked aspect of Banksy's work is his overtly political curatorial projects. The annual Santa's Ghetto Project, for example, in 2007 involved taking a group of artists to Bethlehem and setting up a temporary exhibition space in a shop. In the true spirit of activism, they also made site-specific work on the Israeli separation wall reflecting the political situation of the location.

In terms of impact and raising public awareness, Banksy's career is unmatched. In terms of longevity and quality, the jury is still out. But, to be fair, as he is the most high-profile artist working in this way, he is also the easiest to attack, and criticisms of him could equally applied to many other street artists. As Malcolm MacLaren puts it, 'I'm of two minds about Banksy's work. I think it's clever but it's a bit of a one-note Samba. It's like he's in a rock and roll band without any instruments and he's got to make a song. He's got a bit of paint, he's got a couple of cardboard boxes, and he makes a song, and he makes hundreds of these songs and it works. He makes me smile, but it's a bit like a Chinese meal: you're always starving half an hour after you've finished it.'

Whether we agree with this sentiment or not, we have to be thankful to Banksy for helping bring these art forms to massive new audiences and for putting a sense of fun back into the scene.

Miss Van

Miss Van's work brings a cute sexuality and seductive femininity to the world of street art. Originally from Toulouse in France, she now works primarily between her hometown and Barcelona. Her art first started to appear on the streets in the early 1990s and has since been shown in many galleries around the world, though she continues to work on the street. In terms of aesthetic heritage, it owes much to the mildly kitsch illustrative painting of Mark Ryden, as well as to the comic-book genius of the artist Vaughn Bodé, who has been inspiring generations of graffiti writers since the 1970s. Other influences include the Japanese Manga artist Junko Mizuno, whom Miss Van recently invited to exhibit with her in Los Angeles.

Miss Van focuses purely on the figure. Her chosen material also makes a departure from graffiti writing: the *poupées* (dolls or cute women), as she calls her characters, are painted in acrylic as opposed to the more macho medium of spray paint. This gives the work a certain pop plasticity, which acts as a strong contrast to the spray-paint graffiti tags with which her images often share a wall. Similar to many other artists currently working on the street, Miss Van's practice is heavily rooted in drawing. Her strong sense of line is clear in the fully coloured works, but most evident in the sketches she draws in the street or on paper.

Miss Van's images have been criticised and lauded in equal measure by viewers with

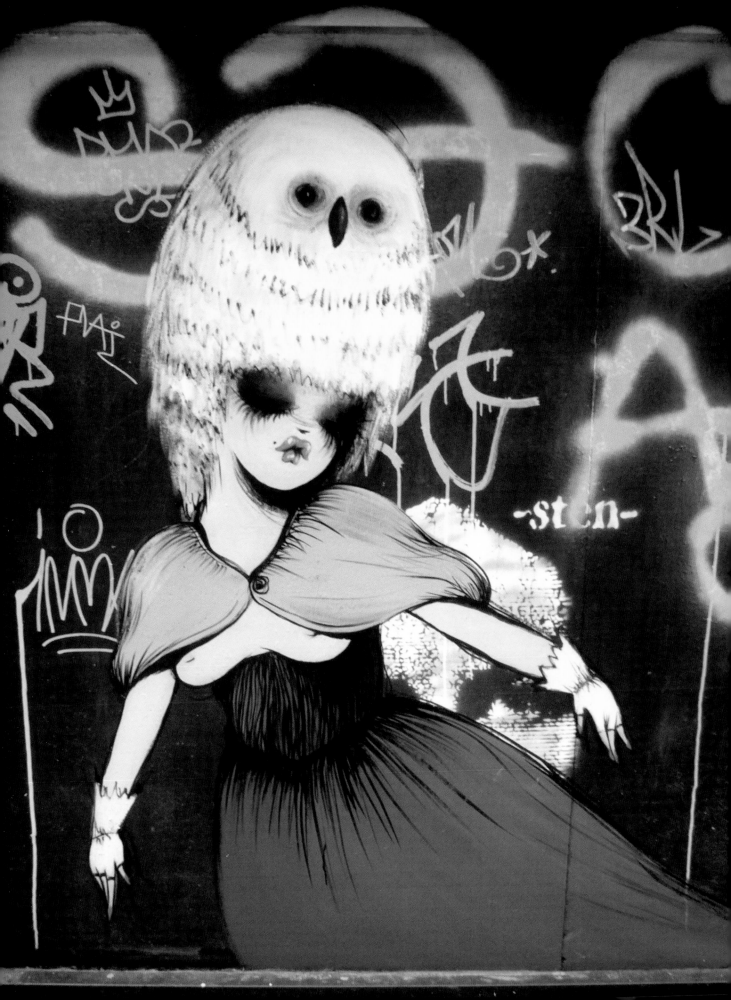

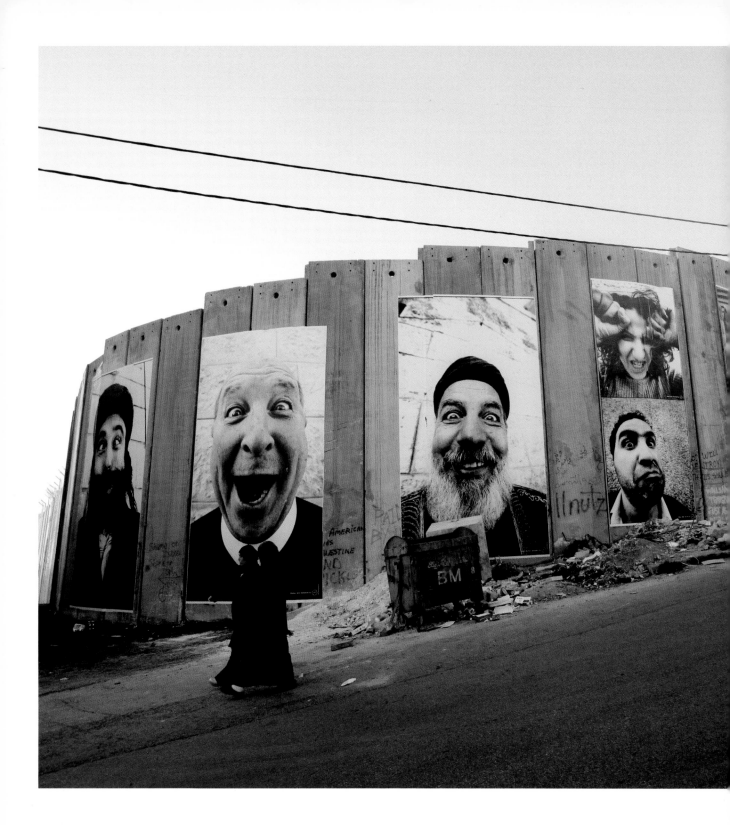

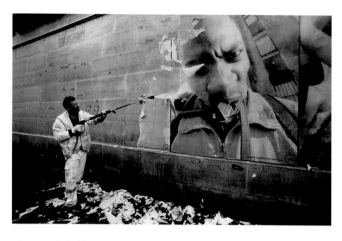

Left: Separation wall,
Bethlehem, March 2007
Right: Espace des
Blancs-Manteaux,
Paris, 4 October 2006

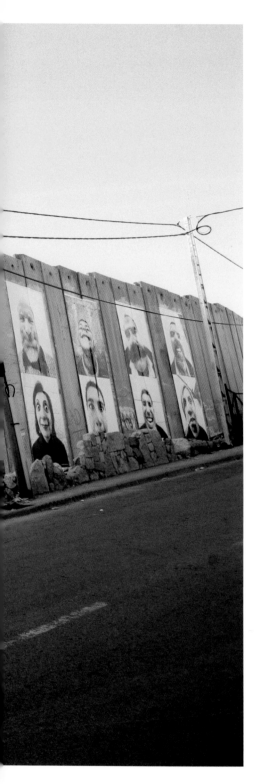

differing opinions about how politically correct it is to paint these often erotic vamps in public places. But she brings a certain complexity of emotion to the female form. The *poupées* are so much more than 'sex kittens': often their eyes betray sadness, melancholy and a sultry stubbornness. Whether made on canvas or on the street, they are expressions of the artist's personal fantasies. This is emphasised by calling all the works *Poupée*, without limiting them to individual titles. In a sense, Miss Van is living out her dreams though her drawings, and surely no one can be criticised for dreaming.

JR

JR's images can now be seen internationally, but he started out on the streets of Paris, using only his initials because of the illegal nature of his work. He is interested in the simple juxtapositions that everyday life produces, while at the same time counteracting the reductive messages propagated by mainstream advertising and media. A major aspect of his practice is taking photographs of people and then pasting these often large-scale works in the streets. Talking about this process he says: 'The street provides me with the support, the wall, the atmosphere, but especially the people. Depending on where I put the photo, the whole thing changes.' For one project, he made portraits of the inhabitants of ghettos in Paris and placed them in the city's centre. The project drew attention to the economic gulf between affluent Parisians and the deprived residents of Clichy-sous-Bois, the scene of riots in recent times.

Another project involved travelling to Israel to make portraits of people on both sides of the religious divide. Images of ordinary Palestinians – such as taxi drivers, cooks, teachers – were pasted above or below images of Israelis with exactly the same job. The project was displayed on both sides of the separation wall. Considering the political situation, the reactions to the work were very positive: 'In Palestine, where the only graffiti in the street is political messages, the first reaction was "Why?"' After people had worked out that this was an art project, the interpretations varied from political to aesthetic readings of the work. For some, because Israelis and Palestinians often look so similar, viewing the work became a 'game', allowing viewers, albeit briefly, to forget the larger problem and concentrate on the more simple issue of who is who.

JR's work in places of conflict has led to a direct experience of locations and situations that has cut through the mediated preconceptions generated by the media: 'Before I went to Israel and Palestine, I had this big cliché of the war, based on what I saw on TV: the fear, the bombs and everything. But after looking with my own eyes, I saw that the majority of people just want peace. As always in any conflict, the media focus on the minority that makes more noise.' His projects are a good example of how street artists working in locations of extreme conflict often expose media stereotypes while at the same time using the media attention the work provokes to spread their alternative message.

Museums + Outlaws

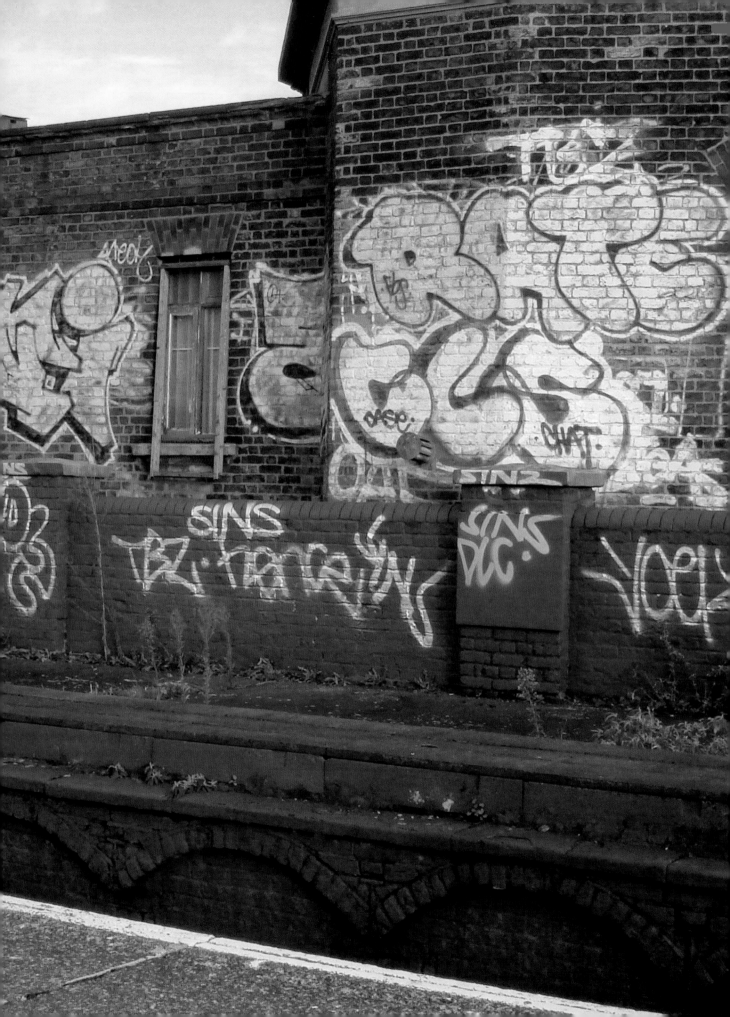

Illegal v. Legal

The best street art and graffiti are illegal. This is because the illegal works have political and ethical connotations that are lost in sanctioned works. There is a tangible conceptual aura that is stronger in illegal graffiti: the sense of danger the artist felt is transferred to the viewer. A work of graffiti or street art in a gallery or museum can feel safe, or as if its wings have been clipped. That's not to say that these works should never be shown in museums; it's just that when they are, we have to realise, as Blek le Rat says, that we're 'looking at the shadow of the real thing'.

The length of time that is spent by the viewer with graffiti or street art also greatly affects its reading. In the street, the work appears from nowhere, is viewed quickly, and then is gone again. This way of experiencing art goes against the slow, studied, contemplative viewing experience with which we have been conditioned by galleries and museums. The museum viewing experience is geared toward a fetishisation of the object in order to gain some deeper understanding. Museums are set up as temples to history; architecturally their structure is designed to intimidate the audience with notions of wealth and culture, and to create a hierarchical value system for the works they display. This has always been a function of museums, where culture and wealth go hand in hand with a slow appreciation of objects and concepts.

Since museums are often funded by the government, we have to consider them as voices of the state. More than ever before, they can be seen as part of the political apparatus – as tools of regeneration, educational vehicles and arbiters of taste. Art on the street is the exact opposite of this, and offers a far more direct viewing experience, but is no less valid. It could in fact be argued that looking at art in the street, with its speed and real-life context, is a more accurate reflection of the world in terms of the way we process information today.

A significant distinction between street art and graffiti is the way in which it is viewed in the eyes of the law. D∗Face gives an example of dealing with the police in London: 'If you're carrying a can of spray paint and you're painting a wall, then you're not going to have any leniency at all with the police. Whereas, I've been stopped many a time from putting posters up, but they've been like, "Don't do any more of this, throw away what you've got, go home", and you're like, "Yeah sure", and you carry on. Generally, with posters and stickers and things like that, they're more lenient.' This illustrates a bizarre situation where the police are acting not only as judge and jury but also as art critic and curator. They are in effect choosing what is art and what is vandalism.

The way in which the law reacts to graffiti and street art in different countries around the world is also telling. While various initiatives have been enforced to deal with graffiti, they tend to shift the activity to a new location rather than stopping it. They also, it would appear, intensify the graffiti writers' resolve. While it's true that the New York Subway Authority did by 1989 succeed in cleaning the trains of painted graffiti, they also helped propel the movement above ground and thus around the world. Though it's rare to see a full-colour piece adorning the outside of a train in the UK, scratchiti, which most people, even many graffiti writers, agree is a far bigger eyesore than graffiti done with marker pens,

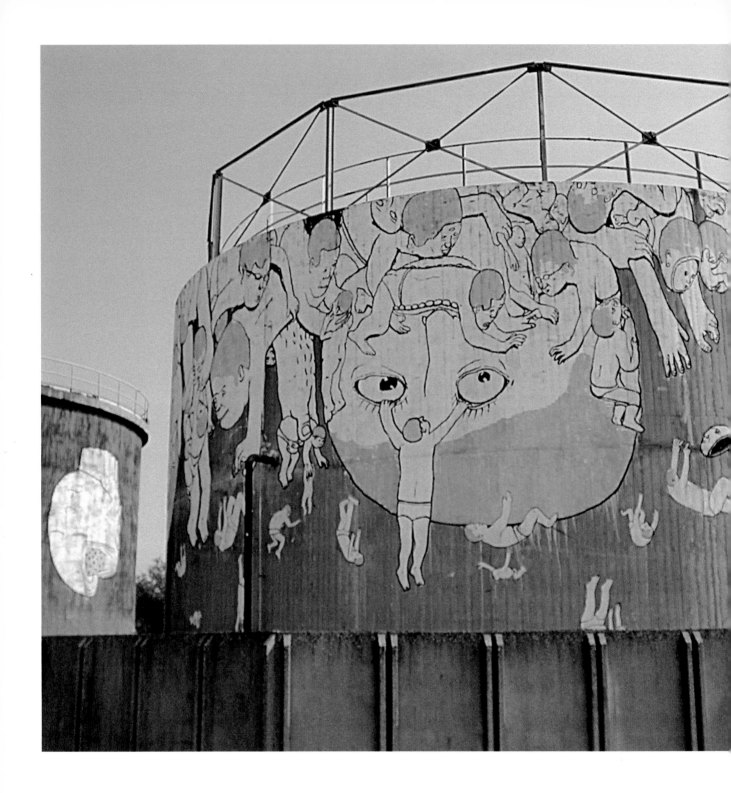

is at an all-time high. It simply seems that as soon as one strand of graffiti is dealt with, another, stronger, more hardcore strand is invented. As Mode 2 says, 'It's an ongoing arms race or sword versus shield thing and now the result is scratchiti.'

Blu

Drawing plays an integral role in the work of Blu. Based in Bologna, Italy, he makes work that consists of very large-scale images of monsters and figures, often involved in scenes of barbarity. These have the look of cartoon creatures, or characters from Greek mythology. Though Blu's work developed out of graffiti writing into a more strictly figurative imagery, he still sees his attitude as being forged by his 'old school' roots. He works with a very limited palette, which has the effect of highlighting his fascination with line and form. As he says, 'I use paint just to fill in the drawing; there are not many elements of painting in my work.' His interest in drawing is influenced by figures such as Robert Crumb, the 'dark, violent, satirical art' of French illustrator Roland Topor, and Italian independent comics such as *Il Male*, *Frigidaire* and *Cannibale*. But he is also inspired by the fresco tradition of his native Italy, and though it is quite removed from his practice, by the work of Matta-Clark. The link is, as Blu puts it, 'the way Matta-Clark used the building as a sculpture; it's something I try to imitate when I paint.'

Blu sees buildings as 'sheets of paper' to sketch on. Due to their massive scale, his works often give the impression that the buildings they're painted on aren't quite big enough. This remarkable attitude to scale is representative of his interest in public art generally.

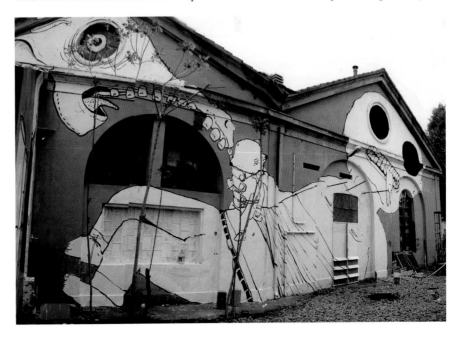

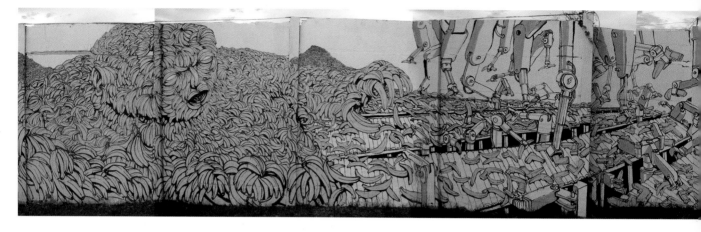

Blu and Ericailcane,
Managua, Nicaragua
(detail)

What is unique about his work is his ability to doodle in a seemingly casual way on an epic scale. In terms of production, the work happens in two stages: first, he draws images in his sketch book, but surprisingly, when he comes to working on the walls, he often improvises something completely new. Referring to this high-risk way of working, Blu says, 'The fact that I always draw during the day shows that I have a lot of confidence and always a bag of ideas.' Working directly from his imagination on such a large scale is an impressive ability to have mastered. It was the practical requirements of working at this size that took his work away from spray-can-based graffiti.

Blu's happy obsession with death and exposing the internal workings of the body share much with the Day of the Dead tradition in the art of South America. A recent project took the artist on a two-month tour of many countries in this region. The trip was also a chance for Blu to make work in the places he visited, as well as an opportunity to research the many aspects of public painting that are still active in central and South America. Art on the street, graffiti and hand-made advertising are all very vibrant activities in this area of the world. As Blu explains, it's very often cheaper to pay a painter to make a billboard than it would be to pay for the printing.

Outsiders

Many of the ideas of what modern art should be were formulated in the late nineteenth century by a small group of critics and historians. They narrowed down the field of what could be considered art and excluded populist tendencies. By the turn of the twentieth century, as the number of artists greatly increased, so did their interest in what was considered lowly by the establishment. The philosophy and values that were now intrinsic to modern art would not bend to these populist or kitsch concerns. As the gallerist Tony Shafrazi points out, they were seen as 'unruly and wild and unclean and dirty, subversive and valueless'.

This battle between the world of good taste and 'the new' still rages on today. Art continues to be governed by a cultural elite that finds it hard to accept or understand cultural movements from outside art's well-trodden lineage. To quote Shafrazi: 'That's the nature of any old industry – they're carrying so much history on their backs that they're stagnantly evolving in that time frame. It takes some time for them to catch up, unfortunately, and they do so very reluctantly. It's the nature of the beast so to speak. It's not that they're bad people.'

Artworks from the nineteenth century that were once considered wild and scandalous are now seen as the height of good taste, and what was subversive or shocking has become generally accepted. Still, in this supposed attitude of anything-goes multiplicity, the mainstream system of the fine-art world tends to relegate street art and graffiti to the field of 'outsider art'. In the eyes of the art world, both street art and graffiti are akin to folk art or 'popular' art. Classifying them in this way, even subconsciously, has made it far easier for mainstream arts organisations to dismiss or ignore them.

Currently, museums have very few examples of graffiti or street art in their collections.

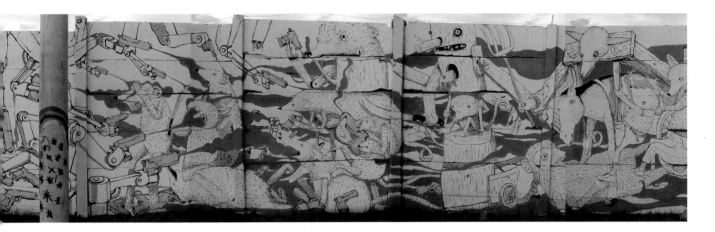

When they do make some small concessions to these art forms, their choices tend to be rather lame, 'graffiti-lite', filtered versions of the original. This is unrepresentative of the effect that these artists have had on culture as a whole and visual culture particularly: many of the paintings and sculptures in contemporary art museums have the look of graffiti and street art – the influence is everywhere – but it's still very rare to see quality examples of the real thing in these institutions.

Museums may be failing to recognise street art and graffiti because it's hard to exhibit ephemeral art. But they also have a responsibility to keep a record of what's happening in the world, beyond the slim mainstream view of art. The work will be different from what was on the street, but if museums don't preserve and record these works, they will simply disappear. Museums, like all organisations, are governed by self-interest and market democracy, so it's inevitable that as the market takes a new interest in the work of artists practising in the street, the museums will eventually follow suit.

One factor that is crucial in this is that street art is taken seriously by the worlds of advertising and fashion, which have an economic and cultural dominance over the museum-led fine art world. Ferry, for example, currently exhibits in small galleries, but is little shown in major museums or blue-chip galleries. He does, however, undertake commissions for major corporations and even Hollywood movies. When he takes these commissions, he does so as an individual artist working to very open creative briefs. The companies pay him to 'do whatever he wants' and they put their name to it. Working in this way is very different from a standard graphic design-process and closer to an art commission.

The degree to which street artists want to be taken seriously by the art world varies from artist to artist. At one level, it is still seen as the pinnacle: they are artists and want their work to be shown in places where art is seen. Others simply see it as a way of making money that can fund their work on the street.

Rebellion is a healthy thing. It keeps our civilisation from becoming stagnant. It keeps the art world from becoming stagnant. It questions the status quo and it keeps it on its toes. Why should art be sanctioned by permission, inside a neat little gallery or museum or something? Why can't art just be the expression of humans wherever the hell they please? Lady Pink

Street art and graffiti have an energy and power that will always be relevant in terms of representing the outside, non-edited view. There's a unique freedom in the simple act of placing your art exactly where you want it. The fact that these forms of creativity primarily exist without financial motive adds a further sense of freedom that we don't see in mainstream fine art. The majority of fine artists associated with galleries and museums have to think about their careers when they make exhibitions. They are invited by the institution and there is an editing process. It's rare that they can act spontaneously. Street artists are for the most part outside of that system. Their art comes direct from the maker to the viewer; there's no curator in between, dictating what is good and what isn't. There will always be relevance in that rawness.

PARK STREET SE1
LONDON BOROUGH OF SOUTHWARK

6° Arr!
RUE
JACOB

BEAR
GARDENS SE1
LONDON BOROUGH OF SOUTHWARK

The museum-led art world is inextricably connected to business, art school being the first step on the ladder of how to fit into 'the market'. If the people in charge of these institutions think about money before creativity, this can lead to very conservative forms of art, and has created a capitalist form of Darwinist hierarchy. Street art provides something refreshing outside of that, since its practitioners don't rely on commerce or publicity for their existence. If they achieve commercial recognition, very well, but they don't consider it essential.

Invader

By marrying a technique that naturally belongs in the street – mosaic – with a process that is thought provoking and subtle, Invader's work captures the pure essence of street art. The artist's primary activity involves making small mosaics out of tiles that depict the pixellated images of computer games, which are affixed with cement to walls all around the world. In this sense, his work is pure street art, having evolved away from text-based graffiti writing. Aside from mosaics, Rubik's Cubes are a recurring visual inspiration. The Rubik's Cube, like the Space Invader computer game, is familiar to everyone who grew up in the 1980s; it also has a visual resemblance to mosaics. The artist explains his interest: 'I was playing Space Invaders on an Atari when I was twelve years old; it's a part of my story and culture.' On his website and printed pamphlets, Invader grades his work in terms of the difficulty of the location he is 'invading', and that location affects the aesthetic of his art: 'Once I invaded Avignon, a historical city in the south of France. I felt it was very dangerous and work wouldn't stay there if it looked too obvious, so I made a camouflage work. I made Space Invaders the same colour as the walls.'

Invader studied art in Paris and had little knowledge of graffiti writing when he started placing art on the streets. After working in the urban setting for some time, he became more aware of the graffiti and was impressed by its energy, particularly in comparison to the world of fine art, which he found dry and elitist. The graffiti writers' complete commitment to their pastime also affected his outlook. The similarities of the two lifestyles are many, as he explains: 'You work at night, you're afraid of being caught by the cops, you become very paranoid'.

Invader's practice is typical of the way in which street artists are constantly finding new materials and ways of adapting them to their purposes. Though the work tends to have a cute, computer-like aesthetic, which may appear totally apolitical, it is in fact the contrast of the nostalgic, utopian imagery he places on the street and the often grim reality of the context that provides the work with a sense of political poignancy. The idea of turning the entire world into a hyper-reality game board also adds an element of existential simulacra to the locations where the work is placed.

Like many street artists, Invader is a modern-day *flâneur*, wandering through the city streets of the world, scouting for interesting locations in which to place his work. To this end, an important aspect of the *Invader* project are the maps produced by the artist. These form a document of 'the invasion' and allow viewers to retrace the artist's steps. This was

inspired by the city maps that he uses as a primary tool when he arrives in a new city. He explains, 'I always have a map with me when I invade a city, and I ask everybody I meet to show me the interesting areas. I mark it on the map and try to go everywhere. I don't want to be just in the centre.' The works are all indicated on the map with the abbreviation of the city, and numbered in order of their placement; this information also provides the work's title. To give an idea of how prolific the project has been, the last work placed in Paris was PA700.

Sanctioning Bodies

Museums have always been reluctant to acknowledge the very best of recent work. They tend to respond to things that are slightly tamer, slightly milder, slightly more educated looking, more academic looking. With something that looks a little wilder, like a wild animal, they have to wait until it had been killed off and then decapitated, and later the head will be cleaned and stuffed and put up on the mantelpiece. Tony Shafrazi

The relationship between sanctioning bodies and graffiti is more complex than it seems. How do you define a sanctioning system? Is it the gallery, the collector, the arts-funding body, or the shop owner who lets people paint on their shutters? If an artist receives funding, or exhibits in a gallery, how does this affect the work?

There are many graffiti writers who have made a successful transition from painting trains to painting canvases; there have also been numerous failed attempts. Many graffiti writers, especially from recent generations, will admit that when graffiti writing started to cross over into swanky art galleries for the first time in the early 1980s, their work couldn't compete with the setting in which it was placed, and suffered through removal from its context. Some of the spark, dynamism and aggression were lost. Because the work was now on canvas, the viewer started to judge it with the same criteria with which they would judge any other painting, but in reality it had a completely different history.

Graffiti writing's early 'failure' to cross over fully to galleries also reflects an art world that wasn't ready for it. Today, Barry McGee can take a tagged-up box from the street, put it in an art gallery and it's accepted; in the 1980s, it was much harder to be so raw. There were preconceptions of what art could be. The first generation of artists who made this transition into galleries twenty or thirty years ago has helped make a path for subsequent generations.

Political art, much like graffiti writing and street art, when placed in a gallery can become neutralised, while non-political gestures will often gain a political dimension in a museum context. The circumstances in which street art and graffiti writing are seen are major factors in their meaning. In the same way that a frame can alter the meaning of a painting, the wall on which it hangs also adds to the meaning. An artwork in the Louvre or MoMA, for example, will be looked at very differently from the same artwork in a provincial museum. In the street, the space and issues of topography are very important: the integration of the work and building or setting, the history of the location, etc. When

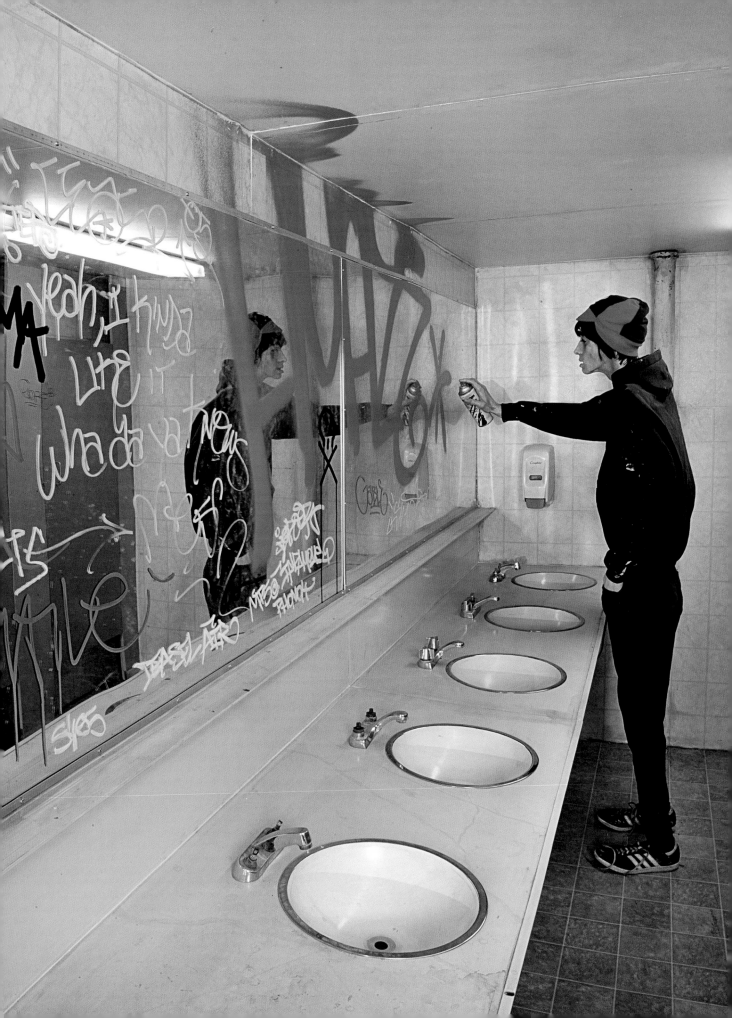

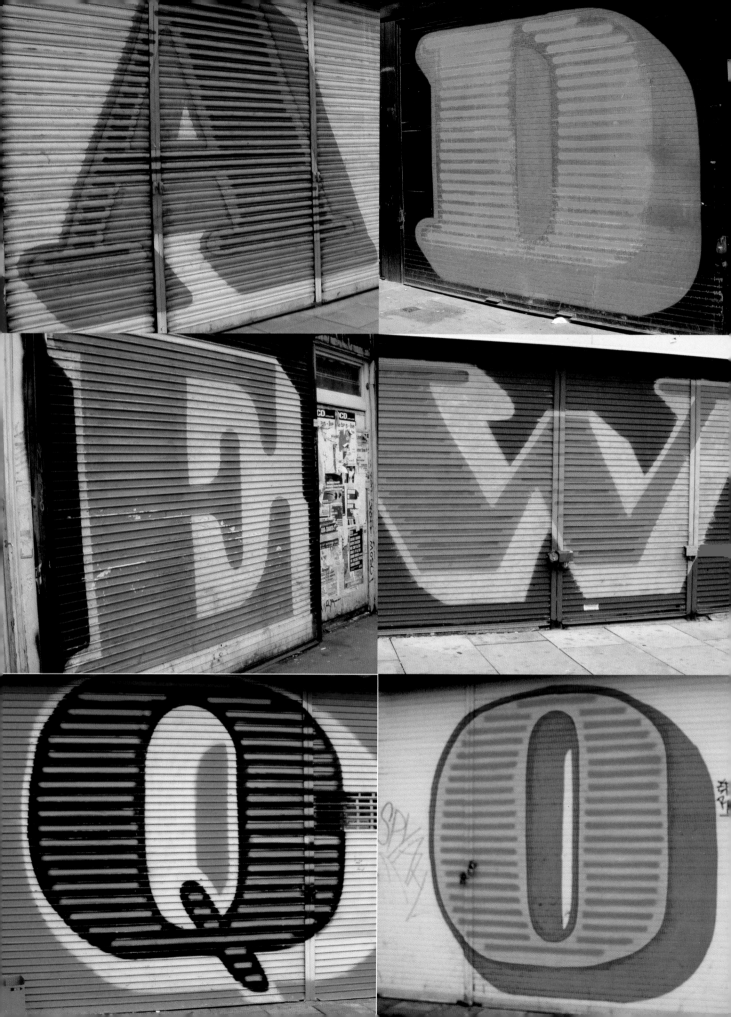

art is placed in the street without the input of a sanctioning body, everything around the image becomes important: the social context and the political context. If you take the same work and put it in a museum, all this extra meaning is lost. For street art and graffiti, the wall and the frame are initially the exterior landscape. Street art, however, is defined by a different set of concepts. It's not necessarily product orientated; it's not so much about the finished piece. Street art is often more about the concept of the object, the making process, and the message that the object conveys.

Eine

Eine is a stalwart of the London graffiti and street-art scenes and a bridge between the two worlds. His experimental approach and left-field attitude has been important in shaping much of the unofficial art that is seen on London's streets. He has been vandalising trains and walls around London since the early 1990s; heavily into tagging for many years, he chose spray paint as his preferred medium of destruction. But even when his activities fell under the rubric of 'graffiti writer', there was something perverse about his style and methodology. He was pushing the boundaries of the genre, but in the wrong direction: against skill, artistry or technical ability. Eine wanted his omnipresent markings to be dumb and messy. As with all graffiti writers, his work is concerned with style, but his is a 'stupid style' or 'happy graff' as he calls it.

After years of defacing London streets with his warped scribbles and graffiti-esque iconography, it was an easy transition for Eine to move from spray cans and marker pens to screen-printed stickers. Sticker bombing is a quick and easy way of putting tags and images into the public realm, and soon every available surface in East London was covered with his garish pink and black stickers. Gone was the whacky styling and in was the Helvetica font. Why spend your time inventing lettering styles when there are hundreds of thousands of perfectly good ones already available? As Eine put the individual and hand-made elements of graffiti writing on the back burner and embraced the ready-made fonts available to anyone, removing the secret code of unreadability from his output, the alphabet itself became an area of research and production. He had entered the world of pure fonts, a parallel universe to that of graffiti writing; different, but with similar values.

Eine's practice has developed, and as well as mounting gallery exhibitions, he was for a time associated with the print-edition website picturesonwalls.com, as well as various other one-off oddities that he leaves around London's streets. His current project involves painting individual letters of the alphabet on shop shutters. He works with one font at a time until the alphabet is complete. According to Eine, graffiti is a young person's game and you can only take jumping over fences and being chased by the police for so long. With his current work, he's more likely to be arrested for dropping litter than criminal damage: 'I've been stopped three times by the police and all three times it's because I've dropped the back of the sticker on the floor!'

The Market

The rise of street art and graffiti has been greatly influenced by the market. The museums may not be investing in the work, but the corporations are; in this sense, street art and graffiti have always had a relationship, if distant, to the mainstream art market. The entry of graffiti writing into the gallery system in New York and Europe in the early 1980s was an important factor both in terms of the spread of the movement and of its status as an art form, producing winners and losers, both in the short and long term. Artists such as Basquiat and Haring are still highly sought-after and their works are constantly breaking records at auction, while many of the graffiti writers associated with this period have faded, in terms of art markets, into relative obscurity.

The New York gallerist Jeffrey Deitch has a long history of selling artworks by graffiti writers and street artists. He sees these markets as being separate from those for more traditional or blue-chip artworks: 'For graffiti and street art in general there's very little connection with the mainstream art market. Yes, there's a market created by the people who collect it, but very few mainstream art collectors buy it.'

A market for artworks is something that is difficult to avoid, no matter what the genre, and is largely a good thing, since artists deserve to make a living from their work. The problems come with speculative buyers looking to make quick profits, who have little interest in the actual work. This sometimes causes unsustainable, inflated markets for artists' works, which are more likely to crash in comparison to markets that are built steadily over time. Artists who use working on the street as a springboard into the commercial sector, then completely leave the street scene behind, can harm the reputations of other artists: it can lead to a false perception that all street artists are looking for commercial acceptance.

Another problem that comes with the increased value of street artworks is people removing them from the street in order either to put them in their homes or to sell them. This is a very regular occurrence and is unsurprisingly frowned upon by most artists. They put their work in the public realm in a spirit of generosity and to share creativity, so for individuals to come along and profit from this generosity goes against everything these artworks stand for. As Deitch puts it: 'An artist really believes in his work and is dismayed by the people who steal pieces off the street. Someone stole an entire billboard by Barry McGee and then it ended up sold at auction, and when an artist has been doing this work for ten years or more, they take that seriously.'

Judith Sulpine

Though now based in New York, Judith Sulpine studied art in London and Amsterdam. After a brief flirtation with tagging-based graffiti, Sulpine quickly developed a purely figurative way of working. It was the 'lack of opportunity' in the gallery world that pushed the artist to continue showing work in this way. The images are made from recycled pictures, which are culled from magazines and old books that Sulpine finds in bins or as

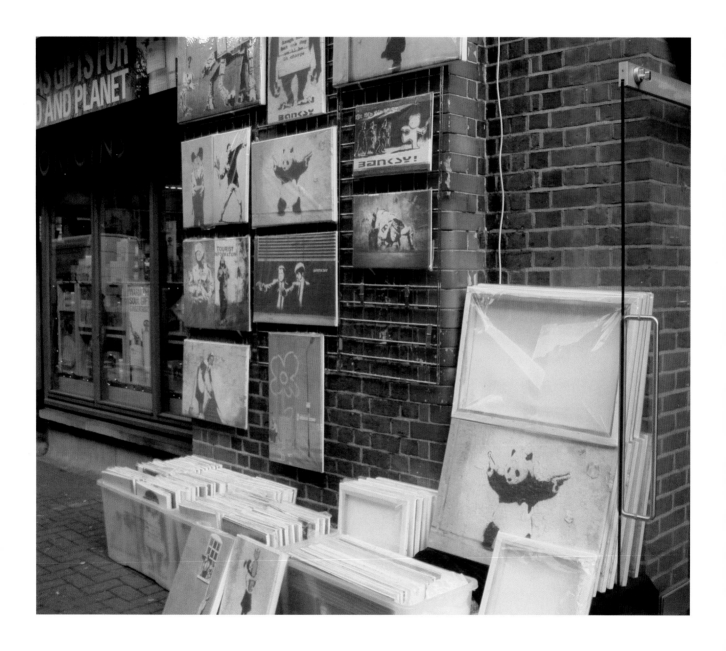

'Street art'
canvases being
sold in Covent
Garden, London

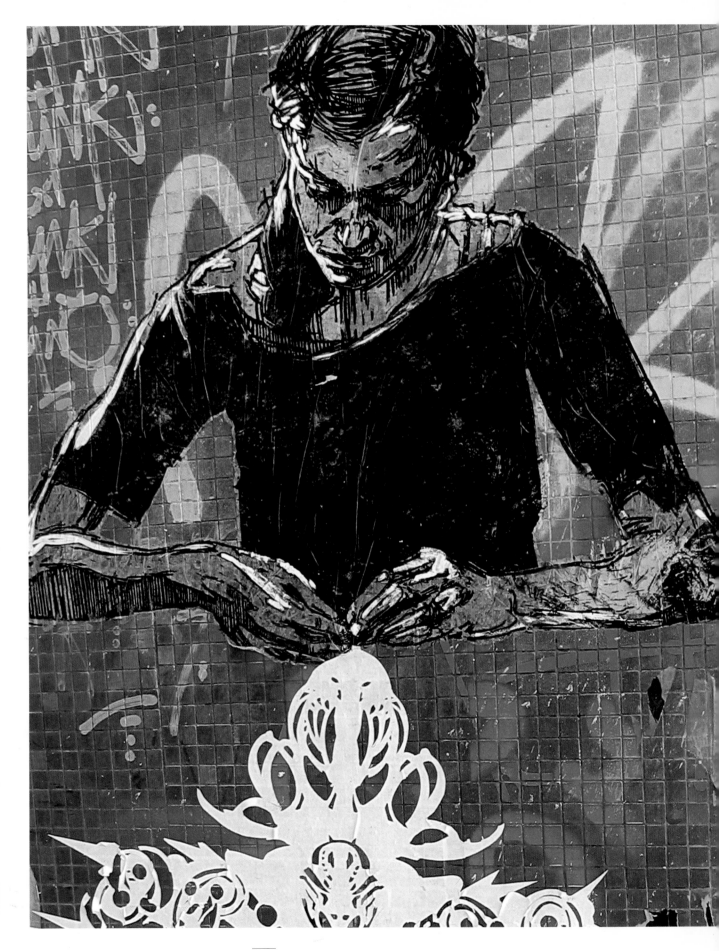

Swoon

Cedar How do you feel about the market in relation to your work?

Swoon I just regard it as something that allows me to live and work as an artist. There are aspects of the market that I avoided for years, like support from corporations such as Nike and that aspect of commercialism. But then I slowly started to be approached by certain galleries, like Deitch Projects in New York, that have a lot more of an open attitude, where they just offer you the opportunity to make something. Then they're selling your work, so you're commercially involved and you're part of the market, but it's a little bit of a different relationship. For me, it's been a good one.

Cedar Do you find there are any negative aspects to selling your work?

Swoon Well yeah. In London I noticed that people are pulling my posters off the walls much faster, with an eye toward selling them. When I first started, people were either pulling them off because they didn't want them on their wall or because they wanted them, but they weren't looking at them as objects of value. I do feel that letting my work become involved in currency in that way does have a bit of a corrupting effect on the idea of creating something free and public.

Cedar Can you tell me a little more about the effect on you of people stealing works from the street?

Swoon Well, when you put your work outside, it's public in a way, so the word 'stolen' doesn't even fit. For me, when I paste something to the wall, I'm sort of hoping that that object will ultimately be destroyed. I want it to be outside and part of the city landscape and to rot away, so that it's never going to stick around and be a permanent thing. The sort of change that happens when people start to view it as an object of value, then take it into their personal possession, was never what was intended for that specific installation.

Cedar What do you think separates artists working today from artists working in this area in the 1980s, in terms of their relationship to the market?

Swoon I think the people coming out in the 1980s were a lot more innocent. My generation had an awareness of that history, whereas the people in the 80s were coming at it just as kids and something they wanted to do. I knew that I was coming from a different place from almost all of the graffiti lineage; I just thought of myself as a painter who happened to want to be outside. But I guess certain paths were already laid by the time I was looking to make work in the city, whereas for Pink and Lee and all those guys, that was something totally new.

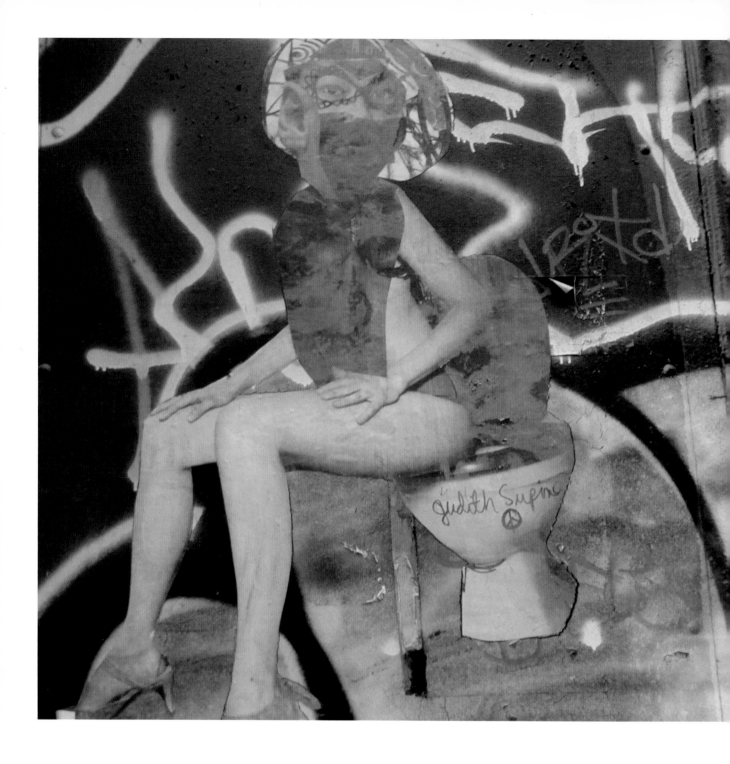

Judith Sulpine

pieces of litter. After the mock-ups are made, the artist often risks arrest in order to finish the production process and save money: 'I go to Kenko's to make the photocopies and print maybe a thousand dollars worth at a time, huge photo-copies, then I run out of the door with them.' A true criminal, Sulpine makes images that are often as perverse and filthy as their production methods: brutal, Frankenstein creations that twist sexuality with the dirt of the world. Mixing elements of the abject with the sentimental, the salacious with the repugnant, ill-fitting body parts are spliced together to give an overall sense of freakish abnormality. The rough, distinctive style conjures up references to collagists such as Kurt Schwitters, George Grosz and particularly the photomontages of Raoul Hausmann and Hannah Höch. Leonard Baskin and Hieronymus Bosch are also influences.

After the works have been enlarged as photocopies, they are coloured using children's watercolours. Once fly-posted in the streets, with the paste with which they are applied acting as a seal, the works scream out from the walls like disfigured prostitutes plying for trade. Whether they're feminist or misogynistic it's hard to tell, and this ambiguity is what sets Sulpine apart from so many others working in the street-art genre. There's no simple didacticism here, only pure art autonomism. The most disarming aspect of viewing this work is the sense that these characters might actually possess a soul.

The Wooster Collective

The Wooster Collective is completely invaluable. They basically devote their lives to what they do, for no reason other than love. What they're doing for the culture is priceless. They're enabling people to connect by seeing what's out there, and more importantly, giving exposure to what would otherwise be completely obscure. Zephyr

The internet has revolutionised many things, bringing the world together and making information available as quickly as it can be uploaded. Of the many websites dedicated to street art and related activities, woostercollective.com stands out, simply for the dedication and commitment of the people running it. This not-for-profit website aims to document and showcase artwork that exists largely outside of the museum and gallery system. It is a cyber salon for artists working all round the world, a place to post images of work, publicise events, feed back and see what's going on. The internet is a perfect communication medium for street art, since it can incorporate an infinite number of images, ideas and content that is constantly expanding. It can be updated by the second, and so long as the technology is available to users, it is universally accessible.

The Wooster Collective was first established around 1999, but the website gained a particular focus as a personal response to the attacks on New York on 11 September 2001. While these historic events marked a new era in twenty-first-century global politics, Sara and Marc Schiller, the site's founders, were overcome with the massive outpouring of personal grief that became visible on the streets and walls of Manhattan in the days, weeks and months following the attacks. People were expressing their deepest fears, sorrows and

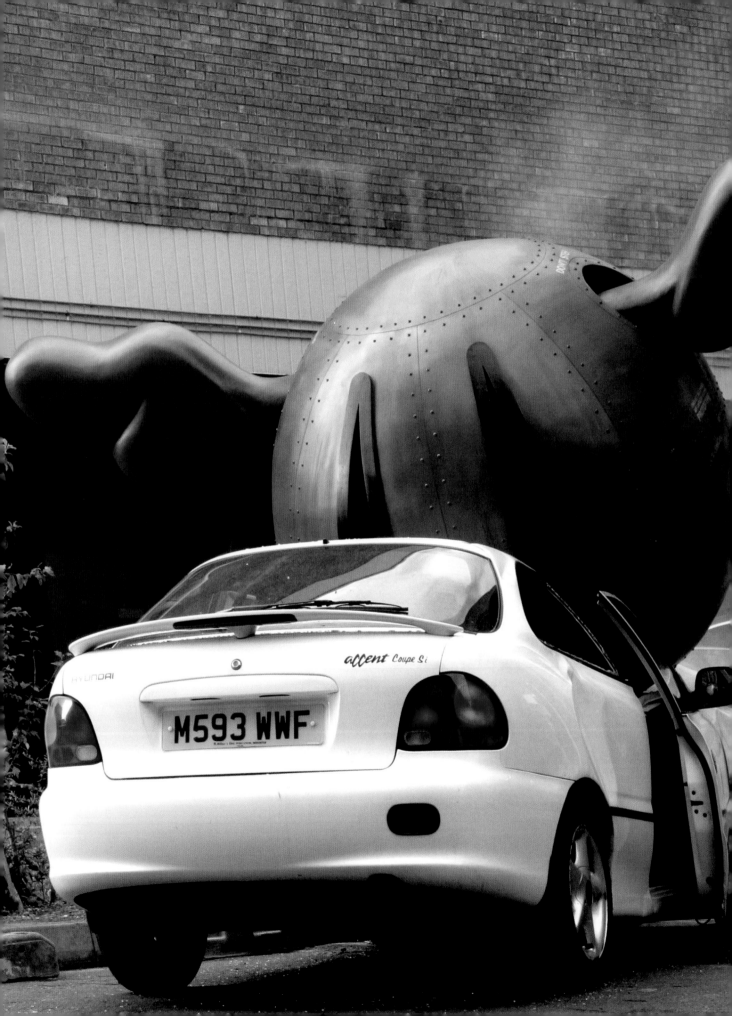

Opposite: D*Face
sculpture from an
exhibition at Stolen
Space, London
Left: D*Face
flyposter, London

loss through drawings, messages, poems, photos, and in any other way they could find on the streets of New York. The project, which started out as an email to thirty-five friends, has continued and expanded and now receives over 150,000 hits a day.

Wooster's attitude towards what can be considered 'street art' is all-embracing, and the site often mixes this type of work with what they simply call, 'shit we're digging'. This casual, friendly approach succeeds in providing a personal framework for the work the collective presents. The rise of woostercollective.com, and the many other street art and graffiti sites, is a clear indication of the continued public interest in this area. These websites are able to highlight work that more traditional media or institutions cannot exhibit, providing the opportunity to showcase artworks completely free of financial concerns. Commenting on this maverick freedom, and the way it has affected their view of art on the street, Marc Schiller says, 'If you were to do a gallery show or a museum show of street art of the last five years, gallerists would normally say, "I want Swoon in the show, I want Banksy in the show." If you asked Sara and me who should be in the show, it would be the people that did one thing and never did it again, but the one thing that they did was like, "What the *fuck*?"'

D*Face

Like many street artists, D∗Face comes from a design and animation background. After working in a commercially driven environment, the 'creative release' of operating on the street was what attracted him. From an early age, he was inspired by graffiti writing, and he describes the books *Spraycan Art* and *Subway Art* as 'eye candy to a visually starving kid'. Though this type of work provided an initial fascination, it was eventually skateboarding and the art associated with it that provided a style and attitude to which he could relate more directly. The 'ethics' of graffiti writing were still appealing, however – putting art up in the streets, illegally and for anyone to see.

Around 1998, after working with Shepard Fairey and helping him put his work up in London, D∗Face started to place his own stickers on his route to work. The walk took longer every day, in line with the desire to make bigger and bigger work. The simple pleasure of walking past his stickers was enough to keep the momentum going. Soon D∗Face was screen-printing his stickers, and what he describes as 'my idle fascination and self indulgence' had started to gain admirers on the London street-art scene. He remembers: 'People started saying, "I've seen *these faces* around".' And so the name 'D∗Face' was born.

D∗Face's work has now developed in a multitude of directions: he makes sculptures for the street and gallery shows, runs a gallery space, and still produces the stickers and fly posters. This diverse and constantly evolving practice highlights how artists working in this fashion are by necessity highly adaptable and constantly innovative. As the artist says, 'Street art is not just about stickers and posters; it's about whatever you can get your hands on. If that's a projector, then you do projection; if its casts and moulds, you can use them as well.' D∗Face's practice, with its roots in design and his savvy with the language and techniques of advertising, also typifies a certain generational attitude that is prevalent

among street artists. He is part of a generation on which advertising no longer 'works' because they can dissect it too quickly; this is perhaps one of their motives for wanting to advertise themselves.

Sculpture

Artists working with sculpture in the worlds of graffiti and street art are much rarer than those working in two dimensions. Material costs may be higher, studio production time longer, and there is the problem of transporting the work to the location. Additionally, the work may well be removed faster. All these factors add up to what street sculptor Mark Jenkins describes as, 'a cost reward thing – putting in all that work and then the stuff gets nicked after only two hours. So people who're trying to "get up" are like, "Screw that!"'

There is, however, a history of illegal three-dimensional work on the streets that is intertwined with the history of mainstream fine artists. Many of the Fluxus artists' happenings, for example, happened in the street without authorisation. According to Mare 139, the graffiti writer Phaze 2 was making works out of wood that referenced his tag as early as 1983. In the mid-1980s, New York street artists such as Charles Simonds, Ann Messner, Tom Otterness and Ken Hiratsuka were working with methods and projects relevant to sculpture. Simonds, for example, created tiny architectural structures on the street that resembled fragments of ancient cities. Hiratsuka carved decorative patterns directly into New York sidewalks.

More recently, the graffiti writer Revs and his partner Cost have had a huge influence on the street-art scene with their innovative techniques. Revs has also had an impact on sculpture in the street with his welded-metal *Revs* pieces, which are bolted to locations around Manhattan.

Jenkins, from Washington DC, has been placing three-dimensional works on the street since the early 2000s. His work is diverse, often jumping between humorous visual puns, serious issues such as homelessness, and pure moments of Surrealism in the street. A constant thread that runs through his work, however, which is also true of much street sculpture, is the strong relation to setting: the surrounding environment always completes the piece. A large part of his practice involves using his own body to make casts out of sticky tape, which he then places on the street. In this sense, his works can be seen in the tradition of self-portraiture. For Jenkins, being at the centre of the work was 'a matter of convenience'. The figures have recently been dressed in clothes and placed in strange scenarios, such as crawling out of bins or disappearing into walls. These human-scale figures often cause viewers to do a double take, and Jenkins himself can even be surprised when he sees the work installed: 'It's surreal to see something that looks like me because it's got the same clothes and dimensions.' He has been influenced by artists such as the Spanish sculptor Juan Muñoz and the Brazilian Arthur Barrio, who made various projects on the streets of Rio in the 1960s and 1970s.

In terms of the graffiti-writing mentality of saturating the city with your name, street sculpture might have little appeal. For artists working in this way, however, the thrill is to

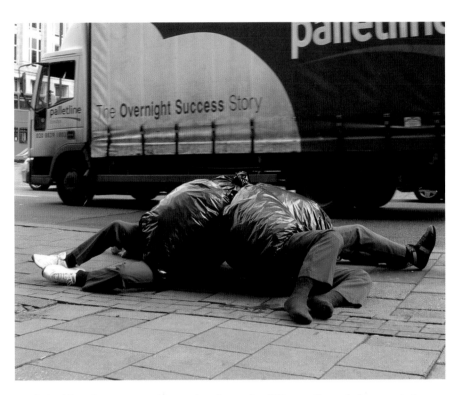

see their objects in context and know that the work will live on through documentation. As Jenkins comments, 'No one is paying me to do this, so what I do, I do for me.' His work pushes the street-art debate forward: the reaction is often not, 'Is this art?', but 'Is this a real person?' The way the work is received in different locations around the world varies according to the culture; Jenkins has found certain cities 'more paranoid' than others. The residents of South American cities, for example, are far more likely to engage with the work, whereas in the artist's hometown of Washington DC, which he describes as a 'high-strung city', people are in his experience, more surprised to see these odd, life-size figures on the streets without explanation. Viewers reaching for their picture-phone cameras, according to Jenkins, typify the response to his artworks across the globe.

The duo Darius and Downey also used three-dimensional objects in the early 2000s, but where Jenkins's work focuses on the body and figuration, Darius and Downey made sculptural interventions on the street that commented on the 'invisible' signs and apparatus of the city. Traffic lights, phone boxes and other public signage were all altered or reproduced in some way to make a mockery of the object's intended purpose. Similar to many others in the street-art community, Brad Downey came from a skateboarding background. What he learned from it was 'how to look at objects in a completely different way. How to use an object to do something different. So a bench isn't just something to sit on, but a tool for self-expression.'

Now working on his own, Downey cites projects by the forefather of Conceptual art as an early influence. Marcel Duchamp's concept of the ready-made, he says, is pure street art and graffiti. He explains: 'If you tag something, you make it your art. If I tag a street pole, I'm turning that pole into a ready-made.' Graffiti writing is like Duchamp signing a urinal, but leaving it in the bathroom instead of transplanting it to the gallery. According to Downey, Joseph Beuys's project, *7000 Oaks* 1983, where he had 7,000 trees planted in Kassel, Germany as a work of art, is another way of working that fits into a street-art ethos: 'It's not trying to be smart or clever; it's just giving more oxygen. It's helping the city in a very direct way.' Martin Kippenberger, who made several works that played with the dimensions and aesthetics of street furniture, also had an influence on Darius and Downey.

In a similar vein to Matta-Clark, Downey engages in more recent work with the concept of 'removing' or subtracting from the street as opposed to adding to it. But where Matta-Clark's subtractions were concerned with mathematical equations and architectural space, Downy's projects are more in line with the genre of street art that Dan Witz describes as 'pranks'. Downy says his reason for making work that appears light-hearted is as a reaction to the often oppressive nature of public space and the functional objects in these locations. 'The city is so serious and can be so depressing, it can get you down. It's really easy to do something negative in that context. If you can do something that's positive and uplifting, that's the best thing you can do outside.'

Crateman

The 'crateman' project is organised by a group of anonymous artists from Melbourne, with backgrounds in a mixture of disciplines including graffiti, street art and architecture. The group came together with the shared concept of working on a large scale with found objects that could have a strong visual impact on the landscape. Far removed from any ideas of ego or the cult of the artist's personality, the group is more interested in the public's reactions to their work than in individual plaudits. The collective doesn't even have a name, but their project is known to the general public and media as 'crateman', since it involves the placing of figures made from milk crates around the city. As they explain: 'We don't need a name; we're not out to create an identity for ourselves.' This refreshing approach to public interaction is further reflected in the group's reluctance to speak directly to the media. They instead prefer to let the art do the talking.

The first crateman was made in 2006 at the time of the Melbourne Commonwealth games, when the local government had cleaned up the city and removed much of the street art and graffiti that had previously been tolerated. The 'crateman' project was in some ways a reaction to this initiative. When the works mysteriously appear on buildings, the responses are often revealing. A typical reaction from the public has been to believe that the sculptures are part of some sort of advertising campaign. This reflects how conditioned people are to being sold things in public spaces. The polished, 'official looking' nature of the work also breaks away from the perceived nature of illegal art in the street. The simplicity of the figures and their gestures, their bright colours and poses, adds a happy, childlike aesthetic to the

Left: Darius and Downey,
The Kiss, **London, 2004**

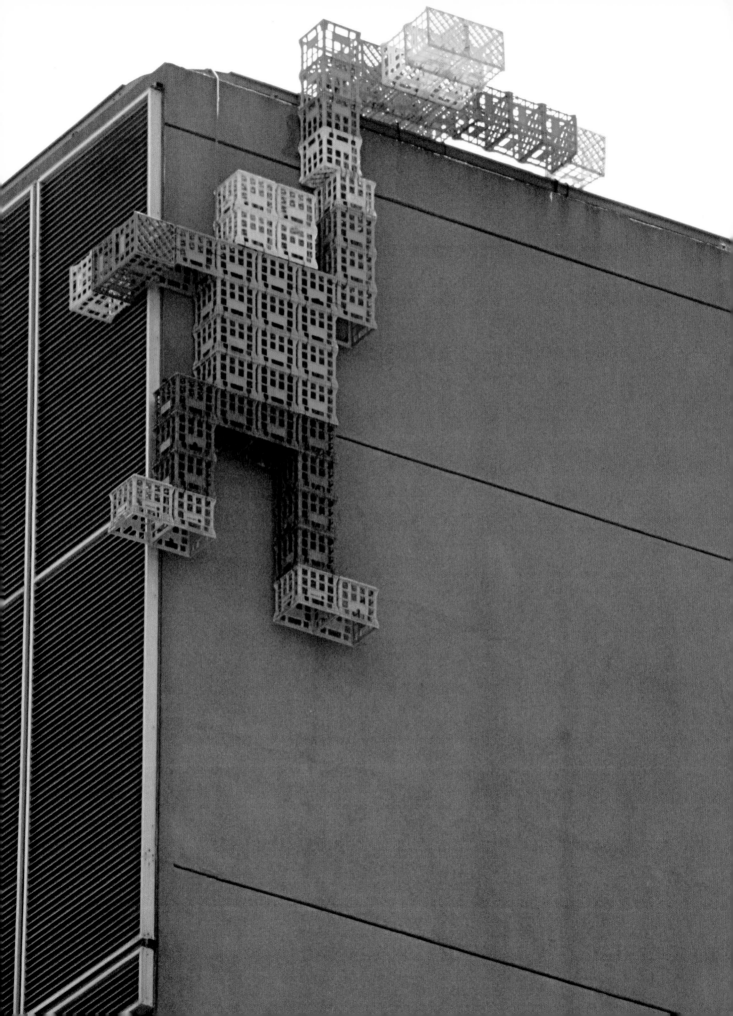

pieces, like toy figures, and the artists are willing to admit the influence of Lego on their practice. Certain cratemen stay up longer than others, often in relation to the public liability of the building's owner. Some pieces have been transported to new locations by the buildings' owners and thus find permanent homes. The objects themselves are made in sections and transported to the intended location, where they are fully assembled. The group will often don official looking overalls when installing the pieces, a tactic that has so far helped them avoid any altercations with the law, though their pieces have all been made illegally.

The initial idea of using milk crates to make these sculptures was a typical case of employing a material that was readily at hand, with a favourable size to weight ratio. It has led to a detailed interest in the boxes on the part of the artists: 'A crate weighs just under a kilogram but is actually quite big. From a distance they also appear quite solid.' The fact that these crates litter the streets of Melbourne and have proved an easily accessible and versatile medium for the group to work with can in some ways be seen as using waste as a way of creating a portrait of the city that produces it.

Graffiti Research Lab

Graffiti Research Lab (GRL) consists of two members: Evan Roth and James Powderly. Their projects revolve around making templates for various low-cost and easy-to-construct devices that assist those making art illegally in public. In GRL's words: 'We make open-source tools for people doing things in the city who aren't asking for permission.' That includes activists, pranksters, graffiti writers, street artists and anyone else interested in this area. Their tools have included the 'L.E.D throwie', which is a scaled-down version of an LED screen that can be used in various ways; in its simplest form it is a little like a set of portable Christmas lights. One of the first graffiti-related projects on which Roth worked was a computer system that allowed graffiti writers to record the process of writing their tags, and using simple technology, to play the process back and project it. The interest in this process was in being able to 'reveal the real-time action of graffiti as a gesture', as opposed to the 'static product', with which the public is more familiar. This was an important step in recognising the process as well as the finished product.

At the time, Powderly was working on the Mars exploration project as an engineer. With the outbreak of the Iraq war, he was assigned to more military-orientated projects. At a certain point in this process, he experienced a 'crisis of conscience' and decided to leave the job. Eventually, he teamed up with Roth on an artist-residency programme aimed at the production of open-source software. Though he had left his previous role behind, Powderly maintained what he describes as his 'pissed off-ness' with the way engineering and technology had been manipulated into the service of war. He explains, 'Engineers had always told me "technology is neutral: it can be used for good or bad." So I thought, "What about a research lab dedicated to graffiti? I bet nobody's going to tell me that's neutral."'

GRL were never concerned with coming up with a final product, but more with helping others who were treating the city as a medium in which to work. Their original concept of

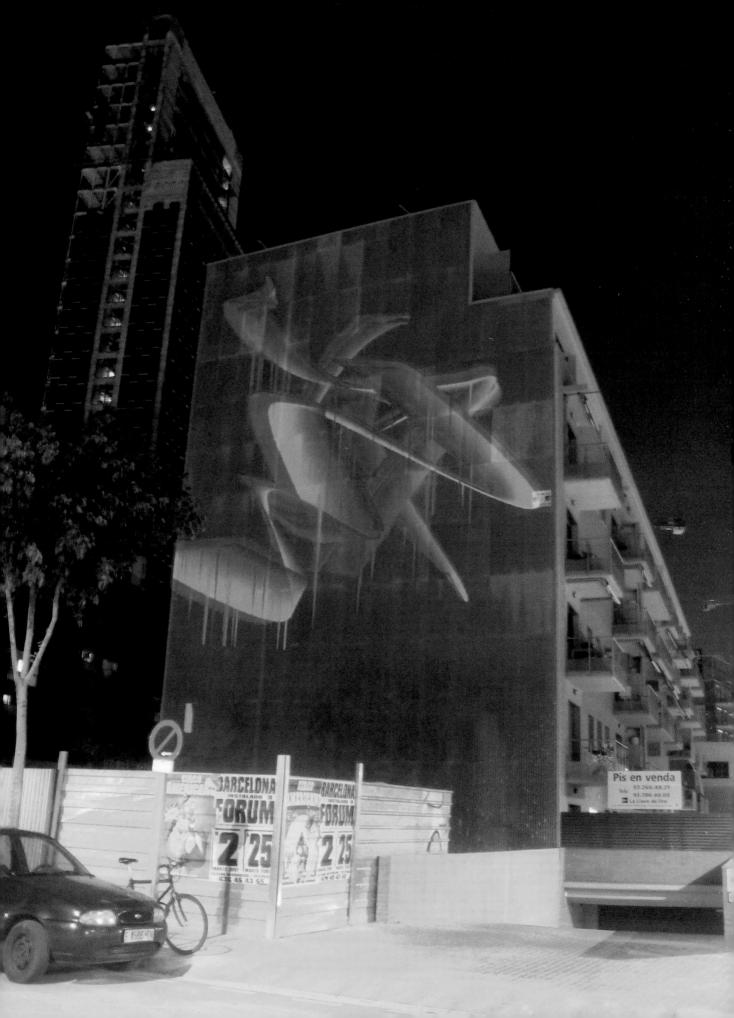

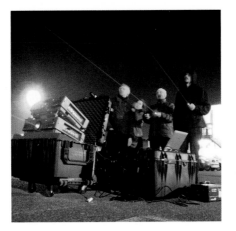

bringing high-tech tools to the street art community changed, however, after spending time with the various artists and activists. As Powderly says: 'Graffiti writers are not a class of people going out there brainless, with little intention. There's a lot of ingenuity: they create their own tools, they create their own "hacks" for systems. They understand the city in a way I realised I never had. What we came to respect is that these people already know how to make tools for their purpose. This is a group of people that doesn't have a market serving their needs.' GRL's opinion is that graffiti writers and street artists have been highly innovative from the start: 'Right from the beginnings of graffiti, the first tool of substance that made the world aware of graffiti writing was a billion-dollar train infrastructure.'

In this sense, GRL are less interested in state-of-the-art inventions than in everyday devices that can be appropriated to serve new means: 'What interests us is the idea of a system that existed, which these people found a way to exploit, and the result was that a bunch of young kids managed to transport their artwork over the biggest metropolitan city in the world.'

The End is No End

Everybody knows the story of David and Goliath, the biblical fable with strong metaphorical overtones. This tale of the smaller, weaker underdog, who had self belief and fought without conventional weapons, and in the end turns his enemy's own sword against him, has parallels with the worlds of graffiti and street art. Whether it's kids from the streets of the Bronx in 1972 using their creativity and the subway system to express a message that they were desperate to deliver, or a lone subvertiser with a can of household paint who manages to spark political and social change simply by altering the text on a billboard, we can think of these activities as the work of the fearless, taking on the might of their oppressors. Win or lose, in the end it doesn't matter; what really counts, and marks these people out as different, is that they have been prepared to take a risk. Graffiti and street art are essentially acts of rebellion, and their true history is an oral one. There are the facts and the whys and wherefores, but most important are the stories: stories of danger, innovation and adventure. In fact, one could say that the history of the world has been written on its walls, and even before there were walls, people found surfaces on which to tell their story.

'Street art', 'graffiti': in the end the name doesn't matter. It's impossible to put a cage around creativity. If we think about these multiple histories, taking place side by side and in succession, from the first forms of paint, simply made with mud, to the invention of aerosol spray paint, the overall impact that these people working outside of the law have made on culture is immeasurable. Their art forms somehow manage to mix social activism, social outrage and creativity in often beautiful public gestures. It's a perfect example of hybridity in constant flux. We now have a global audience for a truly global art form. Is this the end? No. We've only just begun.

Left and above:
Graffiti Research Lab,
Barcelona, May 2007.
This was part of a digital
workshop with an
organisation called
HANGAR. Projection
by Josh Nimoy.
Overleaf: Obey, London

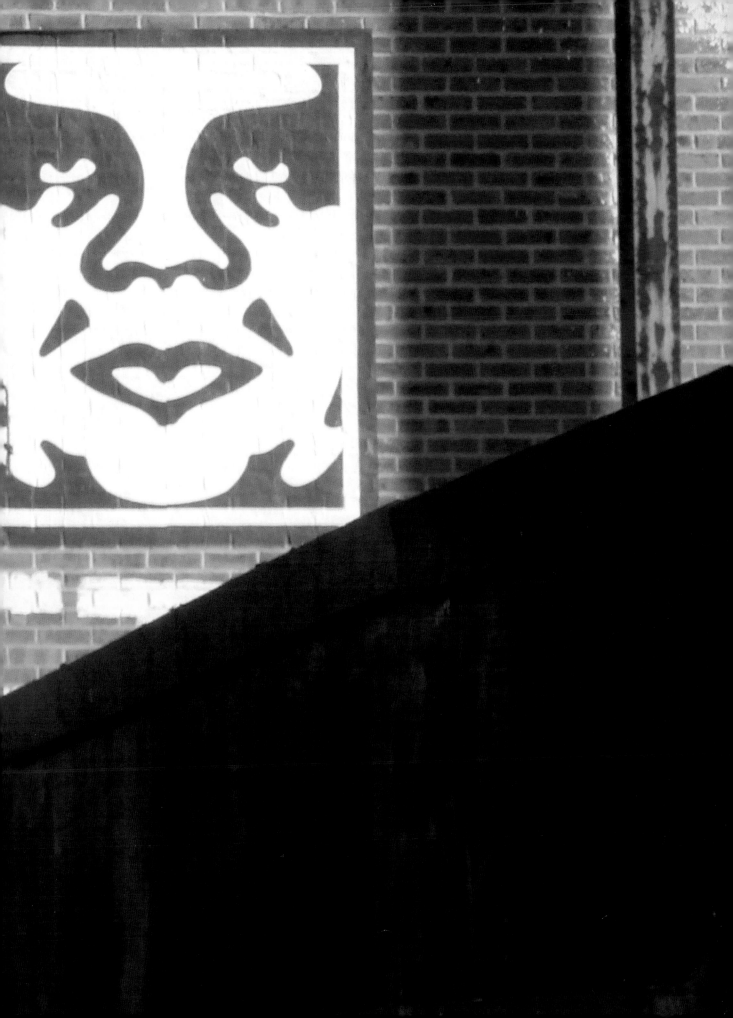

Credits

Index